A NEW WORLD

Pre-Columbian Art from the Carroll Collection

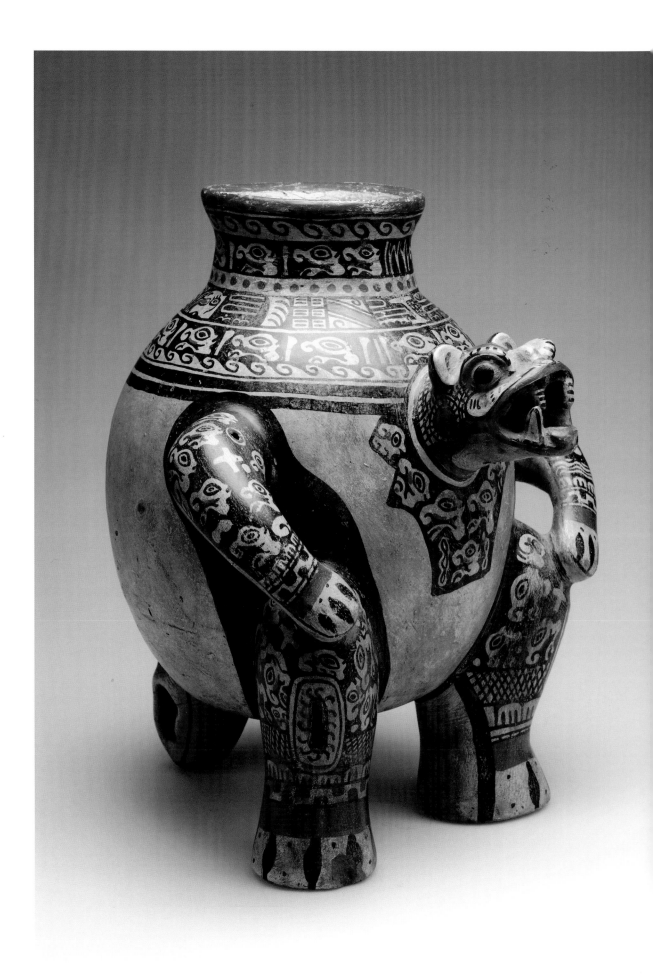

A New World

Pre-Columbian Art from the Carroll Collection

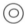

John F. Scott

Laura W. Johnson-Kelly

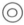

HERBERT F. JOHNSON MUSEUM OF ART, CORNELL UNIVERSITY

This catalogue accompanies
an exhibition organized by the
Herbert F. Johnson Museum of
Art at Cornell University, curated
by Laura Johnson-Kelly, John F.
Scott, and Andrew C. Weislogel,
and presented at the Herbert F.
Johnson Museum of Art,
Ithaca, New York
March 29 – June 15, 2008

COVER: SEATED FEMALE (GIGANTE)
FIGURE WITH CHILD (detail) (cat. 49)

BACK COVER: STIRRUP SPOUT
SPONDYLUS VESSEL (cat. 183)

INSIDE COVERS: Rollout design transfer
from JAMA-COAQUE CYLINDER SEAL
(cat. 76) by Elizabeth Schneider

FRONTISPIECE: JAGUAR EFFIGY JAR
(cat. 242)

Photography by Julie Magura
and digital postproduction by
Jessica Sowls, Johnson Museum

Library of Congress
Control Number:
2008924631
ISBN-13: 978-1-934260-02-9
ISBN-10: 1-934260-02-9
Published by:
Herbert F. Johnson Museum of Art
Cornell University
Ithaca, New York 14853
www.museum.cornell.edu

This catalogue was funded in
part by public funds from the
New York State Council on the
Arts, a state agency.

State of the Arts

NYSCA

Table of Contents

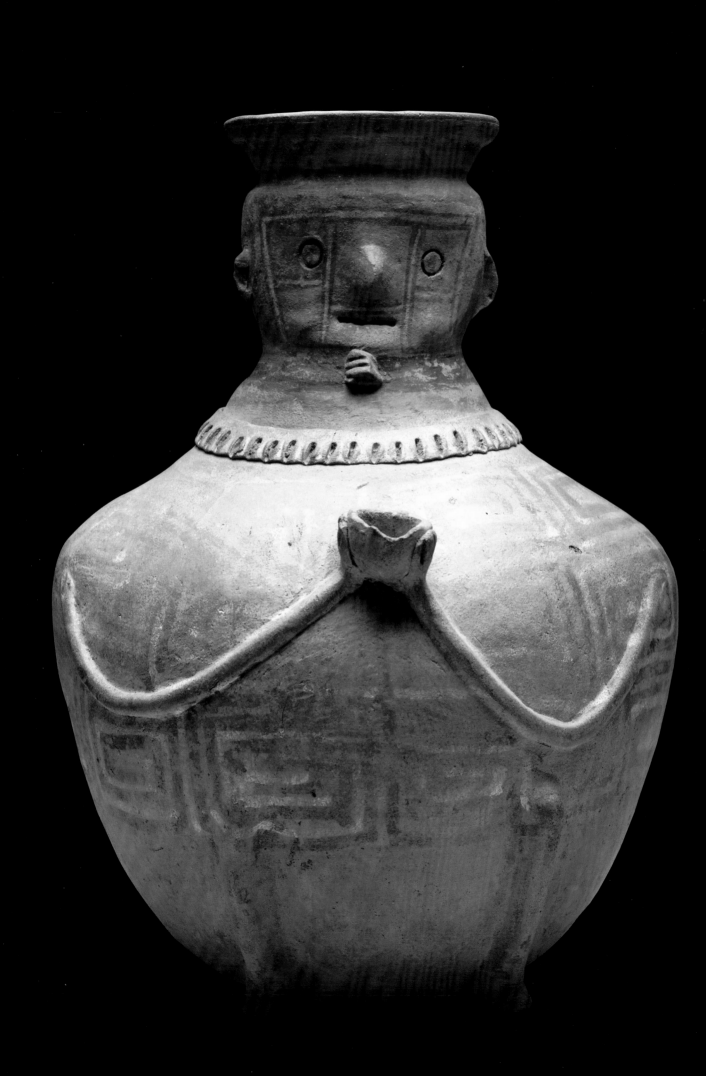

Acknowledgments

When Dr. Thomas Carroll opened the thick binder of notes and photographs he brought to our initial meeting in October 2005, it was immediately apparent that he combined a delight in the fascinating forms of pre-Columbian art with a profound interest in scholarship on the topic. In his search for a permanent home for these objects—painstakingly collected in Ecuador and other parts of South America during the 1950s and '60s during his career as an agricultural economist, and numbered, catalogued, and treasured for more than thirty years—Dr. Carroll looked very carefully for a place where they would be seen, researched, and appreciated. He perceived before we did that his collection would, in his words, fill "some of the gaps . . . especially of highland cultures, while supplying considerable depth to examples already in your possession." We are pleased that, with wisdom and generosity, Dr. Carroll saw fit to add strength to strength and transform in one stroke the Johnson's already respectable holdings in the art of ancient Ecuador into a truly compelling destination for educators, researchers, students, and Museum visitors at Cornell, in the Ithaca community, and beyond. The Carroll collection provides Cornell with a lasting legacy—a new world, to quote our title—upon which we will continue to build.

We thank Dr. Carroll and Charlotte Jones-Carroll for their interest in the Museum, their hospitality on visits to Chevy Chase, and their dedicated correspondence as we moved through the process of the gift and the exhibition. We are also grateful to Peter Carroll, Dr. Carroll's son, who has been immensely helpful with various important logistics and photography, and, of course, for providing the best reason of all for Dr. Carroll's return visits to Ithaca.

Our two contributing authors, John F. Scott and Laura Johnson-Kelly, have been models of thoroughness and dedication, producing a body of informative writing and exacting, well-organized cataloguing information that will propel the Carroll collection out of our doors and onto the bookshelves of professionals in the field, collectors, and enthusiasts alike. I have greatly enjoyed the time the three of us have spent together, puzzling over some pieces, simply admiring others—the most unalloyed satisfaction possible in any curatorial endeavor. We are especially pleased to have Professor Scott back at Cornell; as a member of the History of Art faculty here from 1971–77, Professor Scott advised the Johnson Museum on two significant pre-Columbian art purchases in 1973, the year the Museum opened. Working again with the Museum in 1982, he provided an essay for the Museum's first major exhibition of art from the ancient Americas, *Pre-Columbian Art of Ecuador from the Peggy and Tessim Zorach Collection*. We are very happy that he has agreed to return after a twenty-five-year hiatus to contribute so significantly to what is, in many key respects, the sequel. A Cornell-trained Andean archaeologist, Class of 1985, Ms. Johnson-Kelly brought to the project her impressive knowledge of ancient Peruvian societies and artifacts, as well as a finely honed descriptive vocabulary and ample dedication and goodwill. Her contribution to the cataloguing of this collection will be useful for many years to come.

161 **FACE-NECK JAR**
AD 800–1470
35 x 26 x 11.5 cm

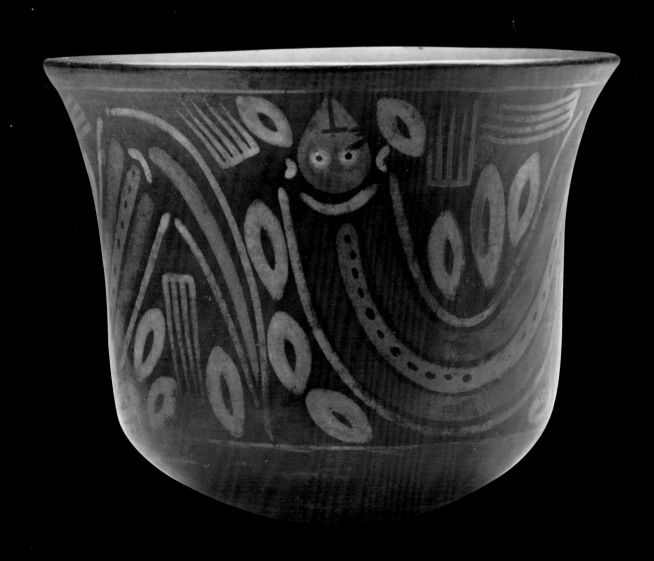

Dr. Thomas Carroll,
Cornell PhD 1951

For expert advice, our thanks go to John Henderson, Cornell professor of anthropology, from whose knowledge of Mayan ceramics we benefited greatly. We also wish to thank Pilar Alliende Estevez, a curator at the Museo Chileño de Arte Precolombino in Santiago de Chile; her fortuitous arrival in Ithaca in the spring of 2006 and the three months she spent verifying cataloguing information on the Carroll collection contributed greatly to our confidence about cultural attributions and periodization. Barbara Moulard, art historian and faculty member at Arizona State University, provided an excellent appraisal document with precise descriptions of the objects in the collection. Kasia Maroney of Boston Restoration conserved several objects in a timely and sensitive manner.

I wish to give special thanks also to the publication team. Ithaca-based designer Mo Viele unified this diverse grouping of objects into a beautiful visual presentation, and Jim Houghton of The Graphic Touch provided the excellent and informative maps. Print room intern and fine arts major Elizabeth Schneider, Class of 2008, transferred the designs of cylinder seals on the inside covers of this catalogue and on page 70 and the decoration of the bottle on page 111 into legible form. Museum photographer Julie Magura is responsible for the vast majority of the photography reproduced here, deftly edited by Jessica Sowls. Massachusetts-based photographer Jon Crispin provided an initial and admirably thorough set of photographs of the Carroll collection, some of which appear in this volume, as well as the photograph of Dr. Carroll reproduced here. Andrea Potochniak presided over the entire publication process, unifying its disparate parts with great intelligence, aplomb, and attention to detail.

Other members of the Johnson Museum staff deserve mention for their role in bringing the works to our visitors. Registrar Matt Conway ensured the safe transport of the collection to Cornell, and assisted by Museum interns Genevieve Civetta and Sarah Ray, accomplished the registration and labor-intensive numbering process for the gift. The efforts of preparators Wil Millard, George Cannon, and David Ryan assured the works would be seen to their best advantage in our galleries.

Lastly, I am grateful to Frank Robinson, the Richard J. Schwartz Director, for his unwavering support of this project.

ANDREW C. WEISLOGEL

ASSISTANT CURATOR/MASTER TEACHER

199 CUP WITH
LIZARD DESIGN
AD 100–400
12.5 x 16 cm

Timeline

	PERIOD	Mesoamerica	Lower Central America	North Andes	Central & Southern Andes
20,000 BC					
	PALEOINDIAN	*Entry of humans into America by land bridge from Siberia*			
8000 BC					
	ARCHAIC				
3500 BC					
	LATE ARCHAIC			*Earliest ceramics* Valdivia	COTTON PRECERAMIC
1800 BC					
	EARLY FORMATIVE			Machalilla	INITIAL PERIOD
1000 BC					
	MIDDLE FORMATIVE	Olmec Tlatilco		Chorrera Ilama	EARLY HORIZON Chavin Cupisnique Chongoyape Paracas
500 BC					
	LATE FORMATIVE	Colima Jalisco Nayarit	*Costa Rican jade begins*	REGIONAL DEVELOPMENT PERIOD Guangala Bahía Jama-Coaque	
BC 0 AD	CLASSIC	Maya	*Gold begins* El Bosque Coclé	La Tolita Capulí	EARLY INTERMEDIATE Nasca Moche Vicús
AD 500					
	INTEGRATION PERIOD		Guanacaste-Nicoya	Quimbaya Manteño Milagro Sinú Tairona	MIDDLE HORIZON Wari Sicán Cajamarca LATE INTERMEDIATE Chimú Chancay LATE HORIZON
		Aztec		Inca	Inca
AD 1500					

Voices from the Past:
The Art and Cultures in the Carroll Collection

When Dr. Thomas Carroll donated more than four hundred works of pre-Columbian art to the Herbert F. Johnson Museum of Art at Cornell University in 2006, he added much depth to the Museum's already strong holdings in West Mexico, Classic Maya, Peru, and Ecuador. Cornell's Ecuadorian collection had already been established as one of the best in this country, thanks primarily to the donations made by Margaret and Tessim Zorach in four large lots from 1974 to 1986. I was privileged to publish all but the last of these gifts in the catalogue accompanying an exhibition at the Johnson Museum in 1982. I was delighted to be asked to return to Cornell and see the Museum's greatly expanded holdings in both Ecuador and Peru added by Dr. Carroll. Furthermore, he has graciously allowed us to incorporate pieces still in his hands into this exhibition and catalogue. In this essay, I hope to give a sense of how positively the Carroll gift enhances our understanding and appreciation of the many cultures represented.

Beginnings of art in early village societies

Permanently settled life began very early on the coastal plains of the Northern Andes, encompassing the modern republics of Colombia and Ecuador. While the Caribbean littoral of Colombia has the earliest documented settlements, dating to the fourth millennium BC, the central coastal villages of Ecuador were discovered earlier, in the 1950s, by Emilio Estrada and his Smithsonian colleagues Clifford Evans and Betty Meggers. They named the culture Valdivia, after a present-day seaside village. The remains found there and elsewhere were best documented by sherds of broken pottery, the earliest then known from Ecuador. Initial radiocarbon dating placed its beginnings at 3100 BC, prior to the later correction by the more recently discovered bristlecone pine correlation. A fine, nearly complete, hemispherical example of such early pottery in the Carroll collection (cat. 1) is red monochrome with barely raised tetrapod legs and loosely patterned rows of Greek keys incised on its surface, brought out by whitish pigment in the grooves. The bright reddish color of the surface in this example was achieved by allowing oxygen to react with the clay during firing, typically in an enclosed pit to concentrate and retain the heat. Such simple monochrome ware enhanced by surface texture is typical of the beginnings of pottery the world over. It was formed by coiling tempered clay and then manipulating the surface in a variety of ways. When leather-hard, the clay could be burnished with a stone. It was then fired in a pit, which converted the clay into ceramic.

1

Contemporary with pottery, by which we refer to ceramics formed into containers, the Valdivia people carved small amulets out of stones already smoothed by the action of water that suggested human shape by their vertical posture even without visible features. Next, notches were cut by string sawing at the base, suggesting legs.[1] Shallow lines incised on the smooth surfaces of numerous examples in the Carroll collection (cats. 2, 3, 4, 5, 6) indicate geometric facial features and hands held against their stomachs. No indication of gender reveals to us age or sex; their geometry therefore abstracts the human without specifying more particular persons.

2–6

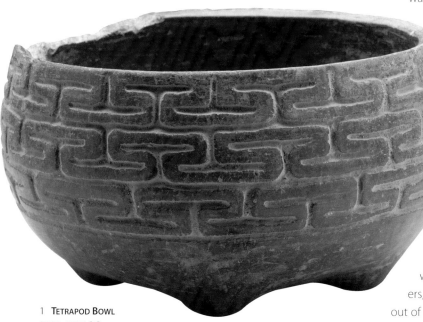

1 TETRAPOD BOWL
2700–2300 BC
8.5 x 18.5 x 16.5 cm

Around 2300 BC, the Valdivia potters began to make their figurines out of the same ceramic medium as their pottery. Greater flexibility of the modeled material permitted them to form figurines with more detail than the geometric stone amulets. They were more gender-specific, with breasts in the great majority indicating females. Their very large coiffures often hung far down their backs, striated in a fashion similar to some of the earliest stone figurines.[2] In the Carroll collection, there are many such figurines or their fragments (here, cats. 8, 9, 10, 11, 12). They correspond to a style that lasted until about 2000 BC. Continuing into the second millennium BC, figurines became far less representational, with more emphasis on the face, which now suggested emotion via smiles and raised eyebrows (cat. 13), in contrast to the horizontal punched lines rendering the earlier Valdivia figurines' facial features. Solid figurines from the subsequent Machalilla phase (1450–800 BC)[3] are flatter and less human in proportions (cat. 15), but they have more interest in red painting of geometric designs on the buff ground. A variety of other Machalilla figurines are found, indicating a great diversity of styles.[4] Bottles with a stirrup spout—a single vertical spout that branches in two before joining the body—created a type later made popular in Peru.[5] The Machalilla period clearly was a time of considerable innovation.

8–12 (margin)
13 (margin)
15 (margin)

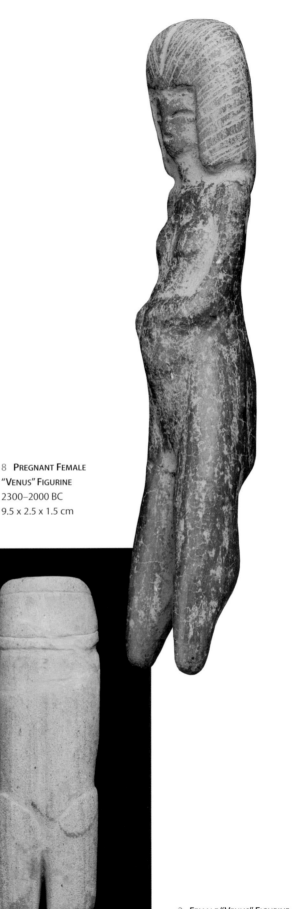

8 PREGNANT FEMALE
"VENUS" FIGURINE
2300–2000 BC
9.5 x 2.5 x 1.5 cm

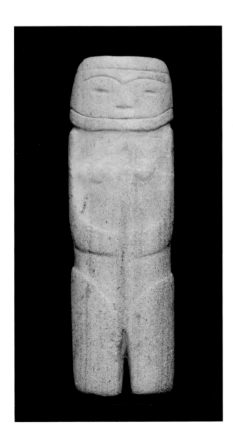

2 FEMALE "VENUS" FIGURINE
2700–2300 BC
15.5 x 4.8 x 2 cm

13

A stone ritual mortar in the Carroll collection (cat. 14), probably used for preparation of narcotic powders, is carved representing a standing jaguar with an incurling tail. The jaguar is a favorite tutelary animal for shamans. Such mortars known from the Chavín culture of Peru, eight hundred years later, have a similar squared, architectural form. Five were excavated at San Isidro, Manabí, by James Zeidler.[6] He definitely showed that these mortars dated to Late Valdivia by radiocarbon (seventeenth–sixteenth centuries BC).[7]

Well-fired pottery and ceramic figurines appear in Central America and Mexico during the second millennium BC as well, from south coastal Panama and Guatemala to the west Mexican state of Colima. A figurine fragment in the Carroll collection (cat. 247) comes from the central highlands of Mexico and is datable in the Middle Formative, contemporary to the first high culture in Mesoamerica, the Olmec (1200–500 BC). Unlike Olmec-style figures found in tombs of the same type-site, at a brickyard called Tlatilco in the northern suburbs of modern Mexico City, this figurine continues the less naturalistic stylization of the village cultures. Their features were quickly modeled in the damp clay with added fillets pressed onto the body and scored with grooves. Following this, figurines begin to be made with molds in both Ecuador and Mesoamerica, although hand-modeling continued being used to add features and touch up details.

182 **Stirrup-spout Vessel With Incised Feline Raptor**
400–200 BC
21.5 x 12 x 6.5 cm

First high cultures of Nuclear America

During the Middle Formative period through the areas embracing the mountainous western spine of the South American continent,[8] high cultures arose in lowland river valleys that extended to many other areas through trade and settlement. They are linked by their religious images of divine animals, prominently featuring the dominant land, air and water predators of the tropics: the jaguar, the harpy eagle, and the crocodile. For this reason, they are often called "mother cultures" of their respective regions. While it is clear that no single people were responsible for the innovations of this period, they coalesce in the cultures dubbed "Olmec" in Mesoamerica (Mexico and upper Central America) and "Chavín" in the Central Andes (mainly Peru and adjoining Bolivia). To these should be added the Chorrera culture of western Ecuador and southern Colombia, since it integrated the coast and riverine areas.[9] The contemporary llama phase in the south-central Colombian highlands modified the Chorrera style; it is represented by one piece in the Carroll collection (cat. 223). The collection includes no works of the Olmec culture, but does have a few fine examples of the Chavín-related coastal cultures such as Cupisnique, Chongoyape, and Paracas. The Chorrera culture is much more extensively represented.

North coastal Chavín ceramics feature a highly burnished surface, often contrasting with areas left matte. The ritual vessels typically have a stirrup spout, possibly to restrict the ease of pouring in order to conserve the liquid contents from evaporation (critical in the desert coastal environment of Peru). Later, Moche images show such vessels being used to pour libations over divine figures or hung from rafters while mortals engage in ritual activities. This style first emerged in various ritual sites in the small river valleys emptying into the Pacific along the central north coast, then coalesced in the highland ritual city of Chavín de Huántar, for which the entire style is named. Smoothly cut architectural stones at that site render highly stylized images of sacred animals, often transforming from humans and sprouting multiple appendages. One such relief sharply incised on the Old Temple represents a crested eagle with wings extended to the sides and tail feathers spread at the bottom.[10] The nearly identical creature can be seen incised on a burnished blackware bottle (cat. 182), although its profile head is rendered with jaguar features. The muscular proportions of the vessel itself and the sharp flare of its lip convey the power inherent in the bottle and its incised image.

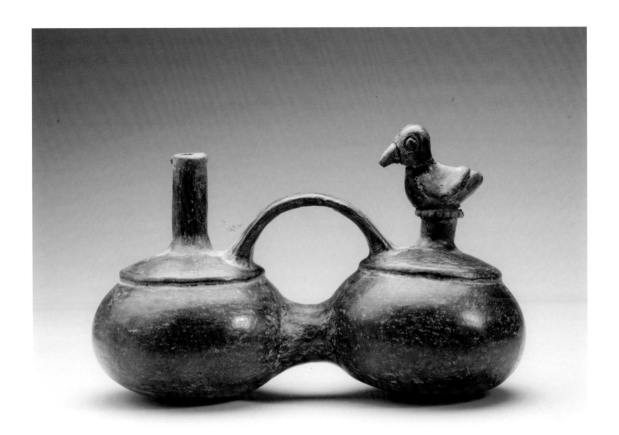

24 **Double-chambered Whistling Vessel**
1100–300 BC
5 x 24 x 11 cm

The south coastal style, probably derived from late Chavín textiles, develops the former's images of powerful predators. The jaguar's face is applied to the body of a bridge-spouted bottle through parallel incisions between which, after firing, resinous pigments of different colors were applied (cat. 186). His whiskers are abstracted into a pair of S-curves extending from the sides of his fanged mouth. His sharp cat eyes are outlined in red and surmounted by thick black eyebrows converging on his button nose. Less fearsome is the bird applied to the front of the body and spout of catalogue 187, in which the powerful raptor eagle of Chavín becomes a geometric quilt of brightly colored shapes. These colored patterns prefigure the dominant art of the Central Andes, woven textiles, which were an important medium for the transference of ideas.

North of the modern boundary of Peru, in Ecuador, art contemporary with the Middle Formative shows strong connections with the Chavín art style. A fine Ecuadorian south highland example from Azuay Province with thick stirrup-spout and distinctive curvilinear incisions[11] already prefigures the burnished and incised Cupisnique pottery. The most likely reason for contacts with coastal Ecuadorians was trade for the bright orange Spondylus shells, already valued for pendants in Ecuador during the

Valdivia period, and appearing in Early Formative (Initial Period) Peruvian ceremonial sites.[12] However, Spondylus were not found in the colder Pacific waters off Peru, fed by the Humboldt Current from Antarctica. The Ecuadorians were able to bring them to Peru, probably on large sailing balsa rafts. Well documented in later times,[13] these rafts permitted Ecuadorians from the Gulf of Guayaquil to trade down the Peruvian coast, where they may have exchanged the shells for valuable items such as textiles, metalwork, and fine pottery.

Suggestive of this trade are whistles incorporated into ceramics. Ecuadorian potters invented both ceramic whistles, seen underneath the bird on catalogue 23, and double-chambered bottles, in which the movement of water from one chamber to the other causes a whistle in the head of one chamber to sound.[14] In the case of Chorrera double-chambered whistling bottles (cats. 24, 25, 26), each chamber has its own spout linked by a bridge handle and a hollow straight tube at the base. This vessel type enters Peru at the end of the Formative. A bird often replaces one of the Chorrera spouts (cats. 24, 26), as in the Paracas single-chambered bottle (cat. 187). The distinctive Chorrera loop-handle spout (cats. 34, 37)

is closely related to the vertical spouted bottle common in Cupisnique that does not have a handle. A geometric motif incised on the body of catalogue 37 is a stepped motif terminating in a scroll, similar to the steps incised without scrolls on a Cupisnique bottle (cat. 184). The full stepped scroll is a very characteristic form often associated with cloud-topped mountains in the later Moche culture of northern coastal Peru. Incised linked scroll forms on the bottom of catalogue 31 and the shoulder of catalogue 32 also recall Chavín-era abstracted imagery such as on the back of catalogue 185, which is rendered in three colors separated by incised lines. Chorrera often abstracted the bat by means of undulating curves meeting at angular points, especially along the rims of bowls (cats. 29, 30, 31).

More northerly connections of Chorrera are suggested in the phytomorphic (or plant-shaped) incurved bowl (cat. 33), which recalls very common shapes in the Classic Quimbaya Incised Brownware of central Colombia, the dating of which has not been securely established although usually placed in the first millennium AD. Classic Quimbaya human figures, found both on Incised Brownware and in cast gold, show the bulbous curves and serene closed "Buddha" eyes of Chorrera hollow figures (cats. 17, 19). The two figures modeled in high relief on opposite sides of the large jar (cat. 27) have these features: their flexed arms and legs are rendered by bulbous ovals outlined by incisions. Chorrera figures are far more stylized than Classic Quimbaya figures, which have specific details of hairstyle and jewelry. Bowls representing a simplified style of recumbent figure common in Chorrera (cat. 21) are reflected in Classic Quimbaya Tricolor ware. I believe the former influenced the latter, perhaps using the llama-period style of Calima[15] and the newly identified Malagana art as intermediaries. llama, decorated by incision on monochrome pottery, is dated to the first millennium BC, while Malagana, which introduces white and yellow into its palette, is dated around the beginning of the Christian era.

The llama period mentioned above was produced by the earliest known culture (1500–100 BC) in the Calima region of Colombia, located in the flanks of the westernmost cordillera facing the Cauca River valley. The double-spouted loop-handled bottle (called an *alcarraza*, a favorite form also of the subsequent Yotoco phase) in the Carroll collection is decorated with dense incisions forming a frieze around the vessel body of a sharp right-angle Greek key set off by crosshatching, read as background (cat. 223). It is monochrome red, although the incisions have a buff color because they removed the burnished red color of the body. Human effigy pottery in llama often renders basket-carriers *(canasteros)*, possibly representing traders in caravans who served as the middlemen between the Chorrera culture to their south with the early Quimbaya culture to their north. A Chorrera loop-handled, single-spouted bottle was excavated in the rich cemetery of the Malagana culture.[16]

The trade between Ecuador and Colombia is shown even more dramatically in gold, a clearly valuable material, than in breakable pottery. Flat repoussé gold masks with geometric features come from the rich Malagana graves, unearthed only in 1992, as well as gold pincers with abstracted facial features on the bottom.[17] A gold piece in the Carroll collection (cat. 224) combines similar geometric facial features on both sides of a clapper, formed like a pincer but incurved along the edge of the faces. Significantly, this piece has been attributed to

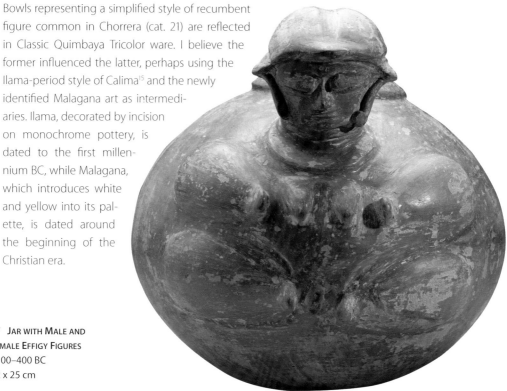

27 JAR WITH MALE AND
FEMALE EFFIGY FIGURES
1100–400 BC
22 x 25 cm

La Tolita, which stylistically is much more naturalistic. Although none of the Carroll pieces has been assayed, they are probably all an alloy of gold and copper, known in the Intermediate Area as *tumbaga*. They typically were bathed in acid, which removes the copper molecules from the surface, leaving only the gold color and giving the impression that the gold is pure. This surface enrichment of gold is very common throughout the Intermediate Area between Ecuador and Costa Rica.

Gold items associated with the much-admired Classic Quimbaya style, mentioned above, were traded widely along the western cordillera of the Andes in the first millennium AD. A cast standing male figurine holding a large hafted axe and a feather fan (cat. 226) looks like the male figurines on top of "pins" (really lime dippers) in the rich Treasure of the Quimbaya. While their faces are mask-like, their postures and casting are similar to the Carroll piece. Such gold figurines were distributed in southwestern Colombia from Malagana and Calima north to the Caribbean lowlands of Urubá and Sinú, and even traded into Lower Central America.

Regional Developmental Period, Ecuador: 300 BC–AD 600

The Bahía phase immediately follows Chorrera in the center of Ecuador's Pacific coastal plain, specifically the province of Manabí. During the earlier part of the phase (300–1 BC), corresponding to the Late Formative in hemispheric terms but the earlier Regional Developmental Period in Ecuadorian terminology, the use of molds becomes quite common in the making of figurines.[18] A hollow figure of a standing woman wearing a geometrically decorated skirt, a necklace of perforated shells or stone beads, hands held together across the abdomen, and a polished black helmet (cat. 48), recalls the closed-eyes Chorrera figures (cat. 18). The Bahía example has the Buddha-like closed lids, painted polychrome within incised zones like Chorrera hollow figures, but is far less open in space. This is a result of the use of a one-sided mold; the back is handmade. Although most are completely plain on the back, catalogue 48 repeats the colorful design of the skirt on its lower back. Nevertheless, the figurine's strong frontality, caused by the one-sided mold, directly arrests the viewer.[19]

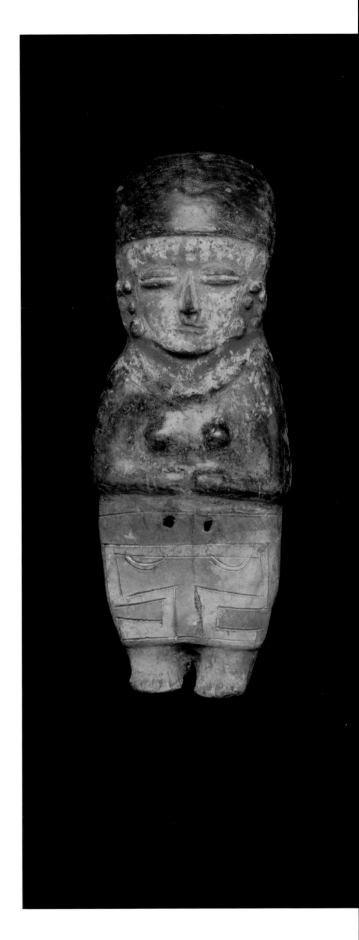

48 STANDING FEMALE
EFFIGY WHISTLE
300 BC–AD 500
28.5 x 10.5 cm

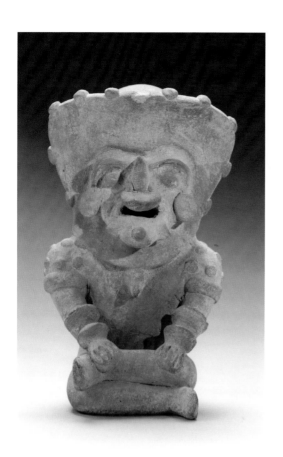

A later Bahía style, which is only partially mold-made, is called a *gigante*, Spanish for "giant," because of its considerable size. They apparently were created to be family groups, such as a seated female pair in the Zorach collection joined at the shoulder and hips before firing (74.053.054). The Carroll collection has no such pair, but it does have a female (cat. 49), her legs parallel, straight out in front, with her knee-length skirt stretched between. Her arms cradle a small, mold-made baby, whom she seems to present to viewers while looking straight out at them. A much smaller male (cat. 50) of the mold-made La Plata type is seated with his legs crossed, a posture so universal in aboriginal American populations that it has been nicknamed "Indian position." He wears only a loincloth, also a widespread designator of a male among aboriginal Americans. On his upper torso are distinctive pellet-decorated shoulder adornments seen in coastal Ecuador and Western Mexico. A more standard, La Plata-style, seated male with wrinkled, mold-made face has similar attributes (cat. 51). The tusk pendants worn by these figures, apparently insignia of rank among Bahía men, may be modeled after sperm whale teeth, but actual ones were carved in stone (cat. 52). The simple grooves articulate the body of a standing figure with its head formed by the intersection of two planes. Also indicative of rank is the semicircular nose ring worn by both this male and the female

50 **VENERABLE SEATED MALE FIGURE**
300 BC–AD 500
17.8 x 10.4 cm

38 **FIVE-LEGGED BOWL**
AD 100–300
14.5 x 8.5 x 11.75 cm

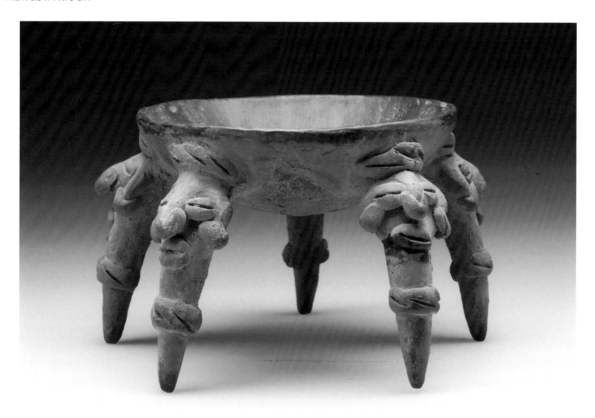

56 STANDING FEMALE FIGURE
300 BC–AD 400
33 x 20 x 6 cm

(cat. 49). These probably are ceramic translations of gold nose rings perforating the wearers' septums. The headdress worn by the Bahía La Plata male (cat. 51) is the outward-flaring bonnet associated with polychrome painted shaman figures holding snakes.[20] It is similar to the fringe that surrounds feline figures with wings in the La Tolita culture, suggesting he is a shaman who has transformed himself into the lord of the animals.

Polypod or multi-legged bowls are diagnostic of the Regional Developmental Period.[21] The Bahía six-legged bowl (cat. 46) has bulbous, hollow legs, each of which is supplied with a firing hole on the outside. They are burnished a dark red, quite different from the buff-colored bowl that they support. More exaggeratedly shaped bulbous supports make a La Tolita white-on-buff tripod bowl one of the most dramatic in the Carroll collection (cat. 91). Inside, down from the rim, it has a fugitive trace of a frieze with scroll designs that resemble the rich cylinder seals of the Jama-Coaque culture (for example, catalogue 79). The Guangala culture of Guayas province produced the handsome five-legged bowl (cat. 38). Its anthropomorphic effigy legs are simplifications of the figurine type (cat. 39) that has very large, closed pellet eyes, flange ears, and a pellet mouth. They are slender and taper to a sharp point, lending the vessel a spidery quality. The bowl supported high in the air by these legs is painted with red chevrons on its buff interior, continuing the painting tradition started in Machalilla.

In the northern part of Manabí and southern Esmeraldas provinces, the Jama-Coaque region, named for two rivers which drain the Pacific watershed, also has a standard mold-made female figurine derived from the Chorrera prototype in the area. The Carroll collection has numerous figures of this type (like catalogue 57 and the head of catalogue 65), but the best of the lot is catalogue 56. Her arms are raised slightly away from her hips and her thumbs are splayed outward. She wears a very thick necklace, probably representing multiple strands of shell beads. Her headdress is bulbous and asymmetrical, with ribbons hanging down freely from either side and joining her shoulders very gracefully. The polychrome post-fired paint on this piece is amazingly well preserved: blue bands mark the bottom of her skirt just inside the hem, her wrists, her necklace, and the front left portion of her head. Her face and clothing are a glowing

49

51

46

91

79

38
39

57

65

56

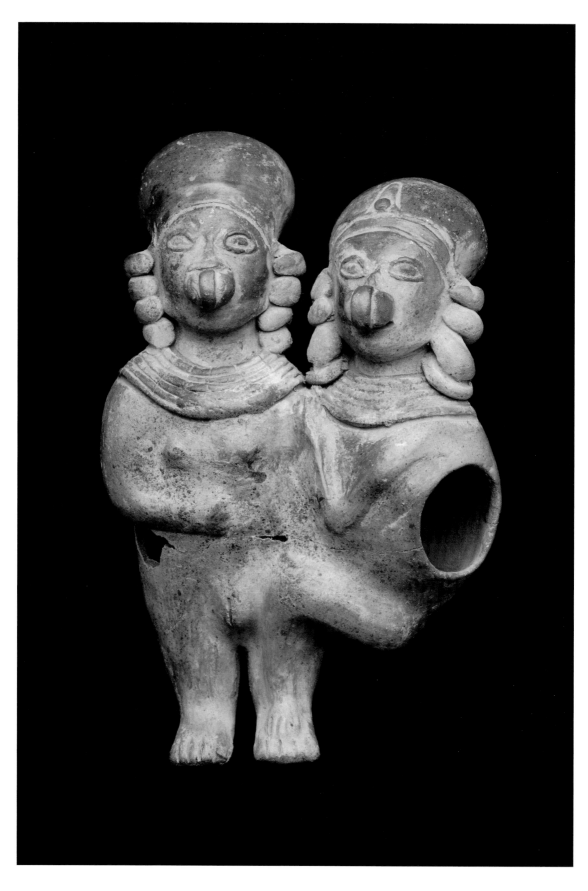

67 **Intertwined Couple**
300 BC–AD 400
24 x 15.5 x 7.5 cm

orange-red. Her eyes have the characteristic rising half-moon shape characteristic of Jama-Coaque.

Jama-Coaque and La Tolita rival each other in inventiveness of posture, including asymmetry, naturalism even when rendering fantastic creatures, richness of ornament and costume and clarity in portraying details. The twisting standing man (cat. 54) is a fine example in the Carroll collection of a richly attired man gesturing with an upraised arm.

An exceptional double effigy bottle (cat. 67) represents a conjoined pair of women with turban headdresses, large nose rings, four cascading earrings on each ear, and thick bead necklaces. At first glance they seem to be an erotic couple because one snuggles against the other, with her right leg overlapping the other's left leg. Conceptually the object is similar to La Tolita plaques showing family figures lying on beds.

Shamans in their distinctive dress form a large corpus of Jama-Coaque figures. One seated male (cat. 60) wears a hat and cape covered with feathers like catalogue 53, the distinctive costume of my third type

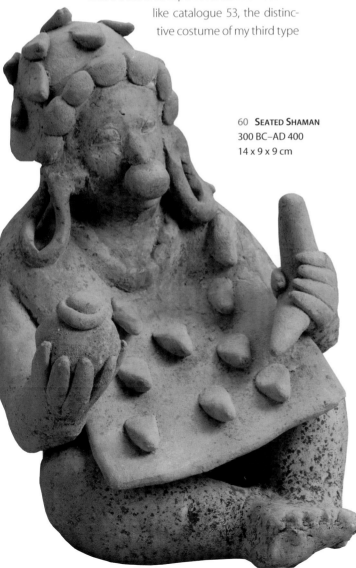

60 **Seated Shaman**
300 BC–AD 400
14 x 9 x 9 cm

of bird-man.[22] He carries a spherical bowl in his right hand and a thin boomerang-shaped object in his left, suggestive of a powdered lime container and dipper used by Colombian Indian shamans to enhance the narcotic effect of coca leaves.[23] The figure tilts forward, seemingly expressing his altered state. Throughout the Americas, shamans communicate with the spirit world by going into trances, often through means of rhythmic music and drumming, sleep deprivation, and hallucinogenic substances. My fourth type of bird-man is closely connected with shamanism from Colombia to Peru.[24] A seated shaman of this type (cat. 62) has birds facing front on a band surrounding his forehead. He holds a shallow cup that merges with his right hand, perhaps for ingesting a hallucinogenic substance needed to induce shamanic flight; his left hand merges with the boomerang shape seen more clearly on catalogue 60. Two birds perch on a circular effigy well in catalogue 69, perhaps protecting the two figures facing out. Stamped on each corner of its complex relief base plaque are monster profiles.

Ceramic roller stamps from Jama-Coaque and La Tolita are numerous in the Carroll collection. They are believed to be used to apply painted designs on textiles, on human body parts, or on wood.[25] The body designs are visible on several of the figures already discussed. Many are geometric, but the most dramatic are asymmetrical, swirling designs, as visible on catalogue 84. In this way, they resemble the asymmetrical figures. Flat stamp seals are not so numerous in the collection. They have a small handle modeled on their plain back, permitting them to be picked up and pressed on a flat surface. Like the cylinder seals, a few are geometric, but the majority are figurative—some very abstract but others, like catalogue 89, the masterpiece of the collection, represent asymmetrical animals. The profile of this creature provides the silhouetted outline of the stamp. The imagery seems again a human-animal transformation, suggesting shamanic content. Catalogue 88 represents the abstraction of a moon animal within a biomorphic circular frame, based on its similarity to one from La Tolita in the Salomone collection.[26] Variations of the moon animal are found from northwest Argentina to central Panama.

The La Tolita culture, already mentioned as sharing many motifs with Jama-Coaque, is located further north in Esmeraldas province and continues on into the Tumaco coastal region of southwestern Colombia. The type site takes

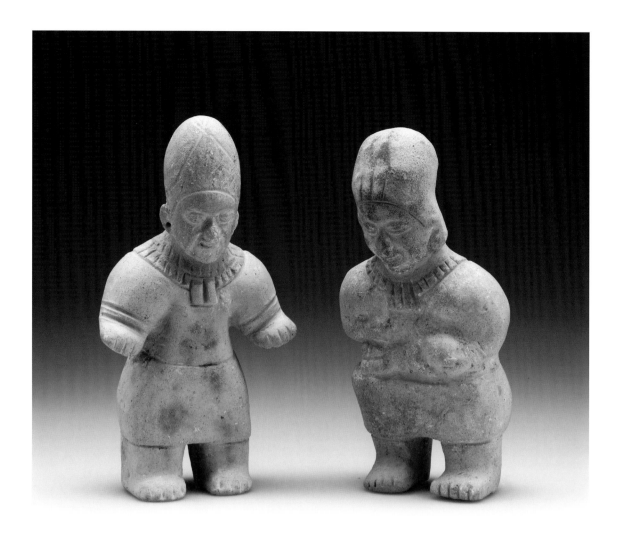

its name from a major ritual center with numerous earthen mounds, called *tolas* in the local Ecuadorian Spanish; the site name hardly deserves the diminutive suffix, since it is the largest site in the culture, built alongside the Santiago River, close to the modern Colombian border. The gray alluvial soil results in the distinctive whitish ceramics of the culture. As elsewhere along the Ecuadorian coast, the style of La Tolita derives from Chorrera.[27] From his excavations at La Tolita, Valdez[28] illustrates typical Chorrera heads with closed eyes swollen in their sockets and large helmeted skulls, which he dates to Early La Tolita (400–200 BC). After that, ceramic molds come into use, both for faces only and for complete figures. A set of mold-made figures represents a family group (cats. 97, 98): a larger woman with a tall miterlike headdress and a mother holding a small child to her breast.[29] Red paint can be applied strikingly to this white paste, as visible on the somewhat fragmentary catalogue 100 that has a headdress band and the long-armed blouse with scoop neck picked out in red. The proportions of

97–8

100

its helmeted head recall the rounded helmet of Chorrera figures, but the facial features are more naturalistic and include nose rings, suggesting that metallurgy was in common use.

Feline images are very common in La Tolita. A ferocious one with a somewhat human face crouches in catalogue 94. A feline head and neck broken from the rim of a vessel shows a deeply wrinkled face with bared fangs (cat. 96); its face is completely mold-made, with a crest suggestive of the Bahía male (cat. 50). Finally, an anthropomorphized feline (cat. 95) raises its arms menacingly. The figure is supported by a thick tail common to the large felines. Its face has the snarling mouth, often identified as a god but also indicative of a shaman in transformation. It is surrounded by a ruff, and its head has two inverted cones flaring upward. A tiny, hollow human head, very delicately and naturalis-

94

96

50

95

97 Standing Human Figure
300 BC–AD 300
18 x 10 x 4.5 cm

98 Figure of Mother Nursing Child
300 BC–AD 500
17.8 x 9 x 4 cm

tically modeled, has two holes in its skull where such cones once were placed (cat. 101).

The site of La Tolita has a large number of gold artworks attributed to it. Metallurgy migrated up the Andean cordillera from central Peru, where it is known as early as 1600 BC. The technique of annealing—hammering over heat to expand the gold nuggets to thin sheets—was prominent in the Chavín culture of Peru, and spread to La Tolita toward the end of that period. The hammering was done from the back, called repoussé, avoiding obvious hammer marks on the front. Four annealed repoussé gold plaques in the Carroll collection all have frontal faces; two are human (cats. 102 and 104), while the other two are feline, or at least display snarling, fanged mouths (cats. 103 and 105). Three are circular, one surrounded with hammered circles, one by a radiance apparently suggesting solar rays, and the last with a ring of frontal human faces obviously subservient to the main face. In Peru, the frontal circular face is associated with the sun god, an iconographic tradition which most likely spread along with metallurgy.

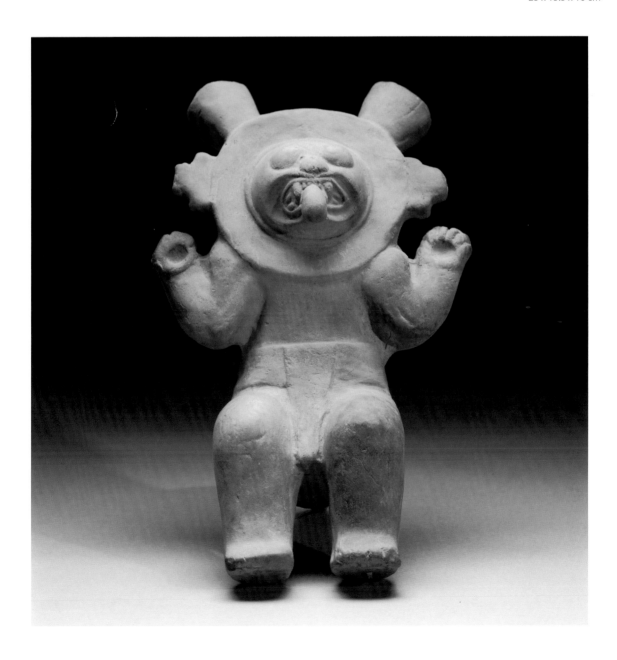

East of the La Tolita-Tumaco coast, in the Andean high plateau, a culture called Capulí prepared deep

101

102–5

103 SNARLING FELINE *TUMBAGA* BREAST PLATE
300 BC–AD 500
15.5 cm

95 RECLINING FIGURE WITH FELINE MASK
300 BC–AD 300
25 x 15.5 x 16 cm

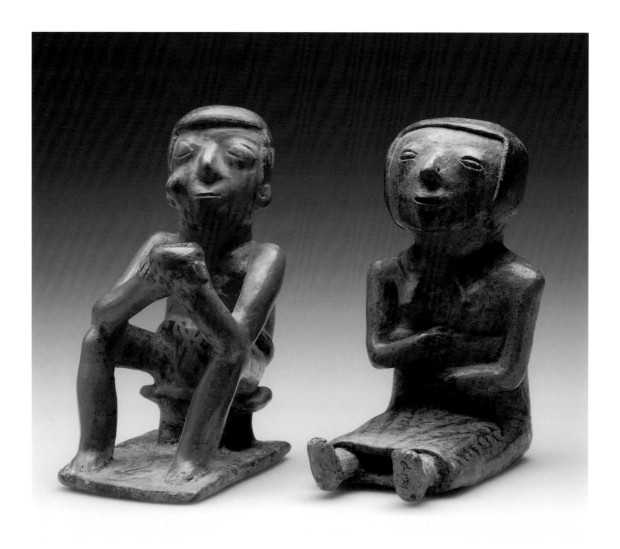

114 SEATED MALE *COQUERO*
300 BC–AD 500
17.3 x 7.5 x 9 cm

115 SEATED FEMALE FIGURE
300 BC–AD 500
15.5 x 8.2 x 1.5 cm

shaft-and-chamber tombs containing repoussé goldwork in the La Tolita style along with abstractly silhouetted cast goldwork in the local style.[30] Like La Tolita-Tumaco, the Capulí culture is similarly divided by the modern national boundary between Colombia and Ecuador: The area south is known in Ecuador by the provincial name Carchi and north in Colombia by the departmental name Nariño.[31] Capulí pottery is painted negative black over a red slip (cats. 106, 107). The resist painting is almost all geometric designs of closely spaced parallel lines forming triangles. Effigy vessels are similarly geometric in form, both in their painted designs and in the modeling of their heads and limbs. A very characteristic form is the *gritona,* literally a "shouting woman," who turns her face up to open her mouth wide to the sky (cat. 112). A pair of *coqueros* (literally coca-chewers, although in this case the woman is not chewing coca) both sit, the woman directly on the ground with her legs extended in front of her, covered by her skirt, and the man, seated on a stool indicating rank and holding a small cup (cats. 114, 115). He has a wad protruding from his left cheek that suggests he is chewing coca leaves. The leaves provide a mild narcotic, unless they are enhanced by chewing an alkaline substance such as lime. Small containers such as he holds (like catalogue 111) could contain potent ground substances meant to enhance the ecstatic experience of a spiritual flight to the world of the gods.

106–7

112

114–5

111

West Mexico, 200 BC–AD 300

The figurine tradition of Formative Central Mexico spread west to the modern states of Colima, Jalisco, and Nayarit, where it sparked a vigorous artistic

expression for over a half millennium. Small, solid ceramic male figurines from the state of Colima or southern Jalisco (cat. 248) clearly express the techniques of manufacture: the body made like a gingerbread cookie, then rolls of damp clay modeled on top of the body, punches made for the facial features, then firing in a pit with abundant oxygen much as is still done by Pueblo groups in the American Southwest, and finally red paint added after the ceramic cooled, to represent skin areas. This type is known for its diamond eye. Larger, hollow ceramic figures were placed in deep shaft-and-chamber tombs to accompany elite family groups. Among the earlier styles of the last centuries BC is the elephantine standing woman identified by her pottery type, San Sebastián Red (cat. 249). Additional regional styles of the early centuries AD are given nicknames like "Chinesco" (cat. 251) for the broad, flat Asiatic face of the drummer, probably intended to be playing at the funeral rites, continued for all eternity in the silence of the tomb in southwestern Nayarit; or a "Sheep-faced" woman from the Tala-Tonalá zone of Jalisco seated with her legs to one side (cat. 250).[32]

Classic Maya, AD 250–850

Bypassed by Ecuadorian rafts during the first millennium AD,[33] the Maya civilization of southern Mexico and neighboring upper Central America flowered in large urban centers from the Late Formative until its collapse in the Terminal Classic. Dating from the Early Classic, the finest work from the Maya in the Carroll collection is a basal-flanged bowl decorated with bright polychrome paint inside and out (cat. 243). Unlike the postfired painting on many coeval Ecuadorian ceramics, this paint was applied prior to firing, creating a more intense color after firing. Two undulating serpents with human faces surround the nearly vertical exterior side above the basal flange. The bottom of the bowl, considerably worn from use in spooning out tamales during elite banquets hosted by the aristocracy, depicts an old god in profile with a large backrack. Originally these large bowls were covered with a massive lid topped with a handle in order to keep the tamales hot. More ordinary Late Classic bowls (cats. 245, 246), both from the southeastern Maya fringe in western Honduras,

have geometric decoration, although a ring-base one (cat. 245) has a modeled duck's head on one rim and a pointed tail on the opposite rim. These bowls eventually were buried with their owners as treasured reminders of banquets, when they probably received them from their hosts.

Lower Central America, AD 500–1100

Because the mountainous landmass contracts to a narrow isthmus between the Atlantic and Pacific, Lower Central America has been a crossroads of influences from the high cultures of Mesoamerica to its north and the Andes to its south. In the earlier period, South American influences seem strongest. Made in Costa Rica during the El Bosque phase of Period IV, AD 1–500, the double-nostril sniffer (cat. 237) from the central highlands is very simple burnished redware also known from the northern Colombian lowlands. Like other Chibchan-speakers, extending from lower Central America to the northern Andes, they inhaled a snuff with psychotropic properties that aided them during shamanistic

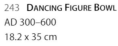

243 Dancing Figure Bowl
AD 300–600
18.2 x 35 cm

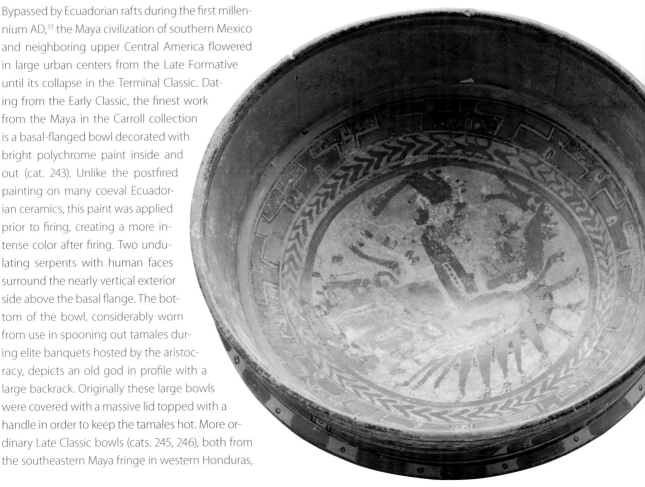

communion with the spirit world. A small tortoise effigy bowl (cat. 238) possibly contained such snuff; because of the value of the contents, the tortoise's owner later drilled a pair of holes surrounding the original opening to permit the container to hang upright from a beam overhead, safeguarding its contents.

238

During Periods V and VI, AD 500–1500, the influences were primarily coming from the Maya and other Mesoamerican people, some of whom actually moved in from the north. The Chorotega people, linguistic cousins of the Mixtec and Zapotec of Oaxaca, settled in the greater Nicoya Peninsula of northwestern Costa Rica and adjoining southwestern Nicaragua. Their dramatic polychrome pottery at first reflects Classic Maya influence, as seen in some Galo Polychrome. The iconography of head commemoration suggests ancestor veneration or trophy head taking. The open eyes of a head effigy bowl (cat. 239) suggest the former, and the elaborate black lines on the skin suggest face painting

238 Miniature Turtle Vessel
AD 300–500
9 x 6.5 x 3.5 cm

239 Face Jar
AD 500–800
11 x 12 x 8.2 cm

239

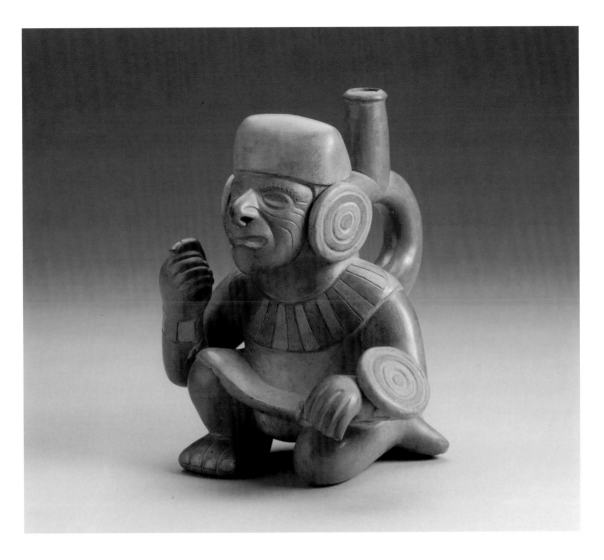

distinctive of each individual. In two seated female figurines with arms akimbo from a later style in the same area (Guabal Polychrome, AD 700–1100), the body painting suggests woven matting, with which houses were divided and floors defined (cat. 240). The brightness of the paint makes them seem new; it is a testament to the dryness of the Nicoya Peninsula where offerings were buried in circular tombs.

240

Early Intermediate Period, Peru
200 BC–AD 600

A more limited bichrome palette is typical of the colors on ceramic objects from the Moche culture of north coastal Peru during the period following the Formative. Post-fired color had been applied to Paracas pottery, the south coastal culture of the latter Formative in Peru (cat. 186), and to the Chorrera culture of central coastal Ecuador at that time. There was a linguistic connection to Chorrera also. Successors in the central coast of Ecuador spoke languages of the Puruhá-Mochica language family that extended from northern Peru to central Manabí on the coast to Cotopaxi province in the

186

central highlands of Ecuador.[34] The Mochica (Muchik or Yunga) language of the Moche culture belonged to its southern extension.

In most Moche examples from the Carroll collection, the shape of the ritual stirrup spouts suggests an early Moche date. Characteristic is a beveled rim around the spout extension, identified in Larco Hoyle's classification as Moche I, and derived from the earlier Chavinoid spouts (cat. 185), but the spout itself is thinner. While some are monochrome (cat. 189), more typically they are red on white. The kneeling warrior has another early trait: the use of incision to demark color zones (cat. 190). The early style of stirrup spout is also found in the Vicús culture of far northern Peru, near the border with Ecuador, where it may have survived longer than in the Moche heartland of the Moche-Chicama river valleys.[35] In this more southerly realm, a spout evolved in Moche IV to a top continuous with the rounded "stirrup" portion and extended up further in an elegant slight taper. In the Carroll collection it is

185

189

190

190 KNEELING WARRIOR EFFIGY VESSEL
400 BC–AD 100
17.5 x 14 x 14.5 cm

applied to an effigy bottle of a seated bird-faced man dressed in the white clothing of a priest (cat. 195). A late Moche (perhaps V) loop-handled, vertical spouted bottle (cat. 196) is a more idealized version of the unforgettably realistic portrait-head jars commemorating Moche leaders.

195
196

Later pottery in the Vicús area seems far more like contemporary Ecuadorian pottery of the Regional Developmental Period. Both coastal Peru and the Bahía culture of Ecuador share the whistling spout bottle with a figure on the front chamber, which is linked by a bridge and hollow lower tube to the rear chamber (cat. 206). The unnatural anatomy typical of Vicús (cats. 204, 205) and the use of negative black paint on a red slip are also

204–6

very characteristic of highland Ecuadorian pottery (for example, catalogues 112 and 154).

112, 154

The south coast of Peru during the Early Intermediate Period produced the more richly colored polychrome pottery vessels of the Nasca culture. The Carroll collection features two early Nasca representations of what is often called a cat god or demon[36] (cats. 197, 200). This feature continues the Chavín tradition of appendages converting into subsidiary beings. Worn as a diadem on their foreheads is a white diving bird, its face bulging at the bottom, its wings extended to each side, and its tail splayed at the top, rendered similarly to the cat whiskers. Catalogue 200 is painted in bright, flat colors on the body of a bridged double-spout bottle, the most typical type of Nasca art. The cat is often involved

197, 200

206 **Double-Chambered Whistling Bottle**
AD 100–400
18 x 12.5 x 9 cm

in trophy-head taking, as here with his left hand, and with a row of such trophy heads encircling the frieze around the rim of a delicate cup (cat. 201).

Later Nasca art becomes more complicated ("proliferous," in the jargon). A prominent woman with characteristically late, curled hair style framing her face (cat. 203) has two late versions of the cat god wrapped around the back of the vessel body; perhaps it renders a woven cloak she wears. Scenes are rendered in considerable detail (cat. 198), with marine life represented by a fish and spiky seaweed suggested in the background; in contrast, no painted scenes with such environmental details are known in Early Nasca. The flaring bridged double spout of this bottle indicates a very late date, around AD 600, and marks the transition to the Middle Horizon.

Middle Horizon, Peru, AD 600

The approximate date of AD 600 marks the beginning of the Middle Horizon in Central Andean terminology, defined by the expansion of the Wari Empire out of the central Peruvian highlands. A provincial, double-loop handled bottle of that Horizon, from an area in the north-central coast conquered by the Wari Empire, shows a similar scene to the Nasca-Wari painted bottle discussed above but executed in low relief (cat. 209). In it, a fisherman stands upside-down on a crescent-shaped watercraft, perhaps one of the totora-reed boats still made today in Peru and Bolivia. Surrounding

the fisherman are numerous creatures animated with large faces floating in a stipple-painted ground meant to be read as water. A pair of silver earflares (cats. 214, 215), although crumpled, also seem to record a fishing scene, although they are likely of a later era (see Chimú). The most typical form for the Middle Horizon is a straight-sided flaring cup (called *quero* in Peruvian Spanish[37]). The painting on the Carroll example (cat. 208) appears to be provincial in its lack of crisp geometric symmetry, so it perhaps comes from the central coast, in a style associated with the Pachacamac ritual center. It features a nude frontal figure with white ray-like elements protruding up from his head. His splayed legs are unequal in length and do not stand firmly on the base line, as would a figure on an imperial Wari *quero*. He seems to be derived from the Gateway God rendered in relief on the Gate of the Sun in Tiwanaku, Bolivia, a solar deity associated with the mountains. However, he lacks that god's diagnostic staffs held out to each side.

Further up the coast in the Lambayeque Valley of northern Peru, a state called Sicán was established by a legendary king whose dynasty kept the state independent of the Wari Empire. While images of that king and deities associated with him have distinctive comma-shaped eyes, an exceptional vessel

214–5

208

200 **DOUBLE-SPOUTED BOTTLE**
AD 100–500
15 x 12 cm

208 *QUERO* (**CUP**)
AD 600–900
11.5 x 12.3 x 13.2 cm

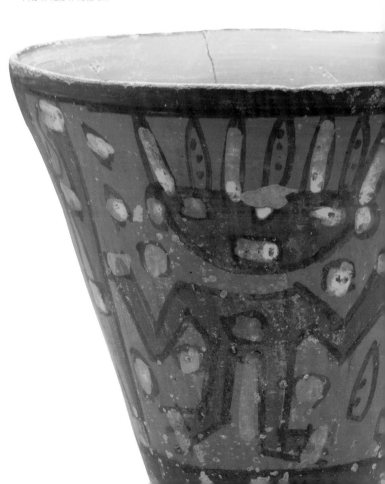

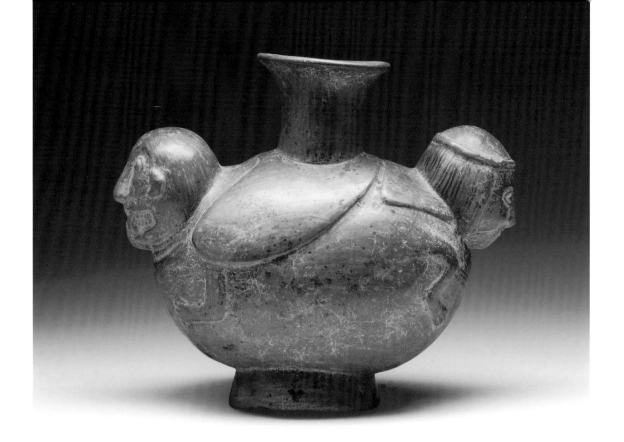

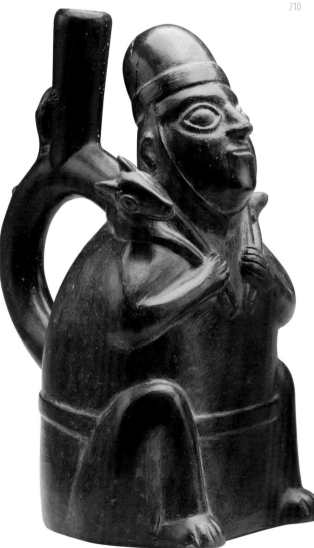

210

in the Carroll collection (cat. 210) can be attributed to Sicán even though the ordinary mortal on one side of the shoulder of the vessel and the snarling feline on the opposite side do not have these eyes. The fine-line black patterns painted after firing on the orange slipped, footed jar are common decorative elements of that style. The sharply defined faces on this jar are incorporated into the more standardized, mold-made forms of the Chimor empire that later conquered the Sicán state.

Late Intermediate Period, Peru, AD 1000–1470

After the collapse of the Wari Empire and before the advent of the Inca Empire, a smaller empire was created by the kingdom of Chimor in the north coast of Peru. Its potters produced numerous mold-made, burnished blackware bottles in an art style called Chimú. Not so warmly naturalistic as the Moche style that preceded Chimú in the same region, it nevertheless revived many Moche motifs rendered in a literal realism. The Carroll collection contains two stirrup-spouted jars with the same motif: a hunter carrying a live baby llama or deer over his shoulders (cats. 211, 212). Another blackware bottle with a jug handle (cat. 213) has four 211–3

panels of long-necked profile seabirds pressed before firing around the shoulder to make a low-relief frieze of birds, much like the stucco reliefs modeled onto architectural walls in the Chimor capital city of Chan Chan.

The central coast flowered during this period as well, with textiles as their highest art. Crudely painted mold-made standing figures made of distinctive white clay accompanied tombs in the Chancay River valley area: a pair of earlier examples, probably made from the same mold, is polychrome painted on their faces in red and wrists and testicles in black 216–7 (cats. 216, 217). They vary only in the difference in the modeling of their headdresses and in their facial painting.

Late Horizon, Peru/Ecuador, AD 1470–1532

The Inca empire extended from southernmost Colombia to central Chile at its maximum extent, and spread its administrative language, Quechua, to many of these areas, supplanting local languages especially in Ecuador. The Carroll collection has four somewhat utilitarian pieces from the Inca: A knife of a shape known as a *tumi* was probably made from a copper-silver alloy, with a llama head decorating 222 the top of its handle (cat. 222). Two stone mace heads in the form of six-pointed stars are both said to come from highland Ecuador, emblematic of its 219–20 conquest by the Inca (cats. 219, 220). An Inca-style 218 pottery quero found in Ecuador (cat. 218) also reminds us of the powerful impact of that Empire, the largest ever achieved in the New World before the European conquest.

Integration Period, Ecuador, AD 800–1500

Two cultures dominate the art of coastal Ecuador after AD 600 and continuing until the Inca conquest around 1500: One, called Milagro, was centered in the Guayas River basin; the other, called Manteño, occupied the coastal areas, from the island of Puná, where a powerful chief ruled, up through Manabí, where the town of Manta, type-site for the culture, impressed the first Spaniards by its size. It was this culture that specialized in the long-distance trade by sailing large balsa rafts with houses built on top of them for the crew. The distinctive pottery associated with the Quevedo variant of Milagro (cat. 119) 119 has low relief fillets modeled and textured on top of a rounded jar.[38] Like Manteño pottery discussed below, the reliefs are divided into squared panels containing spiraling snakes alternating with diagonally placed lizards. This is the first example the Johnson Museum has acquired of this dramatic pottery.

Metalwork from this area is made of copper often mixed with arsenic, creating a variety of bronze. Contemporary cultures in northern Peru had first discovered this bronze alloy and exported it to their Ecuadorian trading partners, along with their taste for blackware pottery. Handsome axeheads with flaring, almost semicircular blades (cat. 120) reflect 120 the popular *tumi* shape (cat. 222). A stone equivalent of that shape (cat. 221) was sym- 221–2 bolic of authority in northern Peru. Their casting technique and formula for arsenical bronze influenced late Western Mexico, and small objects of the axe shape (cat. 121) were used as 121 a kind of money in both areas.[39] The

222 CEREMONIAL "TUMI" KNIFE
AD 1400–1532
11.5 x 11.5 cm

120 SEMILUNAR CUTTING TOOL
AD 800–1500
17.8 x 18.6 x 2.5

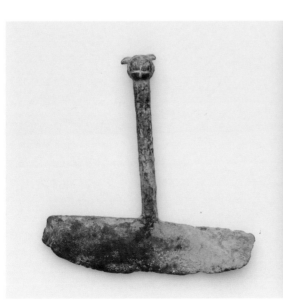

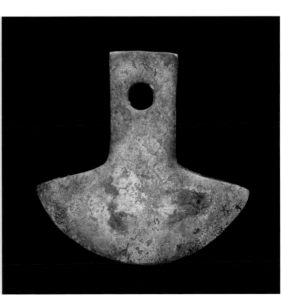

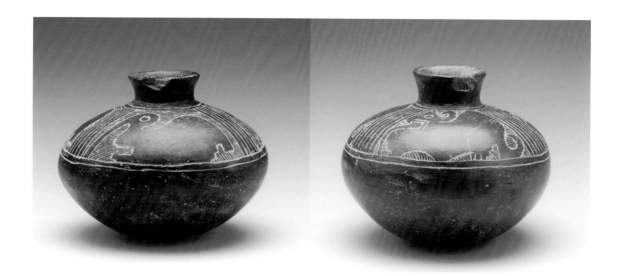

so-called playing cards *(naipes)* of the Sicán kingdom in northern Peru, although different in shape, provided a precedent in bronze of this practice. Ordinary cast copper was used for circular nose ornaments, which could be covered with gold leaf 145 (cat. 145).[40]

Highly burnished blackware pottery of the Chimú culture provided a model for Manteño pottery, although it is less perfectly fired, resulting in a greater 122–3 variation of color. For example, catalogues 122 and 123 seem to be a matched pair, but 122, fired with reduced oxygen, has a lustrous black surface with incised pelicans, while its mate's firing allowed oxygen to enter, resulting in an orange colored surface on which incised long-tongued animals run. Its dense incisions on the shoulder present panels of geometric diamonds alternating with stylized sea 213 birds like catalogue 213, already discussed. Many stamp seals from the Manteño area present images of the same style. The diamond design can be seen 137 in a stamp seal, catalogue 137. Representational subjects are common, too: Birds in square panels confront each other in the large stamp seal's flat sur- 138 face (cat. 138). A lid surviving from a vanished bowl represents an animal chasing its own tail around 140 the handle (cat. 140), while a crab crouches around 139 the handle of catalogue 139. Its irregular outline follows the silhouette of the crab, making its use as a lid problematic. A small blackware bowl still retains powdered white lime residue used to enhance the 126 narcotic effect of coca leaves (cat. 126); the leaves were carried in woven shoulder bags.

The textile industry, another Peruvian introduction, obviously becomes very prominent during Manteño times. It created the need for cotton thread spun with the help of pottery spindle whorls, through the centers of which a wooden spindle was inserted. The centrifugal force created by the circular whorls kept the thread twirling even as the women spinning it went about their daily business. These whorls are so abundant that modern Manabitas collect them and string them like necklaces (cat. 130). Incisions on the whorls rep- 130 licate the kind of designs already seen on the stamp seals. The subjects identified by Wilbert (1974) are mainly related to death and the spirit world, not practical subjects such as the alpacas raised for wool in the Ecuadorian sierra.

In the central highlands of Ecuador, Puruhá-speakers mark the furthest north of the Mochica associated languages, centered in Chimborazo and Tungurahua Provinces. However, their art style is very abstract, not at all naturalistic like the Moche, a feature they share with other highland styles. Their head jars have slightly incurved rims, unlike the Cañari *queros* (cats. 146, 147). The Carroll collection con- 146–7 tains many examples of these head cups (cat. 150). 150 They are distinguished by single curved ear flanges, one of which has multiple perforations in its ears as well as plugs in the lower lip. Others have negative black paint on their basic dark red ground.[41] Full-figure jars (cats. 153, 154) with negative black on 153–4 red certainly recall the Carchi amphoras, but their flanged ears, some with large copper loops inserted, set them apart. The nonfigurative pottery uses the three-color negative palette to make bold triangles down the shoulder (cat. 156), much like the 156 Piartal style to the north. The vessel's sharp defini-

122 **GLOBULAR JAR WITH BIRDS**
AD 600–1500
9.0 x 12.5 x 4.5 cm

123 **GLOBULAR JAR WITH ANIMALS**
AD 600–1500
9.0 x 12.5 x 4.5 cm

tion of angles suggests the clear geometry which these Puruhá Indians obviously enjoyed.

Further north is the Cara territory, centered in eastern Pichincha and Western Napo Provinces around the Quito area; it was called Panzaleo style in an earlier terminology. In that area during the Integration Period, the Cara Indians built large ceremonial centers with high, pyramidal earthen platforms accessed by long ramps all oriented toward the south. They also made painted effigy jars (cats. 160, 161) on which positive red paint on buff defines the style. Both jars represent figures whose heads are formed by incurving neck spouts. They have distinctive hollow-punched eyes on serene faces. An extraordinary piece (cat. 157) originally thought to be a flute has this same type of eyes; in fact, it seems to be an Ecuadorian version of a *paccha,* an Inca funnel to direct libations such as maize beer poured into the top. Only the center figurative bust has an opening, corresponding to an open bottom of the slender hollow cone. The remaining holes were anciently drilled to permit the broken halves to be tied tightly together to insure a good bond. Footed bowls (cat. 159) have white paint applied to their buff surface, setting off figurative *adornos* placed on the shoulders. A recently restored double-chamber bowl with a bridge

160–1

157

159

150 **ANTHROPOMORPHIC FACE JAR**
AD 800–1250
20 x 16.5 x 11 cm

157 **CONICAL FUNNEL WITH THREE FIGURES**
AD 800–1470
40.5 x 11 x 4.3 cm

handle (cat. 158) has swirling white spirals of paint applied to a reddish-buff ground.

The Piartal phase (AD 700–1200), as defined in the Carchi Province on the Ecuadorian frontier (where it is also called Tuncahuán) and north in the Colombian department of Nariño, is probably the earlier expression of the Pasto Indians' culture. They used negative-black second firing on a buff ground with red sparingly used in wide bands. Ring-base bowls (cats. 162, 163, 164, 165) have that color pattern applied to both geometric designs and ones in which animals are fitted inside, just under the inner rim of the bowl (cats. 163, 164). On the former, the animals on pedestals alternate with spectral anthromorphs facing us, their bodies formed by flaring trapezoids. Another footed bowl has long-necked waterbirds placed within a rhomboid frame (cat. 165).

162–5

The Tuza phase (also called Cuasmal) succeeds Piartal directly in the Pasto area. Its potters abandoned the use of negative painting and instead preferred sharp, clear geometric painting in red on a white ground on similarly shaped footed bowls (cats. 174, 175, 176, 177, 178). Many designs are geometric, typically featuring a multiple-line band just below the inner rim, dividing the remaining circular space into quadrants, repeating zigzag motifs within tightly defined frames. Another very distinctive bowl is painted in both red and black, and features deer running across a tightly defined triangular field given texture by stippling, creating a sense of landscape (cat. 175) recalling Late Nasca bottles. Human forms are also occasionally rendered: ceramic human masks (cats. 180, 181) were placed on the deceased in burials. Painted decoration inside the bowl (cat. 174) render a frontal man, whose head and body are both defined by squares, lifting up what looks like a long pole ending in a circular net, possibly a hunting technique for small animals. A warrior is depicted on the inside bottom of one bowl (cat. 176) by a similar technique (surprisingly similar to warriors on each squared side of a

174–8

180–1

174

176

Moche bottle, cat. 193). The geometric style also is applied to catalogue 178, showing twelve men holding hands to make a circle around the inside of the bowl. These bowls' tight geometric painting on pottery is typical of early agricultural cultures the world over. This "Neolithic" style expresses the desire for control of the natural environment by imposing tight borders, much as the society's farmers (maize, beans, and root crops) imposed geometry on their fields, which they not only bordered to protect from grazing domesticated camelids but also divided into parallel rows of mounds to assist in irrigation and enrich the soil. Their villages were not so organized, with clumps of circular houses following the natural rise in the landscape.[42] A scene painted on catalogue 177 renders an idealized version of such a village in which the evenly spaced houses, each containing a man, are neatly separated by fences from each other. The actual houses had rammed earth walls and roofs of thatched grass, shown in the painting in stylized form.

193

178

177

163 **Compotera (footed bowl) with Monkeys**
AD 600–1000
8 x 21 cm

Artificial univalve shells were also formed out of clay, including their interior spiral, were then incised and burnished, painted red and high fired (cats. 168, 169, 170, 171, 172). Their perforations near the base suggest they were worn as amulets, although catalogue 169 is extraordinarily large (6 ¾ inches long) and heavy. Actual univalve shells imported from the coast appear in the shaft and chamber graves, perhaps to sound the voice of the spirits. As small whistles, these ceramic amulets could do the same, and perhaps serve as distinctive calling sounds across the mountainous slopes of the region. Another more musical instrument widely used in the Andes is illustrated in catalogue 168: panpipes played by a musician whose upper torso decorates the top of the shell; the

168–72

177 **Compotera (footed bowl) with Village Scene**
AD 800–1500
8 x 17 cm

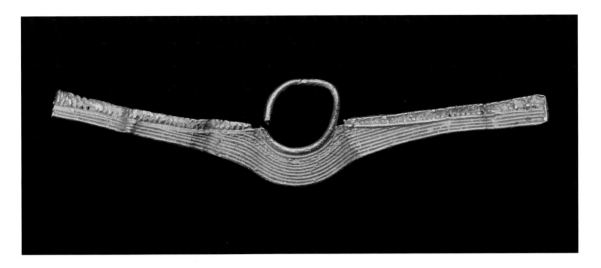

three graduated-length tubes are played by blowing across their tops. Other long ceramic shells with human torsos at their wider ends are decorated by incision, not by painting, and their orange slips burnished. One black shell of this elongated proportion is decorated at its top by just a monkey face defined by three horizontal punches (cat. 171), much like the early Valdivia figurines.

171

Late Period Colombia, AD 1100–1540

The Carroll collection contains several examples of Colombian art, the earlier ones already discussed prior to the Late Quimbaya (cat. 225). Contemporary to that, the Sinú (or Zenú) culture of northwestern Colombia cast numerous small golden decorative pieces for bodily adornment. Shortly before the arrival of the Spaniards around 1500, horizontal ear ornaments were produced in the Hills of San Jacinto,[43] a late refuge area, of a *tumbaga* alloy mainly of copper with a small amount of gold. The earrings are cast in one piece, after thin rolls of wax were braided to create the illusion of filigree (cat. 229).

225

229

Around the snow-capped mountains of the Sierra Nevada de Santa Marta, in northeastern Colombia, lived a group of tribes known archaeologically as the Tairona. Their goldwork—really *tumbaga*—is heavier than the Sinú castings. A smooth solid surface on a lip plug (cat. 233) contrasts effectively with a double braid of wax cast onto its base, creating the illusion of large scale to this tiny object. They did excellent work in polished stone also, as a winged pendant (cat. 234) shows; these forms are thought to represent bats.[44] The culture's polished blackware pottery is extremely well

233–4

229 "Bat Wing" *Tumbaga* Earring or Nose Ring
AD 900–1500
6.7 x 1.4 cm

169 Large *Caracol*
AD 800–1500
20 x 14 x 11 cm

executed as well (cats. 231, 232); notice how the standing animals have a braid around their necks and base of the spout that recalls their metalworking tradition. This high-fired blackware recalls other cultures of the Late or Integration Period, such as the Manteño and the Chimú.

231–2

The world conquered by the Spaniards, beginning with the Taino of the greater Antilles in 1492, had a huge diversity of cultures, from nomadic hunter-gatherers, whose only permanent arts were stone weapons, to the high cultures of Mesoamerica, by then dominated by the Aztecs, and those of the central Andes, then dominated by the Inca Empire. Those empires were true civilizations, formed on the base of preceding civilizations extending over two thousand years in the past. The early and middle civilizations are most richly represented in the Carroll collection. The people of the Intermediate Area, from Ecuador to Costa Rica, were ruled by hereditary chiefs and their noble relatives, in polities much smaller than those of the Inca and Aztec empires bracketing them. They did not produce monumental, permanent architecture, so their material remains can easily be overlooked. Nonetheless, during the Formative period these people provided the early start to the road to settled life throughout Nuclear America, and their pottery and gold during later periods left the fullest expressions of their cultures.

John F. Scott

Professor Emeritus

University of Florida

Endnotes

1. Meggers et al., 1965.

2. One stone figurine in the Carroll collection (cat. 7) echoes the style of these early pottery figurines, and thus must be contemporary with them. While Meggers et al. do not illustrate any stone figurines of this period, they do show later San Pablo stone forms (1965).

3. Zeidler (2003: 494) provides a current summary of contradictory information on Machalilla.

4. A stone owl effigy with a human face at its base (86.026.049) indicates another option, one which looks like a miniature totem pole, with the animal looming over the human. The "Negroid" type in the Johnson Museum's Zorach collection (80.027.023) is a hollow form in larger scale, without the painted surface (Scott 1982:43, #10). Other larger hollow ceramic figures are known from the Norton-Pérez collection (Lathrap 1975: 86).

5. Lathrap 1975: 34. The stirrup-spout bottle makes its earliest appearance in Late Valdivia, according to John Staller's 1994 dissertation (reported by Stothert 2003: 363, n. 10).

6. Zeidler 1988: 262–4.

7. These mortars were for many years attributed to Manteño, as one I published in 1982 (38, #157), with its characteristic tail broken off (74.053.087). Another stone form often attributed to Valdivia or Machalilla, absent in Lathrap (1975) and earlier authors, is a pale colored, flat plaque representing a frontal bird by means of grooves in the stone.

8. Since I am dealing with these cultures on a hemispheric scale, I will occasionally use a pan-American periodization that I developed in my survey book (1999: xx–xxi, 51, 93). While the use of the term "Formative" throughout the Nuclear Area (Mexico-Central America-Colombia-Ecuador-Peru-Bolivia) is quite well accepted, supplanting the earlier term "Preclassic" used in Mesoamerica, it does conflict with the generally used Peruvian sequence devised at Berkeley of alternating Horizons and Intermediate periods. The Early Formative used here corresponds to the Initial Period that saw the first pottery on the Peruvian coast. The Middle Formative here corresponds to the beginnings of the Early Horizon, identified with the spread of Chavín-related elements.

9. Scott 1998.

10. Burger 1995: 147, fig. 138.

11. Lathrap 1975: fig. 31.

12. Burger 1995: 54.

13. Estrada 1957: 47–56.

14. Donnan 1992: 23.

15. Scott 1989: 222–3.

16. Labbé 1998: 153, fig. 15.

17. Ibid., 122; #128, 148.

18. Although unusual, use of molds can occasionally be seen in Late Chorrera (Stothert 2003: U 18–19). The whistle-figurine seems to be an early version of the Jama-Coaque standing asymmetrically coiffed woman (cat. 56, et al.) discussed below. Stothert identifies the extension of her coiffure as an animal pelt.

19. It strongly resembles the piece in the Johnson's Zorach collection from the Jaramijó area (80.029.028) with which I introduced the Early Bahía style (Scott 1982: 44–5), but its colors are better preserved and its size larger, similar to the Chorrera standing figures' sizes.

20. Meggers 1966: fig. 31.

21. Ibid., 68.

22. Scott 2004: 158.

23. In Colombia, spherical gourds are still used by the Kogi Indians to carry powdered lime, into which they insert a wooden pin first wetted in the mouth. When they lick off the lime and chew it with coca leaves, a much stronger effect is obtained from the

cocaine from the leaves. Pre-Columbian examples of these containers *(poporos)* and dipper pins are known from Colombia and the Moche of northern Peru. Manteño miniature bowls were probably used for the same purpose, since one still has a residue of lime left in it (cat. 126).

24 Scott 2004: 159–162.

25 Cummins et al., 1996: 56–63.

26 Scott 1994: 321–2.

27 Scott 1998: 270–1.

28 Valdez 1987: fig. 4a–b.

29 This figure is very similar to one in the Johnson Museum's Zorach collection, 74.053.043, even to its size; however, its nursing baby is not so clearly articulated.

30 Valdez and Veintimilla 1992: 211–2, #155–165.

31 It was generally considered part of the Regional Developmental Period until excavations around the southern Colombian village of Pupiales, Nariño, produced associated radiocarbon dates of AD 1100 and 1460 (Uribe 1977: 167). Upon this basis Uribe hypothesized that Capulí was contemporary with the Integration Period cultures of Piartal and Tuza (discussed later), which she believed were products of the Pasto Indians known from the area at the time of the Conquest. She believed Capulí was the product of another unknown ethnic group, whom others have identified as the Quillacinga, a term she rejects (1995:369). I found unlikely that two coeval people could produce such divergent styles; the history of art shows that even enemies influence each other and produce a common style, albeit with some cultural differences. The more recently discovered site of La Florida south of Carchi Province near Quito had pottery buried in deep shaft tombs that was closely related to Capulí (Ontaneda 1998: 8); La Florida is dated AD 100–500 (Doyon 1995: 70). Further south in northern Peru, the Vicús negative black on red pottery discussed below (cats. 204, 205) has many similarities in style to Capulí.

32 On a third type already in the Johnson Museum collection (2000.058), called Ameca Gray for its pottery type, the copper or arsenical bronze circular earloops evince a trace of connection with Ecuador, recently documented through numerous traits (Anawalt 1998). One of the most specific traits, West Mexico's acquisition of metallurgy, was dated by Dorothy Hosler as first entering Mexico around AD 600 (1994: 89–92). However, the commonly accepted date for the Ameca Gray style is around AD 100–300, thus suggesting an earlier-than-expected arrival of traders coming directly from Ecuador by large seagoing balsa rafts powered by sails.

33 Earlier interaction between the Maya and Ecuador has been hypothesized to explain the sudden appearance of finely made pottery on the Pacific littoral of Guatemala and Chiapas around 1600 BC (Coe 1960).

34 Jijón 1943: III, 427.

35 Moseley 1992: 182.

36 More conservative references to this creature call him the Whiskered or Anthropomorphic Mythical Being (Pang 1992: 213), and see him combining features of a number of creatures: Pampas cat, sea otter, and monkey.

37 Derived from *qero* or kero in Quechua, the Inca language, which is widely spread in different dialects and even separate languages in Bolivia, Peru, and Ecuador, where it is spelled Quichua.

38 Estrada 1957: 48.

39 Hosler et al., 1990.

40 See Holm 1981: 14.

41 Porras 1987: 215.

42 Bray 1978: 59–60, fig. 44.

43 Falchetti 1995: 82, 280,

44 A similar object from the Zorach collection in the Johnson Museum (80.029.037) was catalogued as from Carchi (Scott 1982: 37, #141).

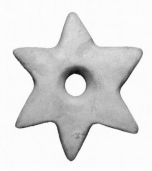

Catalogue of the Exhibition

The works in the exhibition are organized first according to geography, then time period, and finally according to culture, as in the table to the right.

In each catalogue entry, numbers beginning with "2006.070" are Johnson Museum accession numbers. Numbers beginning with "C-" are Thomas Carroll's original catalogue numbers. Items listed only with a "C-" or "TR" number are loans to the exhibition.

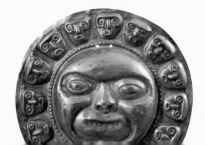

ECUADOR 40

Valdivia	3500–1400 BC	41
Machalilla	1400–1100 BC	46
Chorrera	1200–300 BC	46
Guangala	100 BC–AD 800	55
Bahía	300 BC–AD 600	58
Jama-Coaque	300 BC–AD 600	62
La Tolita/Tumaco	300 BC–AD 500	73
Capulí (Carchi-Nariño)	300 BC–AD 500	80
Milagro	AD 800–1500	85
Manteño	AD 600–1532	86
Cashaloma/Cañari	AD 400–1500	94
Puruhá	AD 800–1250	95
Cara/Panzaleo	AD 800–1470	98
Piartal	AD 600–1200	101
Tuza	AD 1250–1500	104

PERU 110

Chavin/Cupisnique	900–200 BC	111
Chongoyape	600–300 BC	113
Paracas	800–200 BC	114
Moche	400 BC–AD 400	116
Nasca/Nazca	100 BC–AD 650	120
Vicús	AD 100–400	124
Cajamarca	AD 300–1400	125
Wari	AD 600–900	125
Huaylas/Santa	AD 600–1000	126
Sicán/Lambayeque	AD 950–1375	127
Chimú	AD 1200–1470	127
Chancay	AD 1200–1470	129
Inca/Inka and Provincial Inca	AD 1400–1532	130

COLOMBIA 133

Ilama	1000 BC–AD 100	133
Quimbaya	AD 500–1500	134
Sinú	AD 900–1500	136
Tairona	AD 1250–1500	137

PANAMA 139

Coclé	AD 800–1100	139

COSTA RICA 140

El Bosque	AD 0–500	140
Guanacaste-Nicoya	AD 300–1400	140

UPPER CENTRAL AMERICA 144

Maya	AD 250–850	144

MEXICO 146

Tlatilco	1000–500 BC	146
Colima	200 BC–AD 300	146
Jalisco	200 BC–AD 300	147
Nayarit	200 BC–AD 300	148

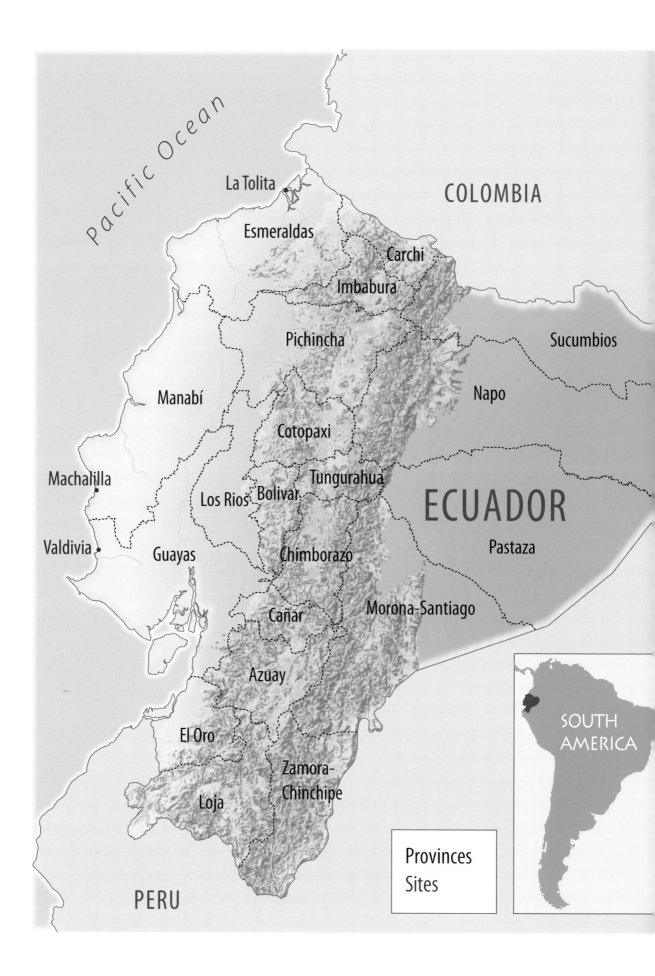

Pacific Ocean

La Tolita

COLOMBIA

Esmeraldas

Carchi

Imbabura

Pichincha

Sucumbios

Manabí

Napo

Cotopaxi

Machalilla

Tungurahua

Los Rios Bolivar

ECUADOR

Pastaza

Valdivia

Guayas

Chimborazo

Morona-Santiago

Cañar

Azuay

El Oro

Zamora-
Chinchipe

Loja

SOUTH
AMERICA

Provinces
Sites

PERU

ECUADOR

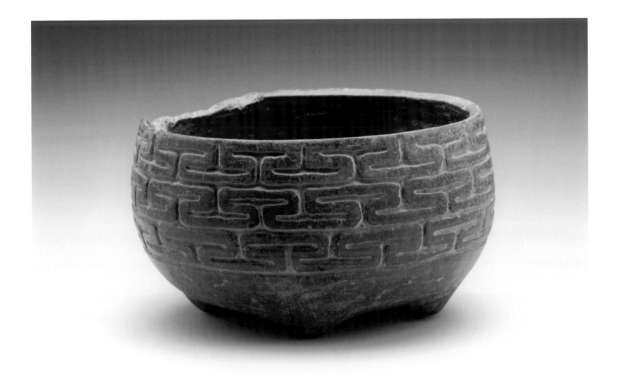

Valdivia

1. TETRAPOD BOWL
Guayas, Valdivia Phase II,
2700–2300 BC
Burnished, incised ceramic
8.5 x 18.5 x 16.5 cm
2006.070.001 (C-001)

This bowl has three rows of deeply incised "Greek key" interlocking fretwork designs on the vessel exterior. The slightly irregular grooves were carved into the surface when the clay was leather-hard prior to firing. The vessel shape is shallow, with gently rounded sides curving inward slightly at the flat rim. The base of the vessel has four low, rounded feet protruding from the surface, with some fireclouding. This bowl is significant because it is from the earliest ceramic culture in Ecuador, which is in turn among the earliest in the Americas.

A very similar tetrapod bowl is pictured in Meggers et al.[1] Meggers and her associates had considered that this style of decoration as well as many others in Valdivia were so similar to decorative techniques found in Japanese pottery during the corresponding period (Jomon) that the entire pottery complex must have been introduced by Japanese fishermen carried away by north Pacific currents. Documented cases of such fishermen landing on the Pacific shores of North America in the eighteenth and nineteenth centuries provide some plausibility to the hypothesis. However, earlier pottery stylistically unrelated to Japan found in Caribbean Colombia makes moot the issue of the introduction of pottery to the Americas, and the lack of correspondence of whole vessel shapes to Jomon vessels indicates that the decorative similarities are more likely coincidental.

[1] Meggers 1965: Pl. 103.

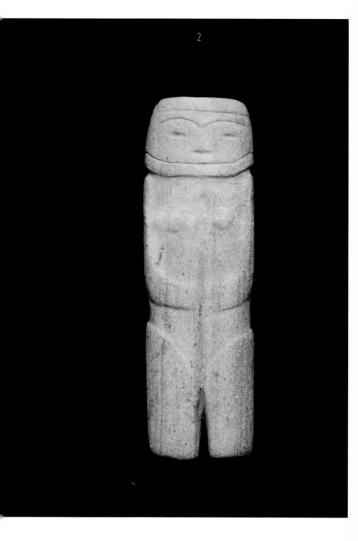

2

venus figurines

Valdivian anthropomorphic figurines were hallmarks of the Valdivia Phase cultures in Ecuador for nearly two millennia, beginning around 3500 BC. These figurines are usually found intentionally broken or mutilated, often decapitated or with damaged faces, and are frequently found discarded in general site refuse with no apparent intent to preserve them for long-term use. Possible functions for these figurines may include a role as aids in shamanic religious or healing practices mediated by hallucinogenic drugs, as found in many contemporary lowland Amazonian cultures. In modern ethnographically known cultures, spirits are called up by a shaman to reside temporarily in anthropomorphic figurines during a variety of rituals, but depart from the figurine at the end of the ritual, leaving the figurine spiritually "vacant," and therefore of no further use.

The earliest figurines were made of stone and have features denoted by simple lines engraved on the surface. Legs are only roughly indicated by string-sawn notches, while gender-specific attributes are usually absent. After 2300 BC, ceramic figurines supplanted the stone figures. This plastic medium allowed Valdivia artists a much broader range of decorative options, and the figurines became much more naturalistic in shape, with modeled hair, legs, and even arms in some cases. Because so many of these figurines are female, many with prominent breasts, some obviously pregnant, it has also been proposed that they may have served as fertility and/or fecundity symbols, charms, or tokens.[2]

2. FEMALE "VENUS" FIGURINE
Valdivia Phase II,
2700–2300 BC
Stone
15.5 x 4.8 x 2 cm
2006.070.363 (C-426)

This is an unusually large and detailed figurine for its type; fifteen centimeters is the maximum size found even among pottery figurines, and stone ones are normally smaller. The torso of this example shows particularly subtle modeling of the legs to indicate where they join the waist.

[2] See Peter W. Stahl, "Hallucinatory imagery and the origin of early South American figurine art" in *World Archaeology* 18 (1): 134–150.

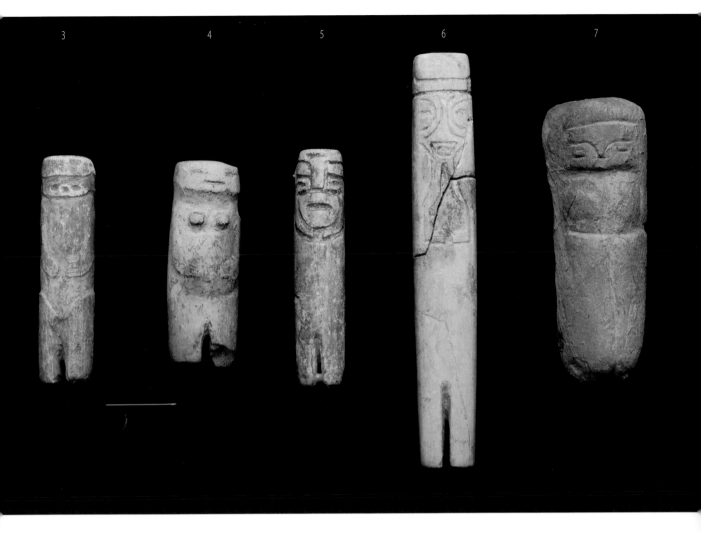

3. "Venus" Figurine
Valdivia Phase II,
2700–2300 BC
Stone
5.3 x 1.3 cm
C-446

**4. Female "Venus"
Figurine**
Valdivia Phase II,
2700–2300 BC
Stone
4.7 x 1.6 cm
C-447

5. Incised Figurine
Valdivia Phase II,
2700-2300 BC
Stone
5.5 x 1 cm
2006.070.352 (C-415)

**6. Anthropomorphic
Figurine**
Valdivia Phase II,
2700-2300 BC
Stone
10 x 1.3 x 1 cm
2006.070.353 (C-416)

**7. Female "Venus"
Figurine**
Valdivia Phase II or III,
2700–2200 BC
Stone
6.5 x 2.5 x 3 cm
2006.070.296 (C-351)

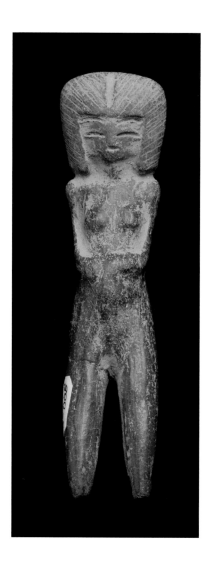

8. PREGNANT FEMALE "VENUS" FIGURINE
Valdivia Phase III,
2300–2000 BC
Slip-painted, burnished,
incised ceramic
9.5 x 2.5 x 1.5 cm
2006.070.005 (C-008)

This figurine stands with its arms folded across its enlarged midsection, displaying the woman's pregnancy. Her head tips slightly forward, as if in awareness of the new life growing in her womb. Her face is completely nonindividualized, with three incised horizontal lines to indicate the minimum facial features. The figurine has the characteristic squared-off hairstyle with central part and shallower grooves indicating the neatly combed, thick hair. Her small modeled breasts are placed anatomically correctly, not high and overly large as in some figurines like cat. 9. This figurine is by far the finest and most complete in the Carroll collection.

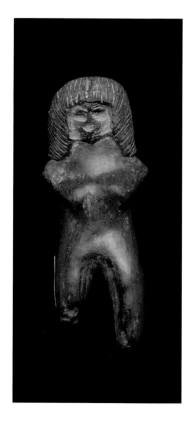

9. FEMALE "VENUS" FIGURINE
Valdivia Phase III,
2300–2000 BC
Slip-painted, burnished,
incised ceramic
7 x 2.7 x 1.3 cm
2006.070.006 (C-009)

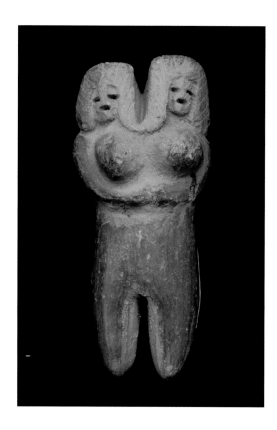

10. TWO-HEADED FEMALE "VENUS" FIGURINE
Valdivia Phase III,
2300–2000 BC
Slip-painted, burnished, incised ceramic
5 x 2.3 x 2.2 cm
2006.070.007 (C-010)

This figurine has two heads separated by a vertical cut in the clay, and is particularly short in stature for its type. The figurine is notable because its two heads spring from a single lower body and torso (with two prominent breasts), rather than two separate torsos joined at the waist, as portrayed in similar two-headed "Venus" figurines. Although this tiny figure may depict conjoined twins, it is more likely that it is a physical symbol representing the concept of duality, one of the primary organizational principles among indigenous Americans. Many social groups in the Andes are divided into moieties or kinship groups called *ayllus*, which determine everything from land ownership to potential marriage partners. The structural opposition of dual characteristics has helped to shape Andean social identity and worldview, and is abundantly reflected in Andean artistic traditions. The importance of duality as an organizational principle is also evident in the frequent use of four-part divisions (duality times two), as was the case for the Inca Empire, whose four provinces stretched from Chile and Argentina in the south, the south coast of Peru to the west, to Ecuador in the north, and to the tropical forest slopes to the east.

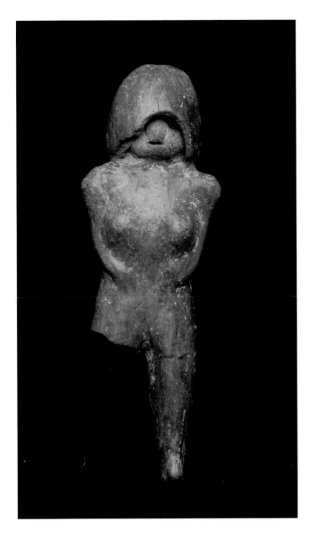

11. FEMALE "VENUS" FIGURINE
Valdivia Phase III,
2300–2000 BC
Slip-painted, burnished,
incised ceramic
11.7 x 4 x 2 cm
2006.070.012 (C-016)

12. FEMALE "VENUS" FIGURINE
Valdivia Phase III,
2300–2000 BC
Slip-painted, burnished,
incised ceramic
8 x 3 x 1.5 cm
2006.070.013 (C-017)

13. FEMALE "VENUS" FIGURINE
Valdivia Phase IV,
2000–1700 BC
Slip-painted, burnished,
incised ceramic
4.5 x 3.7 x 1.8 cm
2006.070.009 (C-012)

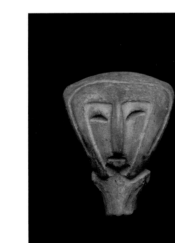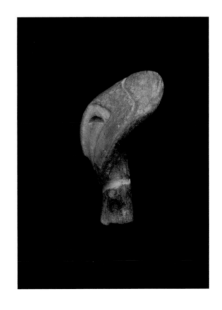

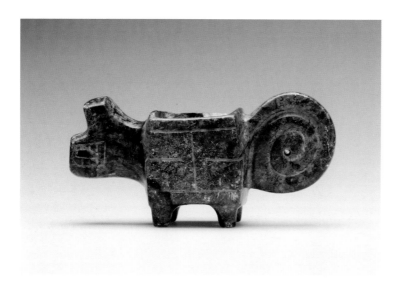

14. FELINE EFFIGY MORTAR
1800–1400 BC
Green stone
6 x 15.3 x 4.5 cm
2006.070.192 (C-235)

This Valdivia or transitional Valdivia-Chorrera mortar may have been used to grind pigments or hallucinogens for ritual use; jaguars in particular are strongly associated with shamans.[3]

Machalilla

15. FEMALE FIGURINE
1400–1100 BC
Burnished ceramic
15 x 6 x 2 cm
C-022

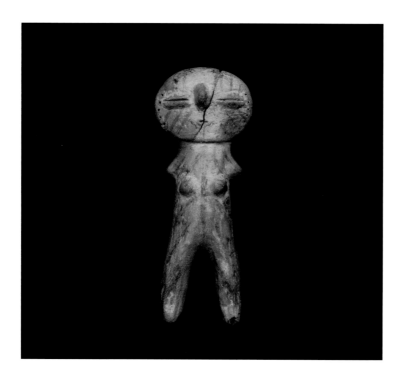
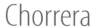

Chorrera

16. ANIMAL EFFIGY
1200–300 BC
Burnished ceramic
10 x 20 cm
C-037

While this animal may be a "Mexican hairless" dog, the only naturalistic example of which has incised spots on its coat,[4] more likely it is a member of the weasel family, such as a coatimundi or kinkajou[5] because these are much more commonly rendered in Chorrera. However, its snout is quite short for those animals, and their prehensile curvilinear tails are not so convincingly rendered here.

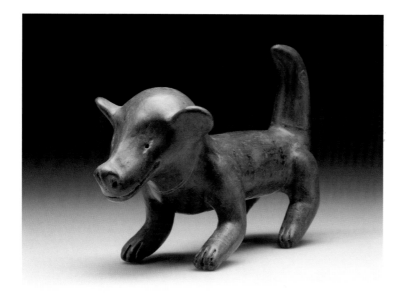

[3] See figures 10 and 12–15 in Valdez and Veintimilla (1992) for comparable items. A very similar feline effigy mortar attributed to the Manteño culture is pictured on page 200 of Crespo and Holm (1977).

[4] Lathrap 1975: 23–5, #349.

[5] Gutiérrez 2002: 76–8, figs. 24–5.

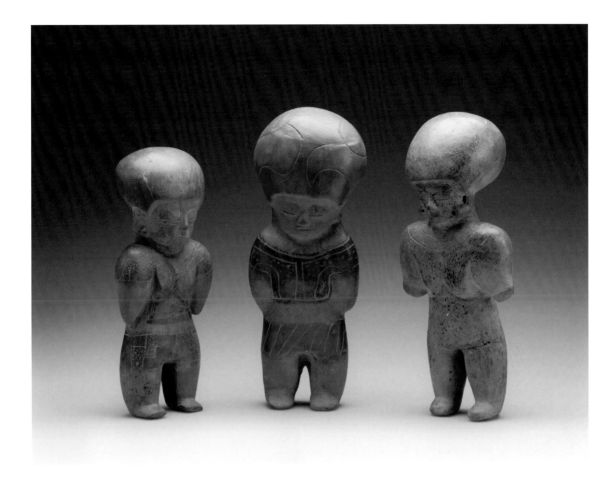

17. Standing Helmeted Figure
1100–300 BC
Ceramic
27 x 12.5 x 4.5 cm
2006.070.019 (C-028)

18. Standing Hermaphrodite Figure
Chacras, Manabí, 1100–300 BC
Slip-painted, burnished,
incised ceramic
24 x 11 x 4 cm
2006.070.020 (C-029)

19. Standing Female Figure
Chacras, Manabí, 1100–300 BC
Slip-painted, burnished,
incised ceramic
28 x 10.5 x 4.7 cm
2006.070.021 (C-030)

All three figures pictured have the typical body proportions of females. Both breasts and apparent male genitalia appear on cat. 18; the small bulge in the pubic area, which normally would read as male genitals, is not so explicit as on the Banco del Pacífico piece (see cat. 20). All three figures have tiny facial features except for their large closed eyes with heavy, defined eyelids. Their headdresses seem to be helmet-like turbans and flare widely out from the face, giving the head a rounded triangular shape. Their shoulders are broader than the males, rather like Polynesian Hawaiian wood figures that suggest their spiritual strength by their muscularity. They all have clearly defined breasts, very unlike the flat chests of the males.[6]

[6] These three figures are similar to a female figure pictured on page 82 of Crespo and Holm (1977).

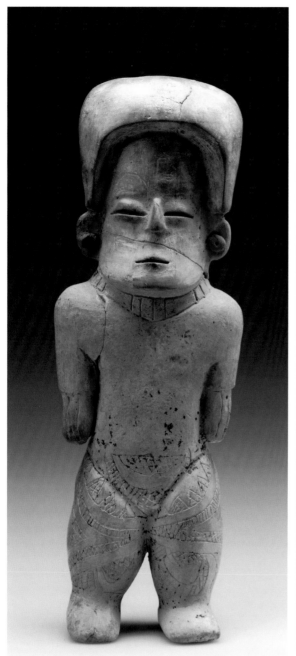
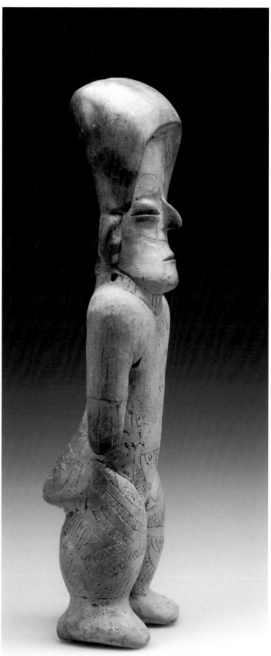

20. STANDING HELMETED FIGURE
1200–300 BC
Painted, burnished, incised ceramic
27.7 x 9.5 x 5 cm
C-031

This standing ceramic Chorrera figure wears a large, unadorned helmet-like head-dress or hairstyle and round ear spools or earrings. Traces of white paint and fire-clouding occur on the face and helmet.[7] Although this figure has no sex specifically indicated, it may be identified as a relatively rare depiction of a male by its similarity to one from Cerro Verde, Manabí, now in the Banco del Pacífico in Guayaquil.[8] That figure has explicitly modeled male genitals, perfectly visible in spite of the apparent pair of pants he wears. Whether these apparent items of clothing in Chorrera figures are actually body paint has long been a problem of interpretation; they may represent elaborate clothing, tattoos, or body-painting. The Carroll figure has no such color indication of clothing, but does have some select burnished areas on the heavily incised area below the waist. His legs and buttocks are decorated with alternating curvilinear and cross-hatched designs. The remainder of the figure is matte except for the burnished face and helmet. The two pieces share body proportions different from the female figures: they are more vertical, less curvaceous, and their heads are rectangular, not triangular. The rarity of male figures may indicate that they are of high status, although the exact function of such figures is unknown.

[7] See Valdez and Veintimilla (1992): 42 for a comparable figure.

[8] Lathrap 1975: 38, fig. 49; 100, #420.

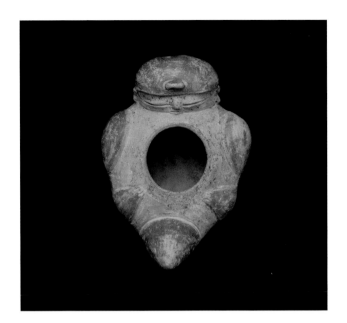

21. ANTHROPOMORPHIC BOWL
1100–400 BC
Slip-painted, burnished ceramic
21.5 x 15.5 x 7 cm
2006.070.023 (C-034)

This vessel shape may be intended
to evoke an overturned turtle with
a human head.

22. NECK REST
1100–400 BC
Burnished, incised ceramic
9 x 25.5 x 16 cm
2006.070.025 (C-036)

This neck rest is in the pointed oval
shape of a boat with a large central
round opening, a spout opening
at one pointed end, and two other
openings at the rear.

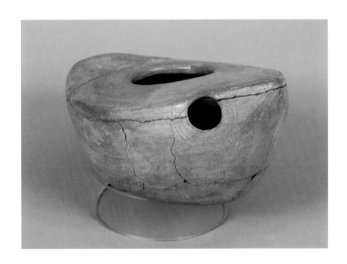

**23. BRIDGE-SPOUTED VESSEL WITH
BIRD WHISTLE**
1100–400 BC
Slip-painted, burnished ceramic
22.5 x 20 cm
2006.070.022 (C-032)

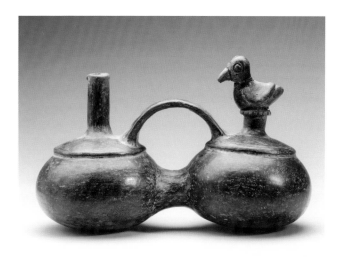

24. Double-chambered Whistling Vessel
Chacras, Manabí, 1100–300 BC
Burnished blackware ceramic
5 x 24 x 11 cm
2006.070.026 (C-038)

Birds were often depicted on the top of the "blind spout" in such whistling vessels, which make sounds when air or liquid moves from one chamber to the other.

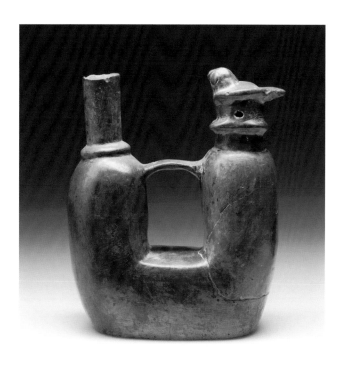

25. Bird-spout Whistling Vessel
1100–400 BC
Slip-painted, burnished ceramic
19 x 16 x 8 cm
2006.070.031 (C-043)

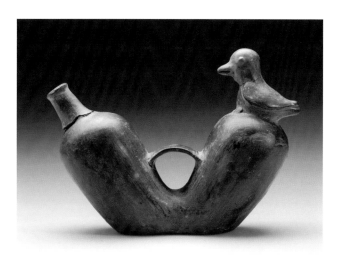

26. Double-chambered Whistling Vessel
Chacras, Manabí, Chorrera, 1100–400 BC
Burnished redware ceramic
14.5 x 20.5 x 6.5 cm
2006.070.040 (C-052)

This whistling vessel features a bird effigy finial atop one of its two chambers whose bulbous shape may indicate fruit or peppers.

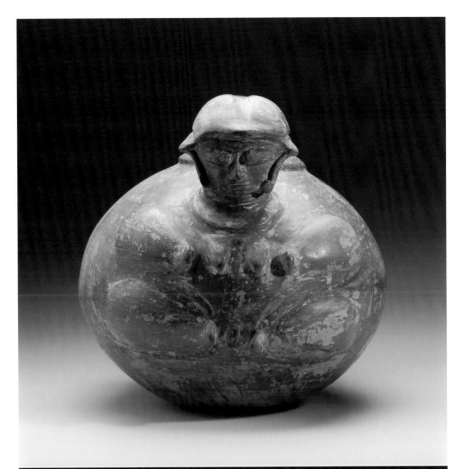

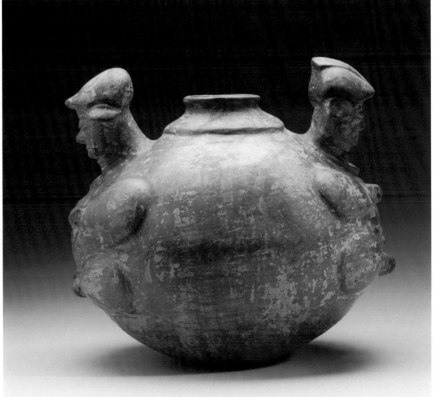

27. Jar with Male and Female Effigy Figures
Chacras, Manabí, 1100–400 BC
Slip-painted ceramic
22 x 25 cm
2006.070.027 (C-039)

This constricted-neck jar has two human effigy figures on its shoulders. The figures wear helmet-like hats and appliqué earrings, have modeled faces and limbs in relief; one is male, the other is female, reflecting the basic dual nature of Andean social organization.

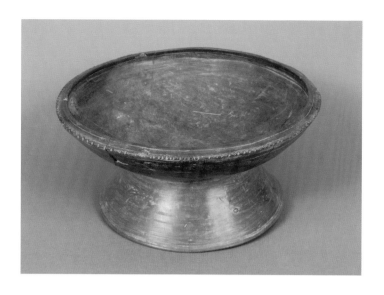

28. FOOTED SHALLOW BOWL
1100–400 BC
Slip-painted, burnished,
incised ceramic
9.8 x 23 cm
2006.070.024 (C-035)

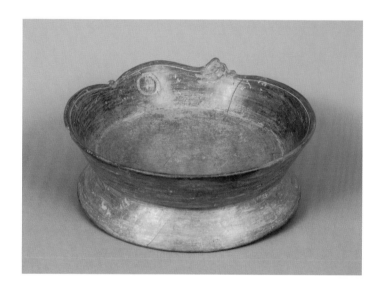

29. FOOTED BAT BOWL
1100–400 BC
Slip-painted, burnished ceramic
9.5 x 25 cm
2006.070.037 (C-049)

The contours of this bowl's rim
indicate the wings of a bat.

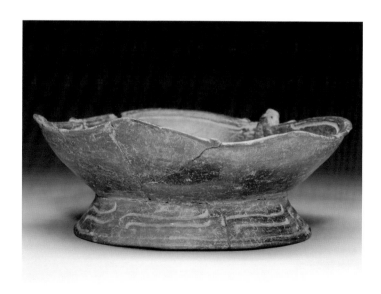

30. FOOTED BAT BOWL
1100–300 BC
Burnished ceramic
8 x 23 cm
2006.070.038 (C-050)

The rim of this bowl features the
wings and head of a bat.[9]

[9] See a comparable bat bowl in
Valdez and Veintimilla (1992): 57.

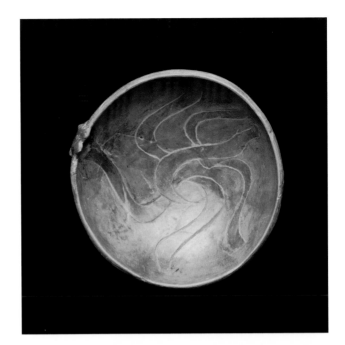

31. Bat-rim Bowl
1100–400 BC
Slip-painted, burnished, incised
ceramic with polychrome decoration
5.5 x 19 cm
2006.070.028 (C-040)

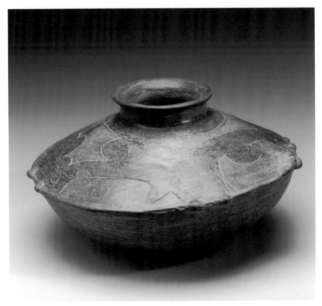

32. Carinated Bat Vessel
1100–400 BC
Slip-painted, burnished, incised
ceramic with polychrome decoration
7.8 x 16 x 6.2 cm
2006.070.029 (C-041)

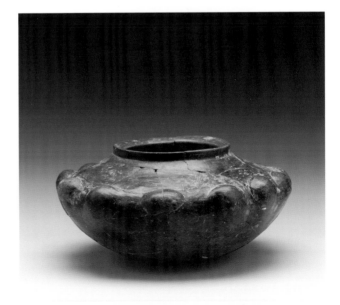

33. Squash Effigy Pot
1100–300 BC
Burnished redware ceramic
6.5 x 14.5 x 7 cm
2006.070.044 (C-057)

This pot takes the form of a patty-pan squash. In some similar vessels,[10] the raised bosses along the shoulders are clearly representations of human faces.

[10] Pictured on page 83 of Crespo and Holm (1977).

34. Bottle with Spout
1100–400 BC
Slip-painted, burnished ceramic
17.5 x 17 cm
2006.070.033 (C-045)

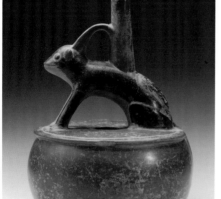

35. Doughnut-shaped Animal Effigy Vessel
Chacras, Manabí, 1100–300 BC
Slip-painted, burnished ceramic
20 x 15 cm
2006.070.034 (C-046)

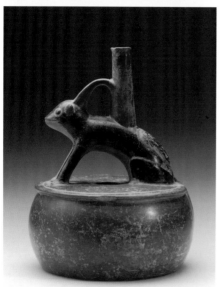

36. Bicolor Monkey Effigy Bottle
Chacras, Manabí, 1100–400 BC
Slip-painted, burnished ceramic
21.5 x 16.5 cm
2006.070.035 (C-047)

The vessel is painted solid red on the spout side and solid buff on the monkey effigy side, a material reflection of dual principles of Andean social organization; the monkey body is red with a buff head.

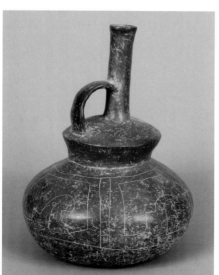

37. Two-tiered Vessel
1100–400 BC
Burnished, incised redware ceramic
17 x 14 x 8.5 cm
2006.070.036 (C-048)

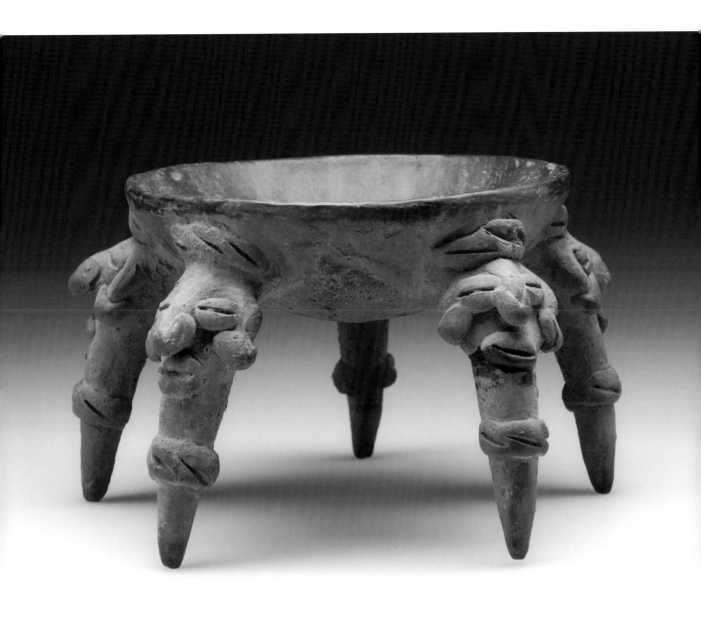

Guangala

38. FIVE-LEGGED BOWL
AD 100–300
Slip-painted, burnished,
incised ceramic
14.5 x 8.5 x 11.75 cm
C-084

This shallow ceramic Guangala bowl is supported by five human-face effigy feet. A very similar single foot broken from its bowl is in the Zorach collection at the Johnson Museum (74.053.016).[11] Each face has "coffee bean" eyes and mouth, earrings, and large nose rings; their expression was identified by Estrada as suffering the "pain of a tooth- or bellyache."[12] The interior of the bowl is burnished and painted in red on tan in a quadripartite repeating design of broad lines starting at the edge and moving toward the center.[13]

Polypod bowls, with five or six legs supporting a shallow bowl high off the ground, are very characteristic of Guangala Red ceramics,[14] although anthropomorphic polypods are known also from Bahía. In Allison Paulsen's sexpartite seriation of Guangala, the early anthropomorphic polypods are characterized by parallel slashes on the appliqué wreaths which surround their skulls and chins,[15] such as the Carroll piece has. We can therefore place it in Guangala 2 or 3, approximately AD 100–300.

[11] Scott 1982: 47, #81.

[12] Estrada 1957: 73.

[13] A nearly identical vessel is pictured on page 115 of Crespo and Holm (1977).

[14] Bushnell 1951: fig. 13.

[15] Paulsen 1970ms: 62.

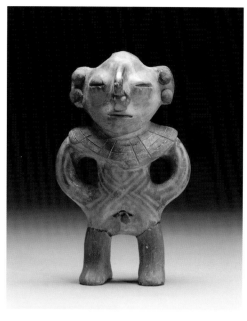

39. Standing Male Effigy Whistle
300 BC–AD 500
Burnished, resist-painted ceramic
13 x 10.5 cm
2006.070.061 (C-078)

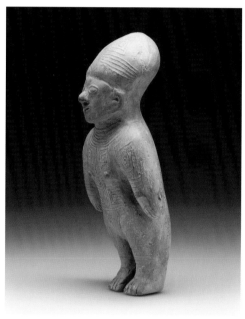

42. Standing Female Figure
El Junco, Manabí, 300 BC–AD 500
Ceramic
25 x 13 x 5.5 cm
2006.070.072 (C-092)

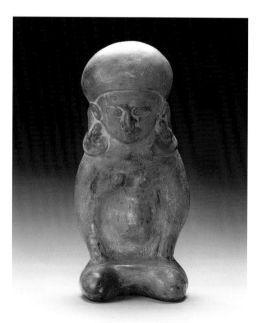

43. Kneeling Female Figure
El Junco, Manabí, 300 BC–AD 500
Burnished redware ceramic
27 x 13 cm
2006.070.067 (C-086)

The figure's kneeling position is characteristic of that assumed while doing household chores such as grinding manioc or maize.[16]

[16] See page 201 in Valdez and Veintimilla (1992) for a comparable figure.

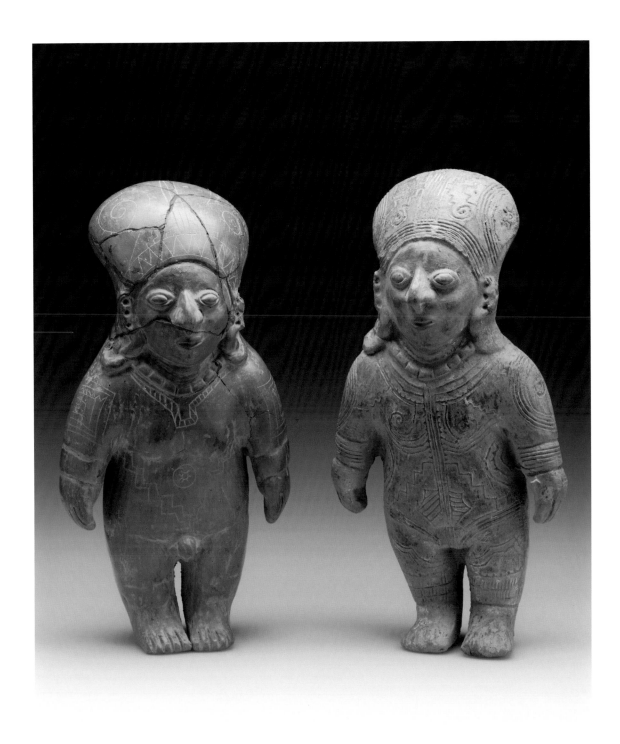

40. Standing Figure
El Junco, Manabí, 300 BC–AD 500
Incised ceramic
26.5 x 13 x 6 cm
2006.070.070 (C-090)

41. Standing Figure
El Junco, Manabí, 300 BC–AD 500
Slip-painted, burnished,
incised ceramic
27.5 x 14 x 5 cm
2006.070.071 (C-091)

These two figures are so similar that they may have been made in the same mold, with the maker using different surface treatments prior to firing. The broad, backswept head shape may indicate possible cranial deformation. The presence of male genitalia and the slight suggestion of breasts may indicate that these figures represent hermaphrodites, as in cat. 18. However, both figures wear the typically male loincloth. Each figure has elaborate geometric body decorations representing fancy clothing, body-painting, or tattoos; on cat. 40 the decoration is incised, while on cat. 41 the decoration is raised. Two options exist for the differing treatment of the torsos: either the original mold would have had the raised relief seen in cat. 41 and it was smoothed out prior to firing, or it was added with a secondary smaller mold. The differing incisions were definitely added after the figures came out of the mold.

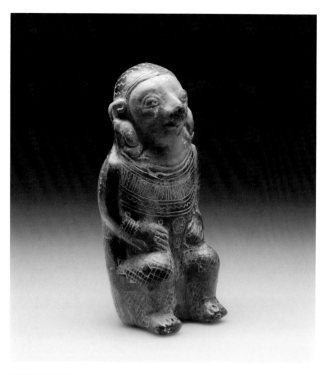

44. SEATED MALE EFFIGY WHISTLE
El Junco, Manabí, 300 BC–AD 500
Burnished ceramic
16 x 8.5 x 5.5 cm
2006.070.277 (C-327)

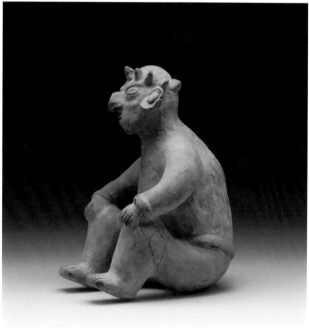

45. SEATED FIGURE
300 BC–AD 500
Ceramic
20.5 x 13.6 cm
C-069

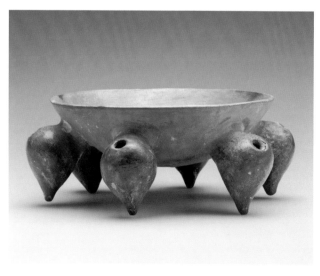

Bahía

46. SIX-FOOTED BOWL
300 BC–AD 500
Slip-painted, burnished ceramic
7 x 16.5 cm
C-061

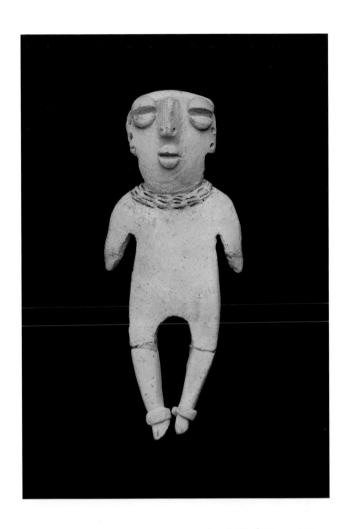

47. Standing Figurine[17]
300 BC–AD 500
Ceramic
9 x 4 x 2 cm
2006.070.219 (C-269)

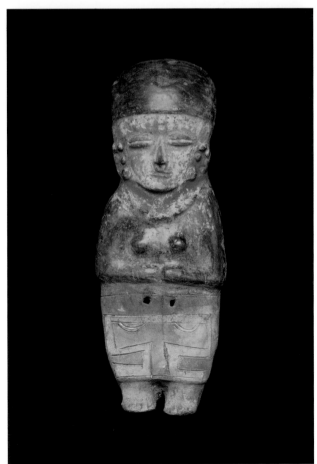

48. Standing Female Effigy Whistle
Los Esteros, Manabí, 300 BC–AD 500
Burnished and ceramic with
polychrome decoration
28.5 x 10.5 cm
2006.070.060 (C-077)

[17] See page 200 in Valdez and Veinti-
milla (1992) for a comparable figure.

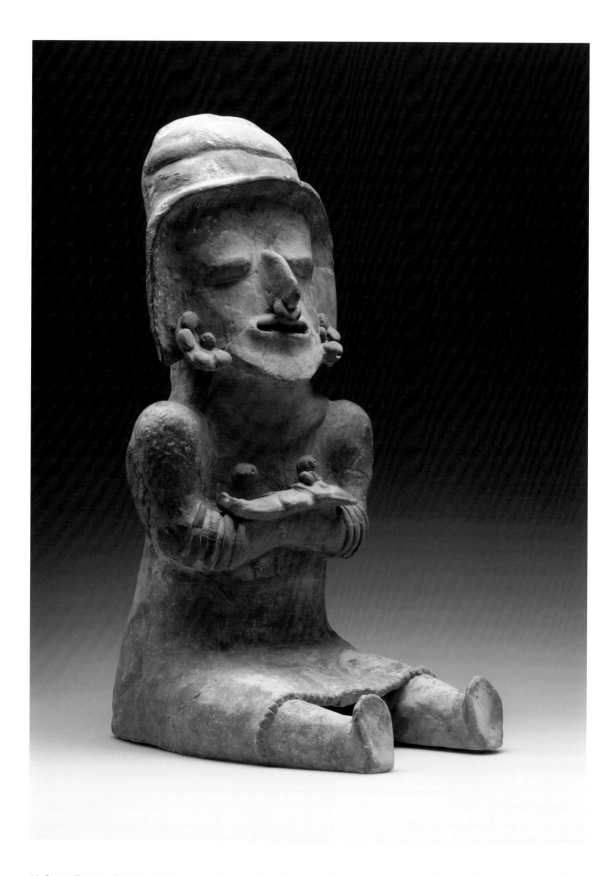

**49. Seated Female *(Gigante)* Figure
with Child**
300 BC–AD 500
Ceramic with polychrome
decoration
47 x 23.5 x 13 cm
2006.070.062 (C-079)

This ceramic Bahía *gigante* female figure cradles an infant in her arms. The main fig-
ure is seated with her legs extended perpendicular to the body, with a skirt stretched
between the knees. She also wears a flanged helmet, nose ring, collar, earrings,
bracelets, and skirt with beaded fringe. The infant, molded separately from the moth-
er, wears a nose ring, helmet, and bracelets. The black paint on the figure's face and
arms may represent body painting or tattoos. Gigante figures are often found in fam-
ily groups, with pairs and couples being common. The Johnson Museum collection
has many other *gigante* figures, including a seated female pair joined at the shoulders
and hips (74.053.054) and another mother-child pair (75.051.013).

50. Venerable Seated Male Figure
Los Esteros, Manabí,
300 BC–AD 500
Ceramic
17.8 x 10.4 cm
2006.070.064 (C-081)

This hollow figure is seated with left
leg crossed over right. The figure
wears an elaborate crested headdress
resembling an Elizabethan attifet,
large round earrings or ear spools, lip
plug or labret, crescent-shaped nose
ring, tusk necklace, bracelets, loin-
cloth, and armbands. The wrinkles
on the figure's face indicate age; the
large size of the ear spools and the
nose ornament, as well as the pres-
ence of a tusk necklace, indicate that
the individual was a person of power
and position within his society. Tusk
effigy pendants, perhaps made in
imitation of sperm whale teeth, ap-
pear to have been indicators of rank
and prestige for the Bahía and for the
neighboring Guangala cultures.

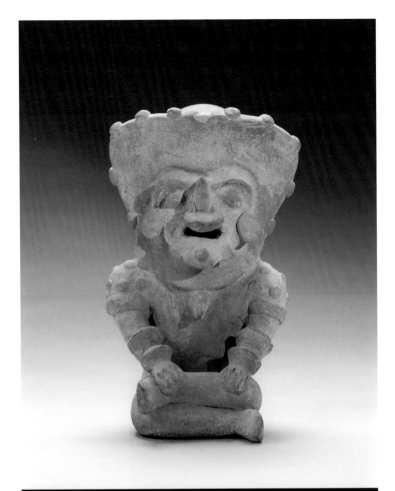

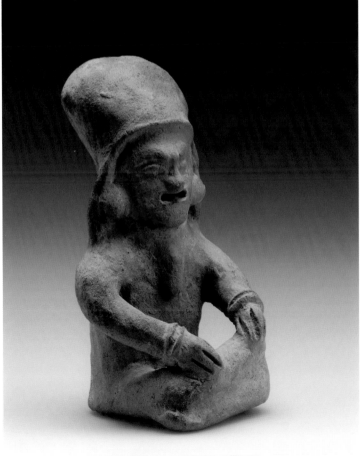

51. Seated Figure
Los Esteros, Manabí,
300 BC–AD 500
Ceramic with traces of
polychrome decoration
13.5 x 7 x 6 cm
2006.070.228 (C-278)

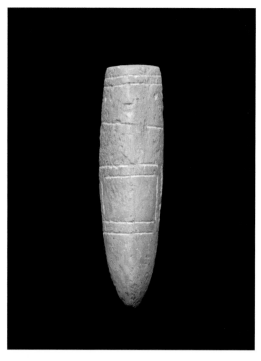

52. Tusk Effigy Pendant
300 BC–AD 500
Volcanic tuff
16 x 4.2 x 5.7 cm
2006.070.329 (C-386)

Tusk effigies were worn as pendants by high-status males, and may have been made to resemble whale teeth.[18] This item is also similar to several tusk effigies in the Johnson Museum collection (74.053.012, 74.053.025, 74.053.037, 75.051.015, and 2006.070.330).

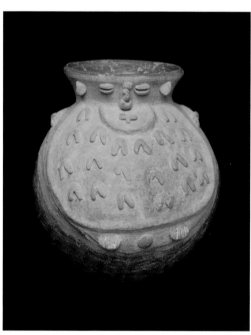

Jama-Coaque

53. Anthropomorphic Round Vessel
300 BC–AD 400
Slip-painted, burnished ceramic
18 x 15 x 10.5 cm
2006.070.075 (C-095)

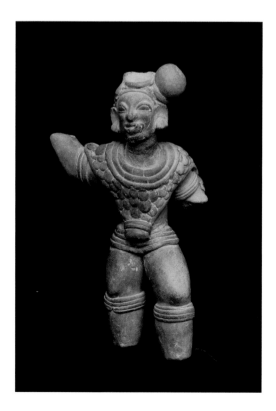

54. Warrior Figurine
300 BC–AD 400
Ceramic with traces of
polychrome decoration
16 x 9 x 6 cm
C-026

[18] See page 200 in Valdez and Veintimilla (1992) for a comparable tusk effigy.

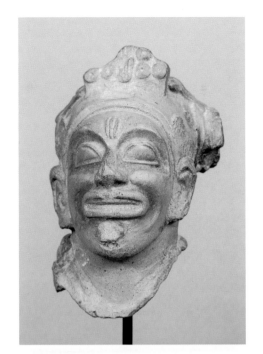

55. HEAD FRAGMENT
300 BC–AD 400
Slip-painted ceramic with traces of
polychrome decoration
9 x 5.5 cm
2006.070.091 (C-111)

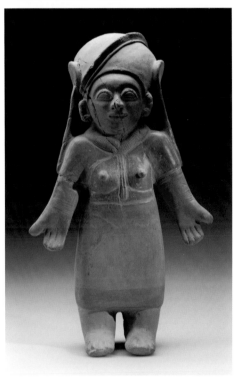

56. STANDING FEMALE FIGURE[19]
El Junco, Manabí, 300 BC–AD 400
Slip-painted, burnished ceramic
with polychrome decoration
33 x 20 x 6 cm
2006.070.080 (C-100)

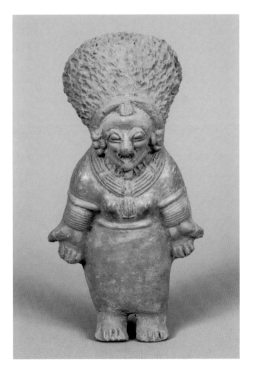

57. STANDING FEMALE FIGURE
El Junco, Manabí, 300 BC–AD 400
Slip-painted, burnished ceramic
20.5 x 11 x 6 cm
2006.070.094 (C-114)

[19] See page 112 in Valdez and Veintimil-
la (1992) for a nearly identical figure.

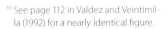

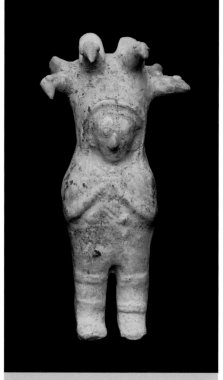

58. STANDING "BIRD-MAN" MUSICIAN
El Junco, Manabí, 300 BC–AD 400
Ceramic
24.5 x 12.3 x 5 cm
2006.070.085 (C-105)

59. FEMALE FIGURE WITH PANPIPES
El Junco, Manabí, 300 BC–AD 400
Ceramic
9 x 12 x 6.5 cm
2006.070.190 (C-232)

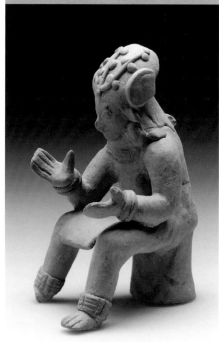

61. GESTURING FIGURE
El Junco, Manabí, 300 BC–AD 400
Slip-painted, burnished ceramic
with polychrome decoration
16 x 9 x 9.5 cm
2006.070.083 (C-103)

60. SEATED SHAMAN

El Junco, Manabí, 300 BC–AD 400
Ceramic
14 x 9 x 9 cm
2006.070.327 (C-384)

This seated shaman wears a large nose plug and loop earrings. He holds a small round pot, possibly a lime pot, in one hand and a tool or weapon in the other, possibly a perishable boomerang-shaped dipper for the pot, although it seems very large to fit. His head tilts to one side and has a serene, sensitively modeled expression, suggesting he has ingested an intoxicating amount of the content of the bowl, probably powdered limestone or crushed, burned shell to accompany chewed coca leaves. His face is very naturalistic in its depiction of bone structure, a characteristic of Jama-Coaque and La Tolita. He has applied stylized feather decorations on his panel tunic and dome-shaped headdress. Like the bird headdress in cat. 62, these bird attributes suggest a shamanic flight out of his body and into the spirit world.

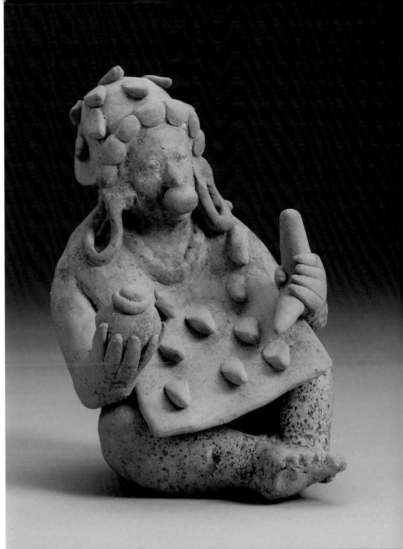

62. SEATED SHAMAN

El Junco, Manabí, 300 BC–AD 400
Ceramic
30.5 x 13 x 14 cm
2006.070.087 (C-107)

This large ceramic Jama-Coaque male figure is seated on a stool with elbows on knees and with hands raised, holding a round plate and a crescent-shaped object, which probably has the same function as the boomerang form held by the cat. 60 figure. This figure wears an elaborate headdress of applied birds, facing forward to form a halo around the face. The long ear ornaments are believed to simulate hammered gold and are similar to designs on cylinder seals.[20] The figure wears a crescent-shaped nose ornament and an extremely large lip plug (labret) that in some comparable pieces is painted blue, suggesting it was of copper,[21] a broad crescent necklace, beaded ankle rings, and a loincloth, which indicates male gender. The drum-shaped stool, not rendered here with much detail, is the mark of a shaman in the tropical forest cultures in historic times. The figure may be ingesting a hallucinogenic substance from the plate using the crescent, with the birds indicating that he will be taking a spiritual flight.

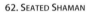

[20] See page 116 in Valdez and Veintimilla (1992) for figures wearing similar earrings and bird headdresses.

[21] Valdez and Veintimilla 1992: 125, #95.

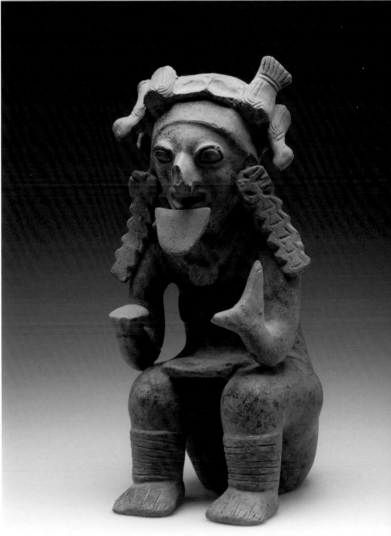

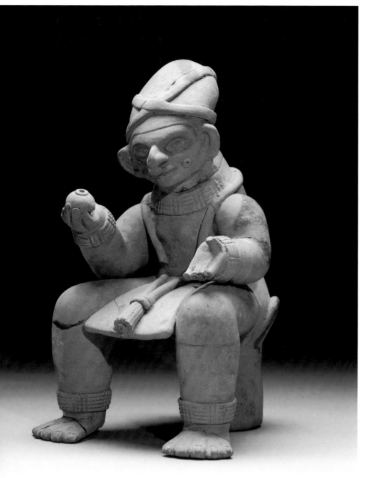

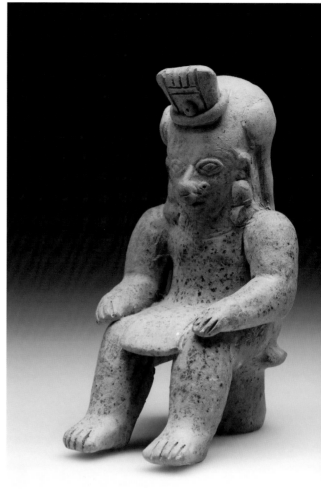

63. Seated Male Figure
El Junco, Manabí, 300 BC–AD 400
Ceramic with polychrome
decoration
22 x 15.5 cm
2006.070.093 (C-113)

64. Seated Figure
El Junco, Manabí, 300 BC–AD 400
Burnished ceramic with
polychrome decoration
13 x 7.2 cm
2006.070.088 (C-108)

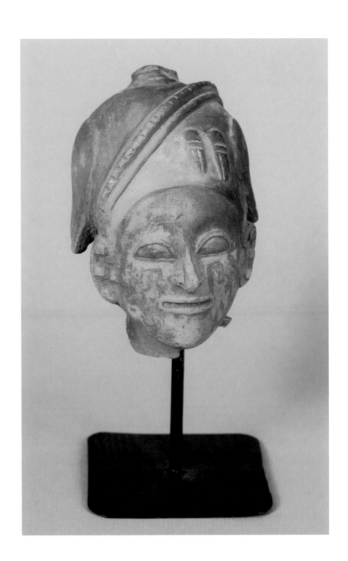

65. HEAD FRAGMENT
300 BC–AD 400
Slip-painted,
burnished ceramic
11.5 x 7.5 cm
2006.070.089 (C-109)

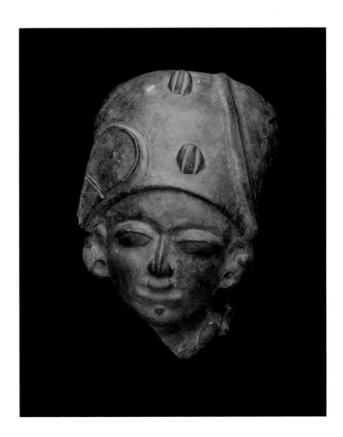

66. HEAD FRAGMENT
300 BC–AD 400
Slip-painted ceramic
12 x 8 x 8 cm
2006.070.090 (C-110)

The hollow interior
of this head bears im-
prints of woven cloth.

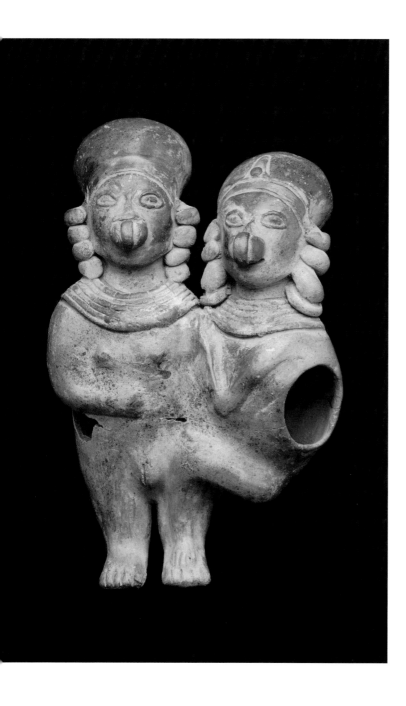

67. INTERTWINED COUPLE
El Junco, Manabí, 300 BC–AD 400
Burnished ceramic
24 x 15.5 x 7.5 cm
2006.070.247 (C-297)

This red-on-buff hollow figure represents an intertwined couple, possibly conjoined twins or an embracing pair similar to La Tolita "bed figures." They both have breasts, making it likely that they are both female. The more vertical figure is lying prone on her back, while the other figure is perched on the first's left side, with one leg visible, bent at the knee, and plastically merging with the other woman's leg. Both figures wear identical large nose rings and quadripartite earrings, similar collar-like necklaces, and similar large, helmet-like headdresses. The backthrust shape of the headdresses may indicate cranial deformation, which was commonly practiced to indicate affiliation with specific social groupings. A large round opening is located on the figure's left side, making it likely that the piece was laid on its back and could only be partially filled.[22]

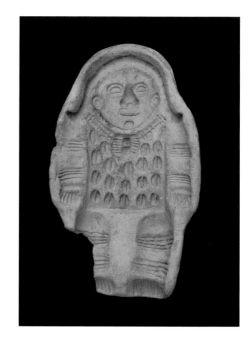

68. FIGURINE MOLD
300 BC–AD 400
Ceramic
14 x 8.5 x 3.5 cm
2006.070.077 (C-097)

[22] An almost identical piece in the Museo del Banco Central del Ecuador in Quito is illustrated in Crespo and Holm (1977: 119).

69. SQUARE PLATFORM WITH WELL
El Junco, Manabí, 300 BC–AD 400
Ceramic with polychrome
decoration
11 x 14 x 10 cm
2006.070.086 (C-106)

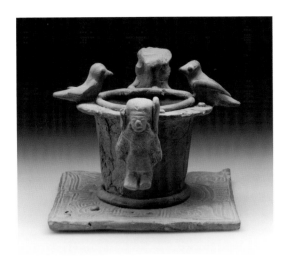

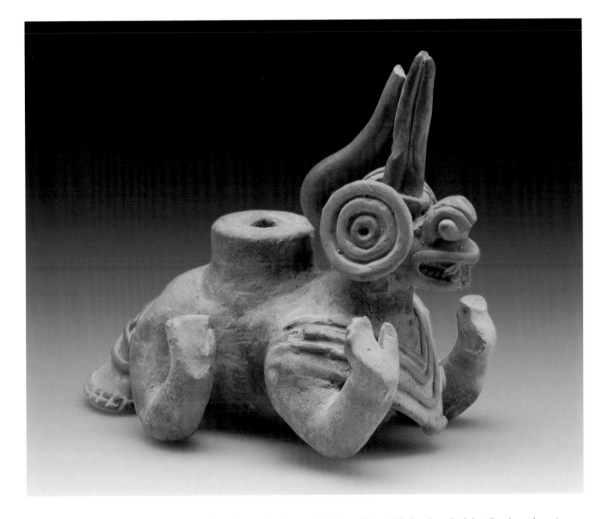

70. FANTASTIC MONSTER VESSEL
El Junco, Manabí,
300 BC–AD 400
Ceramic with
polychrome decoration
13 x 14.5 x 10 cm
2006.070.081 (C-101)

This effigy of a snarling fantastic being with modeled and applied detailing has a low circular spout or neck with a narrow opening rising from its center back. The figure is depicted prone and resting on its elbows and knees with four raised human-like hands. Its other human attributes are expressed in its clothing: large circular earspools painted blue and a V-shaped garment draping from its shoulders to its chest. This figure's posture is matched by a much larger effigy vessel in the Banco Central de Quito that represents a pair of such figures conjoined at their waists and having five-clawed raised paws.[23] This concept is derived from the Fantastic Being of the Ilama phase in Colombia[24] and the Bahía monster such as the Johnson Museum's Chorrera-Bahía Transitional Jar (74.053.131).[25] Nostrils flaring above the snout are diagnostic of this monster; they are made by parallel loops in the Jama-Coaque version. The figure has a pair of attached, red-painted vertical projections back to back, with a curved one coming off its neck and joining the other pair toward their tops. Its back ends with a lobster tail, emphasizing the combination of creatures to express a sense of the powerful and probably malevolent force of nature.

[23] Valdez and Veintimilla 1992:
106, #72.

[24] Labbé 1986: Pl. V.

[25] Scott 1982: 40, 44, #25.

69

cylinder and stamp seals

The Carroll collection contains a large number of cylinder seals (also known as roller stamps) and stamp seals from pre-Columbian Ecuador. Traces of paint may sometimes be found in the crevices of seals, which were likely used to apply paint to many different surfaces, including clothing and even the human body. Stamp seals come in a wide variety of designs and shapes; although flattened on the front surface, they generally have nubs or handles on the back which were used to grip the seal while applying decoration. Cylinder seals, as their name suggests, are round, cylindrical tubes with designs that can only be fully appreciated when rolled out onto a surface. Sometimes cylinder seals have a hollow core so a stick could be inserted to aid in rolling out the seal when applying pigments to a surface; solid cylinder seals were simply rolled by hand over a surface to obtain the desired design. In addition to paint, seals of both types would be dipped in mud, blood, or other media to make their marks.

Jama-Coaque cylinder and stamp seals use the negative space around the design to set it off. For example, the craftsman who made cat. 133 created its animal design by removing clay from the space surrounding the central animal motif before the seal was fired. It is the raised animal motif left intact at the surface of the cylinder that we see when the seal is inked and rolled out.

Images from seals are not found on clay items, so the seals must have been used on perishable items such as skin, leather, cloth, houses, canoes, etc. Much artwork for these pre-Columbian cultures was ephemeral in the same sense as performance art today (songs, dances, etc.), and ephemeral decoration (such as body painting) stems from the same artistic tradition. What we see in clay and stone is largely mortuary art; the art of the seals and stamps permits us a glimpse into the art of the living.[26]

84. CYLINDER SEAL
300 BC–AD 400
Ceramic
7 x 2.5 cm
2006.070.326 (C-383)

[26] See Cummins et al., 1996.

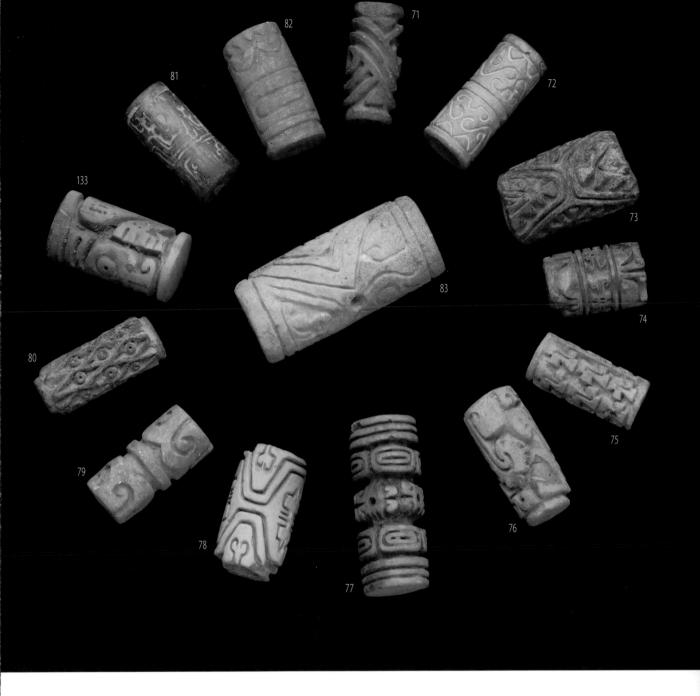

71. CYLINDER SEAL
300 BC–AD 400
Ceramic
6.6 x 2.6 cm
2006.070.100 (C-121)

72. CYLINDER SEAL
300 BC–AD 400
Ceramic
6.5 x 2.5 cm
2006.070.106 (C-127)

73. CYLINDER SEAL
300 BC–AD 400
Ceramic
6.5 x 4 x 1.5 cm
2006.070.111 (C-134)

74. CYLINDER SEAL
300 BC–AD 400
Ceramic
4.6 x 3.2 cm
2006.070.105 (C-126)

75. CYLINDER SEAL
300 BC–AD 400
Ceramic
5.5 x 2.4 cm
2006.070.108 (C-129)

76. CYLINDER SEAL
300 BC–AD 400
Ceramic
6.2 x 2.7 cm
2006.070.103 (C-124)

77. CYLINDER SEAL
300 BC–AD 400
Ceramic
7.9 x 3 cm
2006.070.351 (C-414)

78. CYLINDER SEAL
300 BC–AD 400
Ceramic
6 x 3 cm
2006.070.101 (C-122)

79. CYLINDER SEAL
300 BC–AD 400
Ceramic
5.7 x 3 cm
2006.070.110 (C-132)

80. CYLINDER SEAL
300 BC–AD 400
Ceramic
6.2 x 2.5 cm
2006.070.102 (C-123)

81. CYLINDER SEAL
300 BC–AD 400
Ceramic
5.8 x 2.5 cm
2006.070.286 (C-339)

82. CYLINDER SEAL
300 BC–AD 400
Ceramic
6 x 3 cm
2006.070.109 (C-130)

83. CYLINDER SEAL
300 BC–AD 400
Ceramic
9.5 x 4.3 cm
2006.070.112 (C-137)

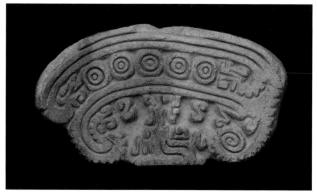

85. Stamp Seal
300 BC–AD 400
11.3 x 6 x 1.5 cm
2006.070.117 (C-146)

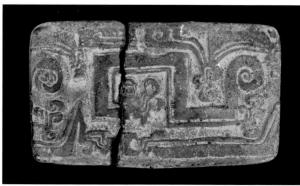

86. Stamp Seal
300 BC–AD 400
Ceramic
11.7 x 6.6 x 2.2 cm
2006.070.119 (C-148)

87. Stamp Seal
300 BC–AD 400
Ceramic
6.3 x 4.4 x 4.6 cm
2006.070.122 (C-151)

88. Stamp Seal
300 BC–AD 400
Ceramic
7.5 x 1.5 x 8 cm
2006.070.125 (C-155)

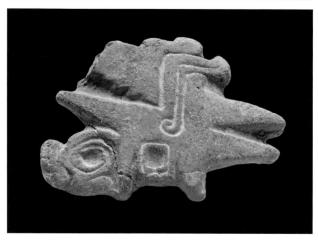

89. Stamp Seal
300 BC–AD 400
Ceramic
11 x 7 cm
C-144

90. Head Rest[27]
300 BC–AD 400
Burnished, incised ceramic
9 x 7.5 x 14 cm
2006.070.337 (C-394)

La Tolita

92. Tetrapod Bowl
300 BC–AD 300
Ceramic
4.3 x 22.5 cm
2006.070.275 (C-325)

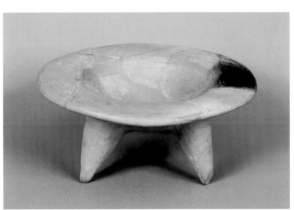

[27] A comparable item is pictured in
Meggers (1966): Pl. 39.

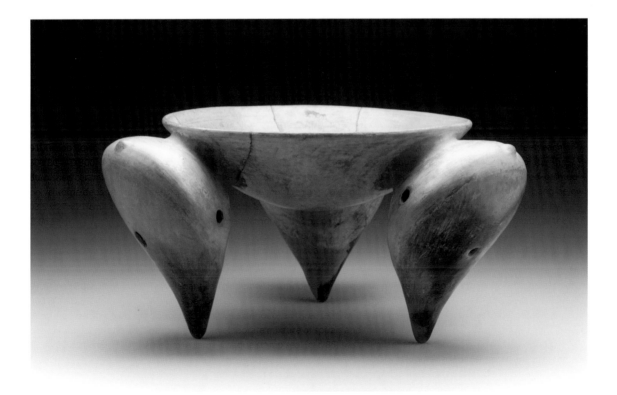

91. Tripod Bowl
300 BC–AD 300
Burnished ceramic with
polychrome decoration
13.5 x 27 x 21 cm
C-062

This elegant La Tolita bowl is supported by three tall, pointed, bulbous "mammiform" feet, each of which is perforated by two holes and has a small applied bump on its upper edge. Decorative fire-clouding colors the exterior of all three feet, while the interior of the bowl has traces of red-painted decoration in an elaborate mixture of spirals and framed row of three dots arranged in a band below the rim. A Jama-Coaque stamp seal (cat. 85) has a similar pattern of concentric circles bound by a pair of parallel lines. Although this piece was originally attributed to Los Esteros, Manabí, of the Bahía culture, another tripod bowl of similar beauty with a frieze of red scroll designs inside the rim, now in the Museo Víctor Emilio Estrada in Guayaquil, is from La Tolita.[28] The beautiful white clay, typical of La Tolita, supports that attribution.

[28] *Diskurs 70* 1969–70: fig. B middle left. Bouchard and Usselmann (2003:64, fig. 11F lower right) illustrate a similar profile from the early phases at Tumaco La Tolita, although not so dramatically flaring as the Carroll piece.

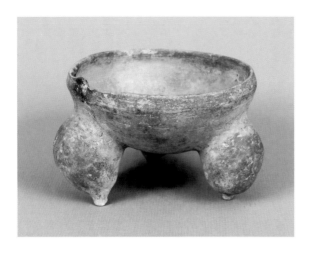

93. Tripod Bowl
300 BC–AD 300
Slip-painted, burnished ceramic
8 x 11.5 cm
2006.070.046 (C-059)

The bulbous feet of this vessel have rattles inside.

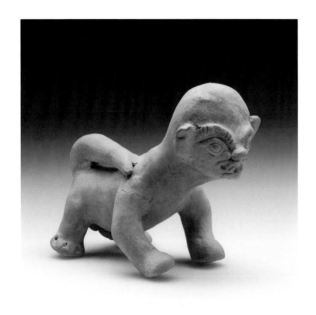

94. Zoomorphic Whistle
300 BC–AD 300
Ceramic with traces of polychrome decoration
9 x 12 x 6.5 cm
C-233

96. "Monster" Head Fragment
300 BC–AD 300
Ceramic
9 x 19 x 4 cm
2006.070.245 (C-295)

This fragment probably served as a decoration on the rim of a large vessel.[30] The fragment is also similar to two works in the Johnson Museum Zorach collection (74.053.080 and .084).

[30] See pages 86–87 of Bouchard and Usselmann (2003) for similar heads pictured on a variety of different vessel types.

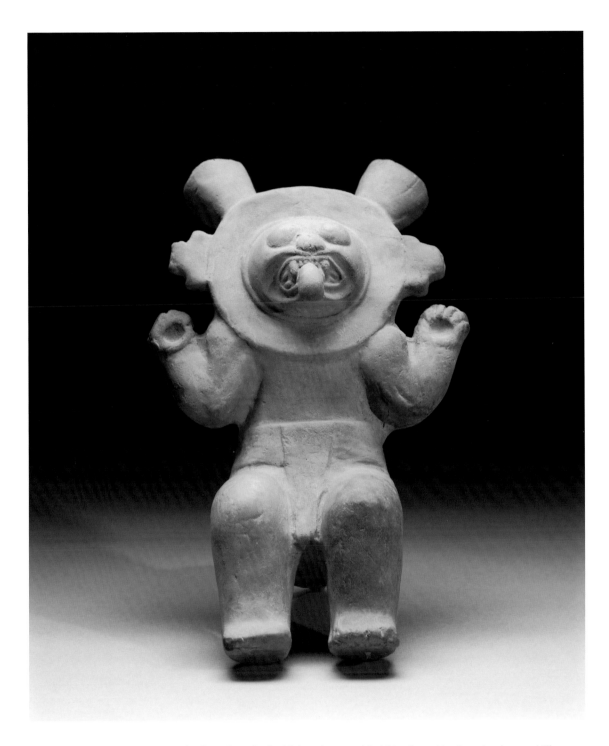

95. Reclining Figure with Feline Mask
300 BC–AD 300
Ceramic with polychrome decoration
25 x 15.5 x 16 cm
2006.070.059 (C-075)

This figure leans back with bent knees on his thick tail, resulting in a tripod support. The figure's arms are upraised, bent at the elbows, and have round depressions in the palms of its paws. The face is surrounded by rounded ruff with flaring conical projections very typical of La Tolita. Its tongue protrudes from the mouth; its fangs are exposed. The eyes are rounded, bulbous, and the figure wears a loincloth, evidence of its male gender. The figure retains traces of post-fired red paint on the pale pottery surface. This appears to be a more symmetrical variation of the twisting, rampant nude feline who represents one of the major deities of La Tolita.[29]

[29] Scott 1999: fig. 3.18.

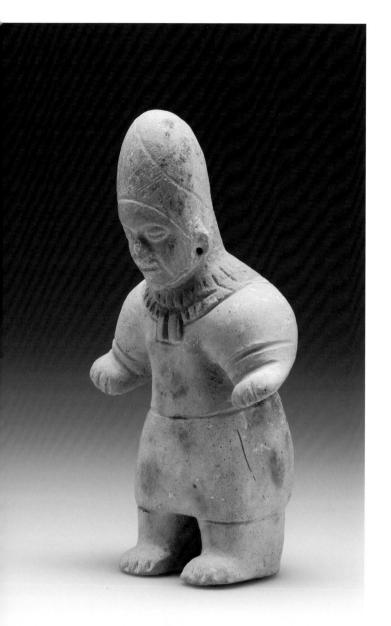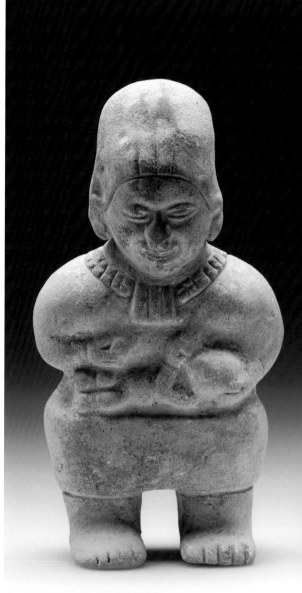

97. Standing Human Figure
300 BC–AD 300
Ceramic
18 x 10 x 4.5 cm
2006.070.057 (C-073)

98. Figure of Mother Nursing Child[31]
300 BC–AD 500
Ceramic
17.8 x 9 x 4 cm
2006.070.058 (C-074)

The similar scale of these two works and their identical white paste lead us to believe they were made to be a genuine pair. Family groups in the form of bed plaques were very common in La Tolita: they show a man, often sexually fondling a woman who nurses a child at the same time. However, both of these mold-made figures from La Tolita culture appear to be female because they each wear a skirt, the hallmark of indigenous women's dress in the Americas.

[31] A figure nearly identical from the neck down is pictured on page 118 of Crespo and Holm (1977).

99. SEATED FIGURINE
300 BC–AD 400
Ceramic
14.5 x 7.5 x 9 cm
2006.070.082 (C-102)

With its prominently rounded
upper back and one shoulder sig-
nificantly higher than the other,
this figure may be a hunchback.
The left hand grasping the stom-
ach may also indicate illness.

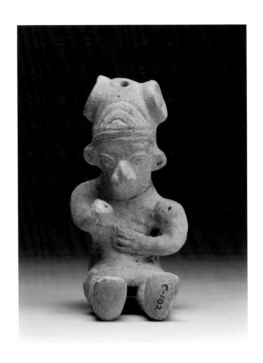

100. PAINTED FEMALE WHISTLE
300 BC–AD 300
Ceramic with polychrome
decoration
10.8 x 8.6 x 3 cm
2006.070.120 (C-149)

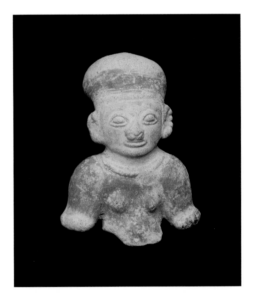

101. HEAD EFFIGY AMULET
300 BC–AD 400
Ceramic
5 x 4.5 x 4 cm
2006.070.266 (C-316)

The two large round openings above each temple of
this head may indicate trepanation, a procedure in
which circular holes are surgically made in the skull.
Trepanation was practiced for a variety of reasons,
including the release of evil spirits, and to cure head-
aches. Well-healed holes in archaeological skulls from
Peru indicate that patients could survive the proce-
dure and that individuals sometimes had the proce-
dure done more than once. An alternate explanation
for these holes is that they once may have had conical
headdress *adornos* similar to those found on cat. 95
inserted there. Because nothing appears to have bro-
ken off this amulet, the *adornos* may have been made
of perishable organic materials such as cloth, feathers,
or wood.

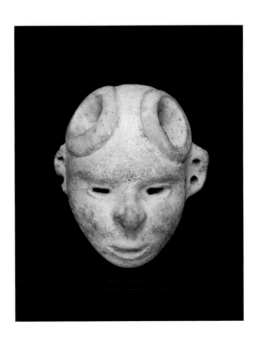

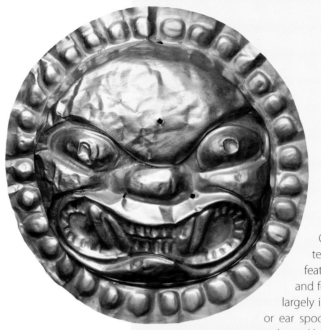

103. SNARLING FELINE
***TUMBAGA* BREAST PLATE**
La Tolita, Esmeraldas,
300 BC–AD 500
Gold-copper alloy
15.5 cm
2006.070.369 (C-432)

The feline character is communicated by its button nose and detailed fangs. The ferocity of this image is achieved by the upturned elliptical eyes with sunken circular pupils, communicating fury and threat. The image of a fanged feline extends back to the Chavín culture of Formative Peru, which also was the first to use gold in repoussé plaques rendering their gods and myths. This feline face is surrounded by a border of rounded disks inside trapezoidal units like feathers radiating out from the center. This radiance suggests the solar disk, an association which the Peruvians made with gold. The yellow-gold color also relates to the dominant felines in the area: the jaguar and the ocelot.[32]

gold

Goldsmithing is generally thought to have arisen in the highlands of Peru, after which it spread northward to what is now Ecuador, Colombia, and into Mesoamerica. Gold objects were used to adorn textiles, to decorate architectural features such as walls and doorways, and for personal adornment as jewelry, largely in the form of nose rings, earrings or ear spools, headdresses, diadems, collars, pectorals, necklaces, and funerary masks. Gold was also crafted into a wide range of zoomorphic and other votive figures as well as religious idols rich in cosmological meaning to their makers. Because gold was scarce and not used for day-to-day utilitarian purposes, objects crafted from this precious metal are associated with the sacred, with power and prestige, and with status and wealth.

Most "gold" objects found in the Andes are actually alloys of various other metals mixed with gold. *Tumbaga* is formed from a mixture of copper and gold, and usually also contains some silver. For pre-Columbian peoples, the union of gold and copper was symbolic of sexual union, and metallurgy had connotations of procreation, fertility, and growth. Silver was rare in Ecuador, and artifacts with the highest concentrations of gold and silver appear to have been high-status items.

Tumbaga's melting point at a temperature of 800˚C is 260˚C below that of pure gold, making it easier to manipulate in a liquid state. The less viscous nature of *tumbaga* when liquid makes it easier to pour into molds. Although more affected by the elements than is pure gold, *tumbaga* is also harder, and hence more apt to retain ornamental details without losing its shape. One other advantage of the *tumbaga* alloy over either of its constituent metals is the ability of the goldsmith to manipulate the color of the finished product by changing the percent of red copper and of yellow gold in its makeup. The golden appearance of *tumbaga* objects was enhanced by a "depletion gilding" process, which involved coating or bathing the object in acid to remove copper and any other impurities or constituents of the *tumbaga* alloy, leaving a thin layer of shiny, chemically inert gold on the surface.

When objects were crafted of gold or *tumbaga* hammered into thin sheets, decorations were generally applied using a repoussé technique, with separate, three-dimensional additions formed by rolling, cutting, and piercing the sheet metal. In Ecuador and Peru, goldsmithing was largely confined to the manipulation of sheet metal, while to the north in Colombia and Central America, lost-wax casting of three-dimensional objects was more common. The lost-wax technique then spread into Mesoamerica in the Postclassic, where it was widely used in the manufacture of gold objects by late Maya, Mixtec, and Aztec.

[32] Similar to medallions on pages 188–189 in Valdez and Veintimilla (1992).

102. *TUMBAGA* BREASTPLATE
OR PENDANT
300 BC–AD 300
Gold-copper alloy
12 cm
2006.070.333 (C-390)

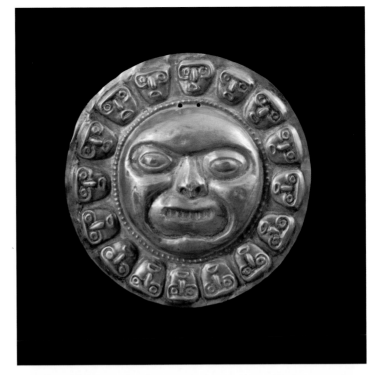

104. *TUMBAGA* MEDALLION[33]
300 BC–AD 500
Gold-copper alloy
10.5 x 1.5 cm
C-476

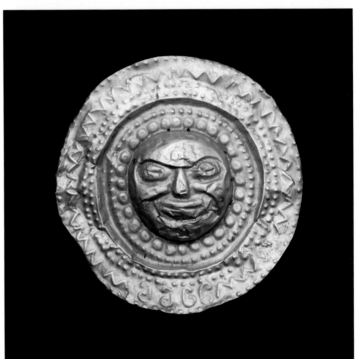

105. *TUMBAGA* MEDALLION
300 BC–AD 500
Gold-copper alloy
15 x 11.3 x 2 cm
2006.070.377 (C-441)

[33] Similar to medallions on
pages 188–189 in Valdez
and Veintimilla (1992).

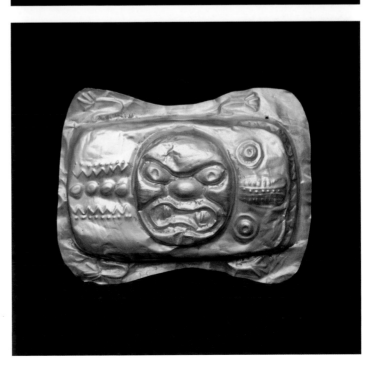

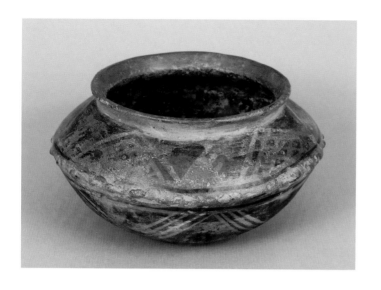

Capulí

106. CARINATED BOWL
Capulí/Tuncahuan, Carchi Province,
300 BC–AD 500
Slip-painted ceramic with
resist decoration
8.5 x 17 x 11.8 cm
2006.070.128 (C-159)

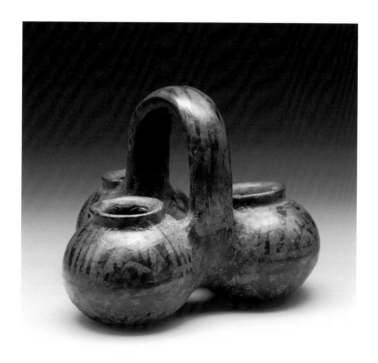

107. THREE-CHAMBERED VESSEL
Capulí/Tuncahuan, Carchi Province,
300 BC–AD 500
Slip-painted ceramic with resist
decoration
12 x 16 x 4.2 cm
2006.070.129 (C-160)

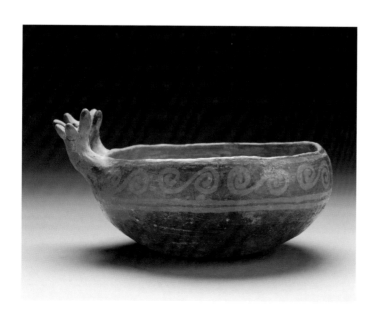

108. BOWL WITH RAISED HANDS
Capulí/Tuncahuan, Carchi Province,
300 BC–AD 500
Redware ceramic with resist
decoration
7 x 18 cm
2006.070.142 (C-177)

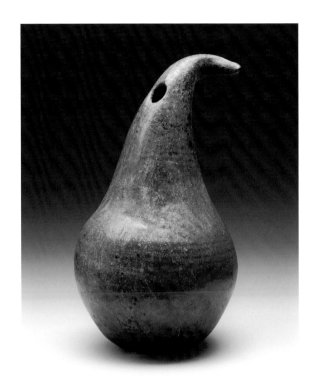

109. Gourd-shaped Vessel[34]
Capulí/Tuncahuan, Carchi Province,
300 BC–AD 500
Slip-painted, burnished ceramic
with resist decoration
22 x 12 cm
2006.070.143 (C-178)

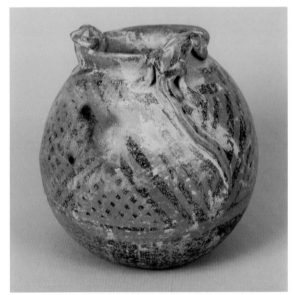

110. Globular Lizard Jar
Capulí/Tuncahuan, Carchi Province,
300 BC–AD 500
Burnished ceramic with
resist decoration
12 x 12.5 x 7 cm
2006.070.370 (C-433)

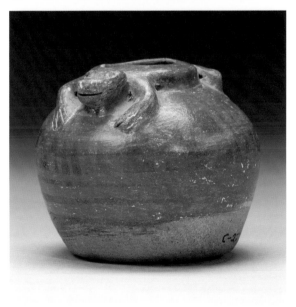

**111. Miniature Vessel
with Frog Effigy**
300 BC–AD 500
Slip-painted, burnished ceramic
with resist decoration
6.2 x 7.5 cm
2006.070.227 (C-277)

[34] See page 2 in Crespo and Holm
(1977) for a very similar Cuasmal
bottle.

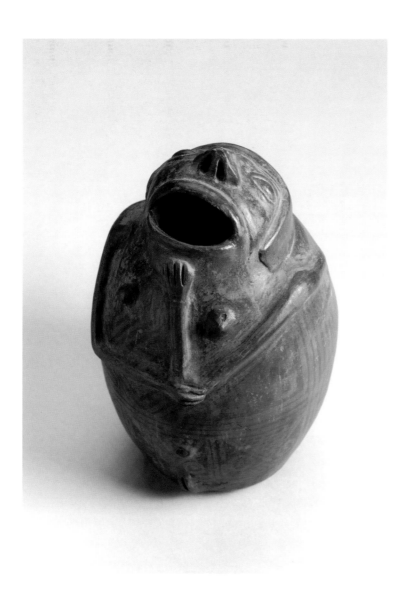

112. SHOUTING FEMALE (GRITONA) JAR
Capulí/Tuncahuan,
Northern Highlands,
Carchi Province, 300 BC–AD 500
Ceramic with resist decoration
20 x 12 cm
2006.070.141 (C-176)

This jar is rounded, with an ellipsoidal body, high shoulder, and restricted neck. The opening of the jar is formed by the woman's gaping mouth, with her realistically modeled nose placed at the upper tip of the jar; her left hand is on her chin while her right hand supports her left elbow. Her distended navel and the rounded shape of the jar as a whole suggests pregnancy; her genitals are indicated by paired vertical low relief strips at the base of the vessel. She has no legs indicated, a common convention in animating vessels in the northern Andes.

The open mouth has been interpreted, by analogy with tropical forest Indians in modern times, as a shaman singing his power song for rain or to diagnose the future or the cause of an illness. Since this is a woman, the song may be related to her pregnancy. There certainly are women shamans, but they are portrayed sitting on the ground.[35]

[35] Labbé 1998: 40, #87; 36.

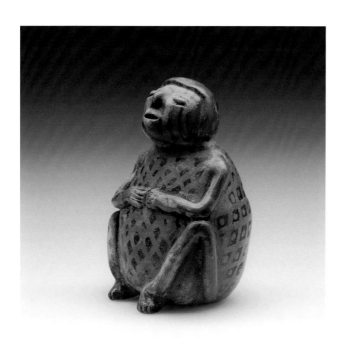

113. PREGNANT FIGURE
Capulí/Tuncahuan,
Northern Highlands, Carchi
Province, 300 BC–AD 500
Slip-painted, burnished ceramic
with resist decoration
10.4 x 7 x 6.7 cm
2006.070.136 (C-171)

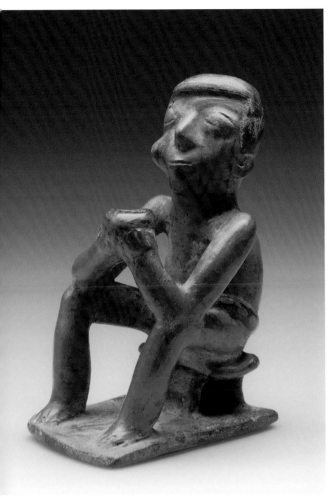
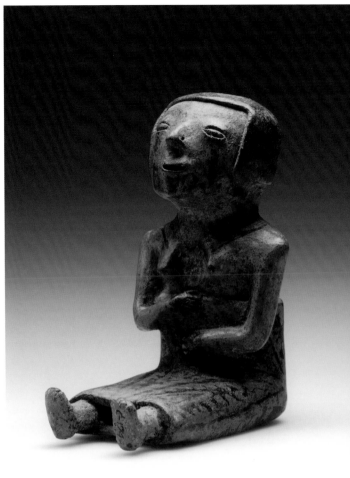

114. Seated Male *Coquero*
Capulí/Tuncahuan, Northern
Highlands, Carchi Province,
300 BC–AD 500
Burnished ceramic with
resist decoration
17.3 x 7.5 x 9 cm
2006.070.138 (C-173)

115. Seated Female Figure
Capulí/Tuncahuan, Northern
Highlands, Carchi Province,
300 BC–AD 500
Burnished ceramic with
resist decoration
15.5 x 8.2 x 1.5 cm
2006.070.139 (C-174)

Figures such as these are typically referred to as *coqueros*; although the woman does not appear to be chewing a coca quid herself, other similar female figures do have the telltale bulge in one cheek. The Spanish word *coquero* (coca-chewer) refers to the widespread practice of chewing coca leaves; coca-chewing was widely practiced in the past and continues to be an important part of traditional lifestyles in the Andes today. A pinch of an alkaline substance such as powdered lime (from a *poporo* or lime pot, such as the one held by the male figure) is added to the coca leaves to strengthen the stimulant effect, and the chewed quid is kept in the mouth until the effect ceases. The stool is a standard piece of equipment for tropical forest shamans even today, providing stability as a shaman takes narcotics to commune with the spirit world. Stools in the pre-European Americas were status symbols used by chiefs. In small societies, such as modern Amazonian tribes, the shaman often served as the chief as well. Women are occasionally shamans in small-scale societies; however, the posture of this female figure, seated with her legs outstretched in front rather than on a stool, argues for no special status. Some textiles with geometric patterns similar to those depicted on the woman's skirt have been recovered from Nariño, across the international boundary, but they have no cultural provenance. Although these two figures are not a true pair, they resemble those figure pairs intended to be placed in a tomb together.[36]

[36] A group of similar figures are pictured on page 226 of Crespo and Holm (1977).

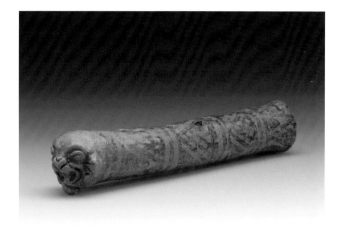

116. FLUTE WITH SNARLING FELINE FACE
Capulí/Tuncahuan, Carchi Province,
300 BC–AD 500
Burnished ceramic with
resist decoration
18.3 x 3 cm
C-408

This hollow ceramic flute has four
holes evenly spaced along the
upper edge and is decorated with
burnished resist-painted black-on-
red paint. The end of the flute has a
snarling feline "monster" face with
bared fangs. A large, teardrop-
shaped tongue or labret dangles
from the feline's open mouth.

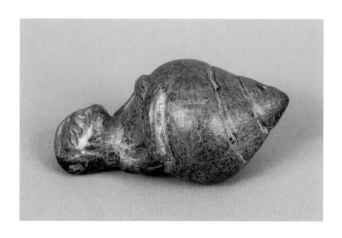

117. SHELL-SHAPED OCARINA
300 BC–AD 500
Slip-painted, burnished ceramic
10 x 5.5 x 9.5 cm
2006.070.345 (C-403)

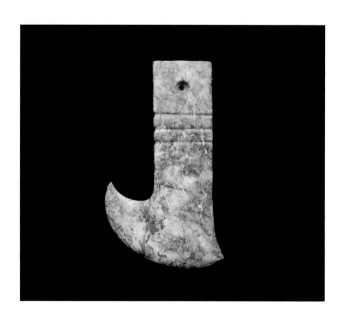

118. CUTTING TOOL
Capulí, Carchi Province,
300 BC–AD 500
Green jadeite
17 x 9 x 1.3 cm
C-483

Milagro

119. GLOBULAR JAR
Milagro/Quevedo, AD 800–1500
Burnished, incised ceramic
10 x 10.5 cm
2006.070.215 (C-264)

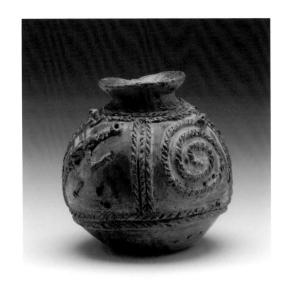

120. SEMILUNAR CUTTING TOOL
AD 800–1500
Copper
17.8 x 18.6 x 2.5
C-241

This large tool has a crescent-shaped blade and an aged green patina. The handle is pierced by a large round hole, perhaps for inserting a round wooden handle. A tool this large might have been hafted horizontally for use as a hoe or adze rather than directly into a handle.[37]

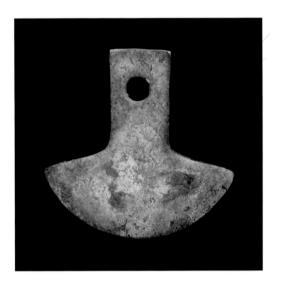

121. SET OF SIX KNIVES
Milagro/Quevedo (Ecuador),
AD 800–1500
Copper
7.5 x 10.5 cm
2006.070.207 a-f (C-256)

These knives were used for exchange, as a kind of money. They are similar to Mesoamerican trade items and may reflect trading relationships with cultures farther to the north.

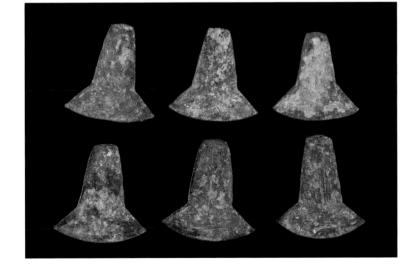

[37] A similar *hacha* is pictured on page 203 of Crespo and Holm (1977).

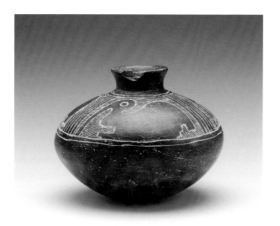

Manteño

122. Globular Jar with Birds
AD 600–1500
Burnished, incised
blackware ceramic
9 x 12.5 x 4.5 cm
C-472

The shoulder of this jar is incised
with birds, possibly pelicans.
It was probably made by the
same hand as cat. 123.

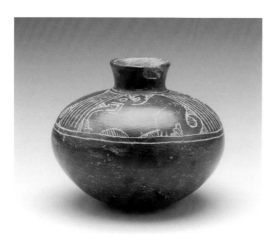

123. Globular Jar with Animals
AD 600–1500
Burnished, incised
redware ceramic
9 x 12.5 x 4.5 cm
C-473

The shoulder of this jar is incised
with plump, curly tailed animals,
possibly felines. It was probably
made by the same hand as cat. 122.

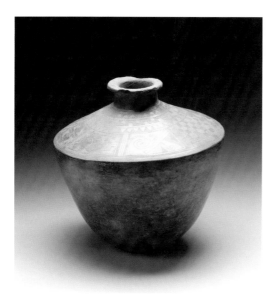

**124. Carinated Vessel with
Checkerboard Pattern**
Manabí, AD 600–1500
Burnished, incised ceramic
23.5 x 24 x 7.5 cm
2006.070.193 (C-236)

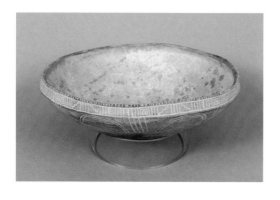

125. Shallow Bowl
AD 600–1500
Slip-painted, incised
redware ceramic
8 x 23.5 cm
2006.070.194 (C-239)

126. LIME POT (*POPORO*)

AD 600–1500
Burnished ceramic
2.8 x 3.5 x 6 cm
2006.070.297 (C-352)

This lime pot still holds traces of lime inside. Lime is used when chewing coca leaves to release the biologically active alkaloids. Coca chewing has profound ritual significance in the Andes; chewing the leaves has a stimulant effect similar to caffeine, while also enabling people to work better in the thin air found at high altitudes. In addition, coca leaves provide a large number of vitamins and minerals.

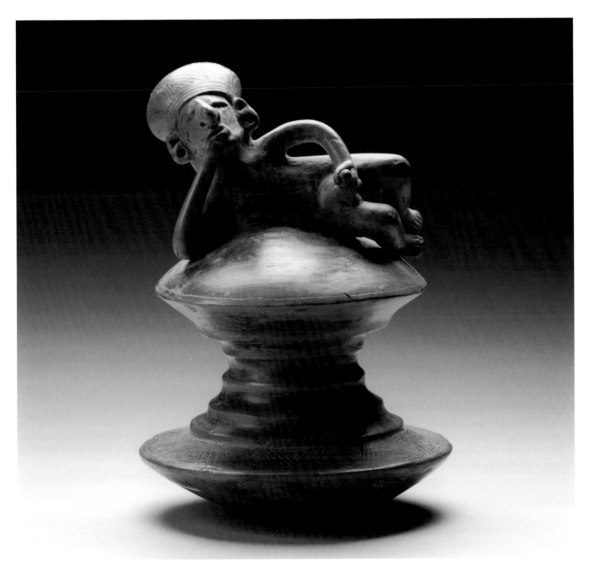

127. MASTURBATING MALE EFFIGY VESSEL

AD 600–1500
Burnished blackware ceramic
19.5 x 13.5 cm
2006.070.276 (C-326)

[38] A similar vessel is illustrated by a drawing in Meggers (1966: 131, fig. 38).

[39] Martínez 1986: #781.

[40] Ibid., 148.

This vessel with the figure of a masturbating male reclining on top appears to be an imperfectly fired blackware type, since others identical to its format are blackware.[38] The masturbation may achieve a form of ecstasy, not just personal pleasure, but communication with the divine.

Depiction of sexual acts on pottery is not unusual in pre-Columbian America. Contemporary with Manteño are blackware Chimú bottles that represent a woman masturbating her male partner[39] as well as images of actual coitus. Cruz Martínez[40] cites Allan Sawyer, who in 1975 wrote that "certain sexual practices can generate similar states to those which are brought on by hallucinogenic drugs, and like them form part of ritual ceremonies." The Chimú artists are continuing a tradition of Moche art in representing the same sexual acts. Moche men display their gigantic erect phalluses on effigy bottles; Colima men on West Mexican redware vessels do the same. La Tolita plaques show copulation scenes in relief, as mentioned in cat. 67.

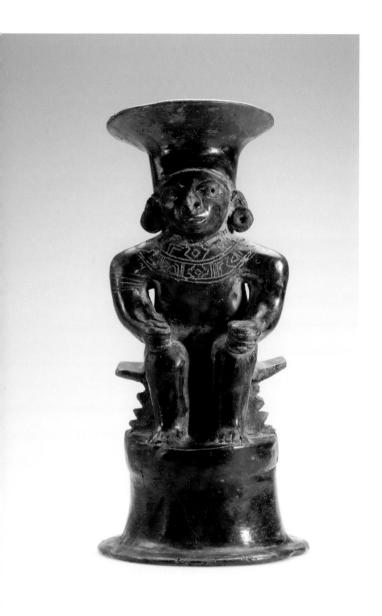

128. Seated Chieftain Figure
Manabí Province, AD 400–1400
Burnished blackware ceramic
32 x 15.5 x 15.5 cm
2006.070.448

This striking Manteño figure depicts a high-status male seated on a bench situated on top of a campaniform (bell-shaped) lid. The figure wears a tall hat which joins the broad, flared vessel rim. The purpose of these figures is unclear—although they are typically referred to as incense burners,[41] according to Mercedes Guinea, "they don't appear to have been incense burners, nor could they have served to contain anything, since they are hollow from top to bottom."[42] The Johnson Museum's Zorach collection has a similar piece (74.053.039) that still retains its original gold nose ornament.[43] Objects of this type may have been lids for large jars used to hold offerings. The funnel-shaped headdress on this type of figure suggests that a liquid or fine granular substance could have been poured through it into the vessel below.[44] As is typical of these square-shouldered, Manteño figures, "the torso is full and powerful, a sign of the chief's strength. Incisions on part of the torso suggest body painting or tattooing. . . . The facial features, especially the nose, are heavily modeled and large, emphasizing the strong personality of the chief. Modern inhabitants of Manabí, although completely acculturated, still preserve these strong features."[45]

[41] A similar *incensario* is pictured on page 208 of Crespo and Holm (1977).
[42] Guinea 2004: 12.
[43] Scott 1982: #163, 28, 38.
[44] Ibid., 53.
[45] Scott 1999: 120.

129. Fox Effigy Whistle
AD 600–1500
Burnished blackware ceramic
5.5 x 5.5 x 5 cm
2006.070.281 (C-334)

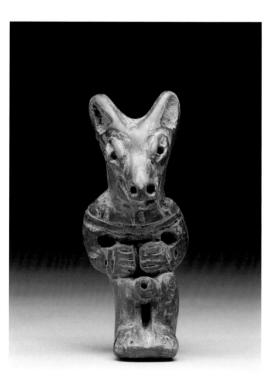

130. String of 63 Spindle Whorls
AD 600–1500
Incised redware ceramic
72 cm
2006.070.210 (C-259)

Spindle whorls were the weights used on the drop spindles used to spin the thread used in weaving textiles for clothing, blankets, and bags.

131. String of Beads
AD 600–1500
Ceramic
80 cm
2006.070.211 (C-260)

Animal heads represented on some of these beads may be llamas, foxes, rabbits, or viscachas.

132. Crested Bird Whistle
AD 600–1500
Burnished ceramic
6 x 2 cm
2006.070.251 (C-301)

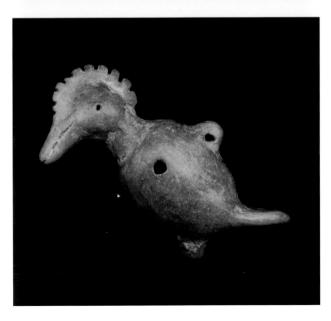

133. Zoomorphic Cylinder Seal
AD 600–1500
Ceramic
6.3 x 3.4 cm
2006.070.325 (C-382)
Illustrated on page 71

134. Zoomorphic Stamp Seal
AD 600–1500
Ceramic
4.8 x 5.2 x 2.5 cm
2006.070.310 (C-367)

136. Stamp Seal with Animal
AD 600–1500
Ceramic
7 x 5 x 5 cm
2006.070.338 (C-395)

137. Stamp Seal
AD 600–1500
Ceramic
11.5 x 10.5 x 5 cm
2006.070.365 (C-428)

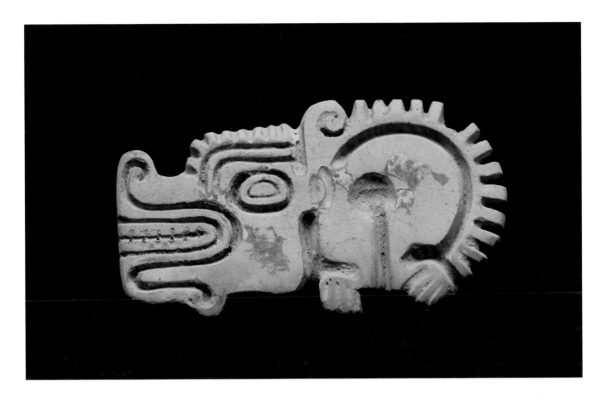

135. Dragon Stamp Seal
AD 600–1500
Ceramic
16.5 x 8.5 x 8.5 cm
2006.070.287 (C-342)

The fierce quadruped depicted on this stamp is shown facing left with a bristling back. Such bristling is characteristic especially of felines in defensive mode, although canines also raise their fur in such instances. This creature is neither of these, but a fantastic creature often called a dragon, associated with the moon in Moche iconography, where it is called a moon monster, and as a protective being in Recuay, where it is called the Recuay cat.[46] Characteristic of this dragon are his bared teeth set in a horizontal row, an upcurled nose, vertical fur above his eyes which sometimes flies free and becomes a backward flaring crest, and a tail that curls up behind his back. In this case it appears attached to the back, but the deep groove separating the back and the tail makes us able to read it as separate. The seal is of white paste with traces of red on its surface, perhaps where the paint was applied to stamp on a flat surface.

138. Stamp Seal with Birds
AD 600–1500
Burnished blackware ceramic
14.3 x 11.5 x 7 cm
C-158

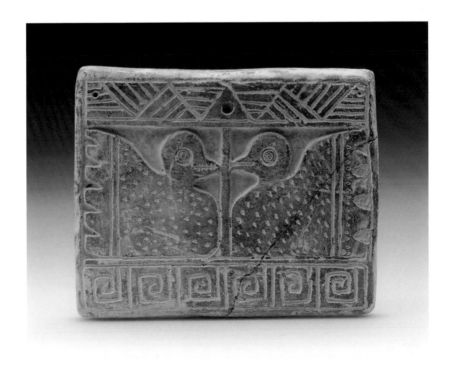

[46] Scott 1994 has a complete analysis and distribution of this creature.

139. Lid with Crab Design
AD 600–1500
Burnished ceramic
11.3 x 7.5 cm
2006.070.113 (C-139)

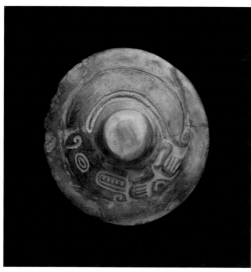

140. Round Lid with Zoomorphic Design
AD 600–1500
Burnished ceramic
10.5 cm diameter
2006.070.114 (C-141)

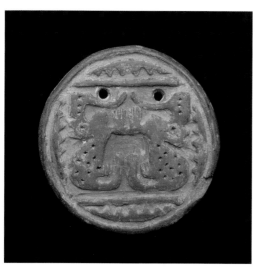

141. Heraldic Animal Medallion
AD 600–1500
Burnished redware ceramic
0.8 x 11 cm
2006.070.118 (C-147)

142. Round Medallion with Animal Profile
AD 600–1500
Burnished blackware ceramic
3 x 13 cm
2006.070.364 (C-427)

143. Semilunar Knife
AD 600–1500
Copper
8.3 x 10.5 x 1.7 cm
C-242

This heavy knife has the semilunar shape characteristic of many Andean blades. The crescent shape would have been ideal for chopping foods in a round-bottomed wooden bowl.[47]

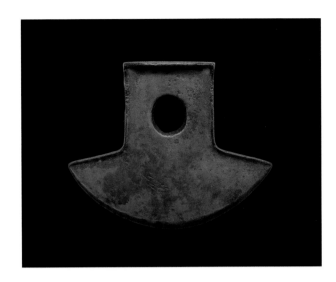

144. Knife
AD 600–1500
Copper
8 x 8 x 0.2 cm
C-361

This thin copper or possibly bronze Manteño knife has a crescent-shaped or semilunar blade with beveling along the edge indicating sharpening for use rather than display. There is a thin incised line around the entire non-working edge of the piece, on both sides. The blade would have been hafted into a handle for use.

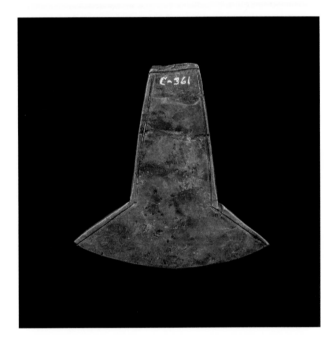

145. Nose Ring
AD 600–1500
Copper alloy
2.3 x 2 x 1 cm
2006.070.295 (C-350)

Extensive green oxidation over the surface of the nose ring, with some gold visible on the surface only on one side, indicates that this piece may be mostly copper, with the gold left largely on the surface through the process of depletion gilding.[48]

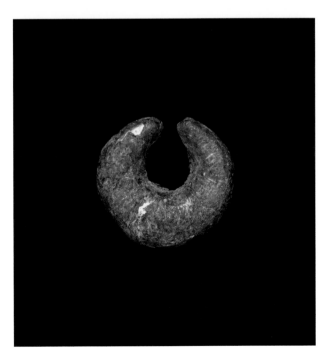

[47] A similar *hacha* is pictured on page 203 of Crespo and Holm (1977).

[48] This piece is very similar to Milagro-Quevedo nose rings (Ibid., 205).

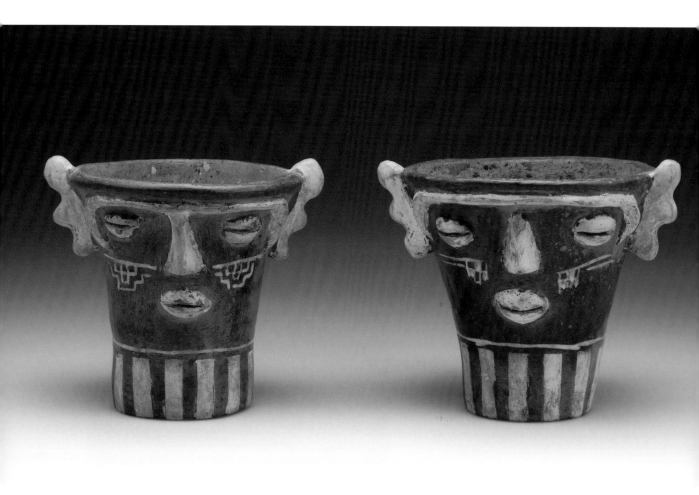

Cashaloma

146. ANTHROPOMORPHIC ANTLERED *QUERO* (CUP)
AD 1200–1500
Slip-painted, burnished ceramic with polychrome decoration
12.5 x 15.5 cm
2006.070.216 (C-265)

147. ANTHROPOMORPHIC ANTLERED *QUERO* (CUP)
AD 1200–1500
Slip-painted, burnished ceramic with polychrome decoration
12.2 x 14.5 cm
C-266

This pair of cups belong to the Cashaloma culture produced by the Cañari Indians, centered in the southern highlands inland from the Gulf of Guayaquil.[49] Ecuador's Cañar Province is named for them, and Azuay Province was their main population center. Their ceremonial center Ingapirca was taken over by the Inca and turned into a fortress with beautifully cut stones laid in regular rows.[50] The Cañari were heavily influenced by Peruvian traditions of matching cups, or *queros,* used for ritual toasting. These two *queros* seem to be a true pair, with the same proportions, paint texture, and scale. Face *queros* with this outward curving profile suggest the influence of the Wari Empire of the Middle Horizon, although certainly the empire did not reach that far north. However, the area's conquest in 1460 by the Inca Empire reinforced that tradition. Heavy application of white paint on the red and almost chocolate brown is distinctive of Cañari ceramics (cats. 148, 149). Double-scalloped flanges defining their ears distinguish these *queros* from the true Inca ones. Some consider that they represent deer antlers.[51] Their wide-spread eyes are characteristic of late pre-Columbian facial features throughout the northern Andes.[52]

[49] Porras 1987: 187, fig. 55b.

[50] Bravomalo de Espinosa 1992: 212.

[51] Gutiérrez 2002: 231, fig. 172.

[52] Nearly identical to a *vaso* pictured on page 247 of Crespo and Holm (1977), and to fig. 16.25 on page 317 of Bruhns (1994).

148. HEAD EFFIGY JAR
AD 1200–1500
Ceramic with polychrome
decoration
10.7 x 9.7 cm
2006.070.217 (C-267)

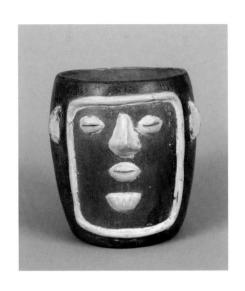

**149. ASYMMETRICAL PITCHER
WITH FELINE HEAD HANDLE**
AD 800–1500
Slip-painted,
burnished ceramic
13 x 18 cm
2006.070.380 (C-444)

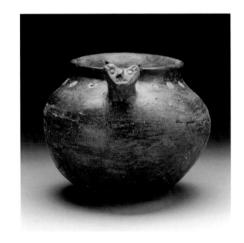

Puruhá

150. ANTHROPOMORPHIC FACE JAR
AD 800–1250
Burnished ceramic with
resist decoration
20 x 16.5 x 11 cm
2006.070.165 (C-204)

This softly burnished black-on-red resist-painted ceramic anthropomorphic head jar has a flat base which flares to the high placed ears, then incurves to a direct rim. The eyes, made of paired horizontal strips of clay, are at the level of the ears, whereas the bridge of the nose is placed higher and descends in high relief to its tip. The lips are formed with thin strips of clay, with much more projecting three conical labrets below the lower lip. The resist decoration on the face does not correspond to naturalistic facial forms, unless it is facial paint or tattoos, and divides the face into a triangular zone on each cheek into which panels of X's are painted. This jar is similar to another example in the Carroll collection (2006.070.166; not presented in this exhibition).

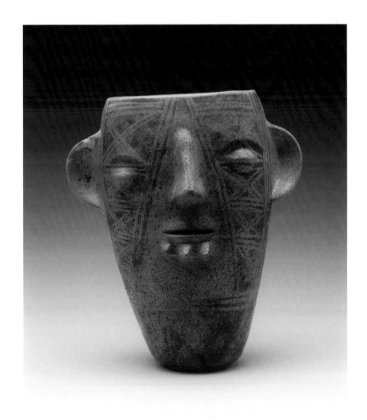

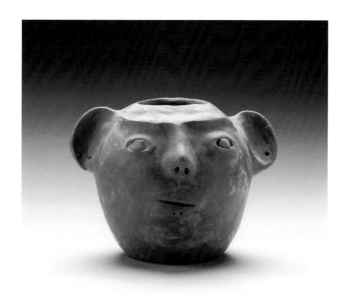

151. Anthropomorphic Face Jar
AD 800–1250
Slip-painted
redware ceramic
16.5 x 15 x 11 cm
2006.070.168 (C-208)

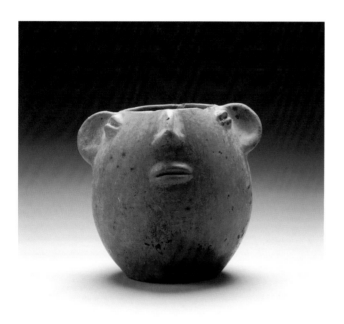

152. Anthropomorphic Face Jar
AD 800–1250
Slip-painted
redware ceramic
15 x 17 x 14.5 cm
2006.070.189 (C-231)

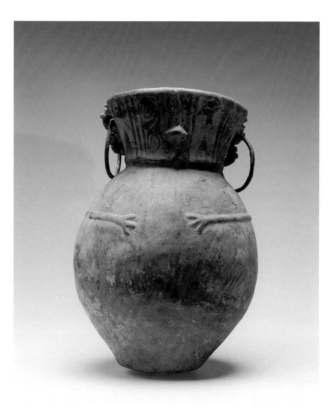

153. Face-Neck Urn
AD 800–1250
Ceramic with
resist decoration
34 x 23 cm
2006.070.170 (C-210)

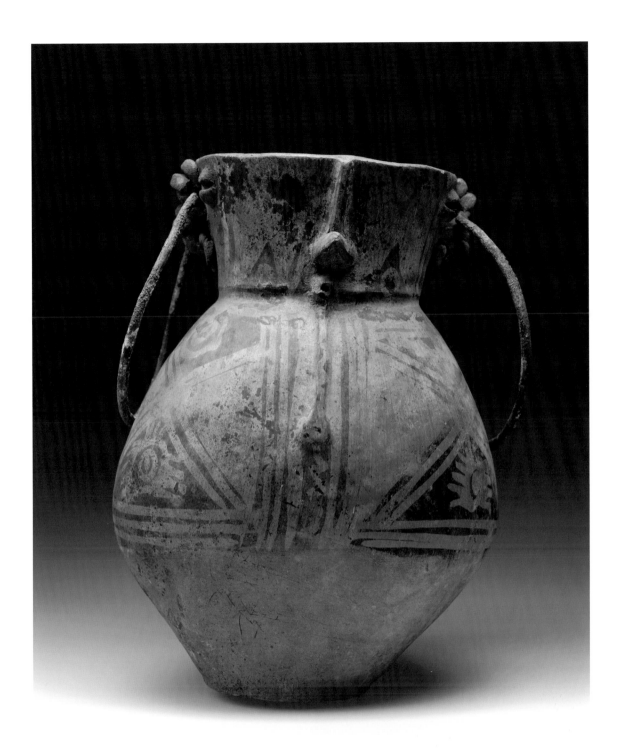

**154. ANTHROPOMORPHIC URN
WITH COPPER EARRINGS**
AD 800–1250
Ceramic with resist
decoration
29 x 22 x 14 cm
2006.070.171 (C-211)

This impressive urn has an abstract anthropomorphic face on its neck, with double loop-handle ears wearing multiple ceramic loop earrings and very large copper hoop earrings reaching halfway down the body of the vessel. Another, more typical anthropomorphic urn (cat. 153) has smaller copper hoop earrings that just reach to its shoulders. The face has a long, prominent nose modeled in relief, a rudimentary punched mouth, and raised-relief arms and hands resting on the body of the vessel. This urn is very similar to cat. 153 and cat. 155 in this exhibition.[53]

[53] Also similar to several vessels pictured on page 239 of Crespo and Holm (1977).

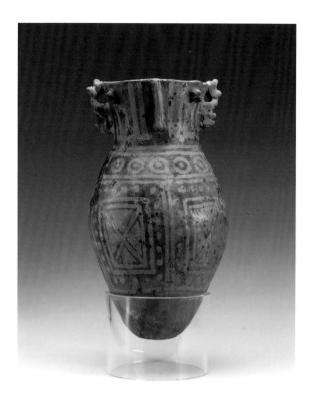

155. FACE-NECK URN
AD 800–1250
Ceramic with resist decoration
30.5 x 16.5 cm
2006.070.173 (C-213)

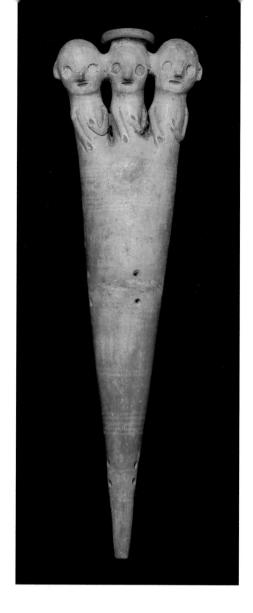

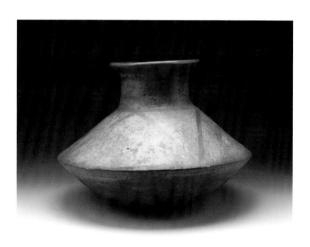

156. CARINATED VESSEL
AD 600–1300
Slip-painted, burnished ceramic
28 x 35 cm
2006.070.214 (C-263)

Cara/Panzaleo

157. CONICAL FUNNEL WITH THREE FIGURES
AD 800–1470
Incised ceramic with resist decoration
40.5 x 11 x 4.3 cm
2006.070.140 (C-175)

This elongated conical vessel is crowned by a rather whimsical trio of human figures. It has holes drilled on either side of two old breaks, evidence of deft pre-Columbian repairs. Although a nearly identical item from the site of Píllaro in Tungurahua Province (the southernmost extent of the Cara style), now in the Colegio Bolívar in Ambato, was called a funnel,[54] the original purpose of this vessel is not clear. Its general form resembles Inca libation tubes (*paccha* in Quechua), which were used to pour libations or liquid offerings, usually of maize beer, to the mother earth spirit (*Pachamama*). The wear on the pointed end may indicate an alternate function as a "clyster tube," used to administer hallucinogenic enemas, although Tuza and Capulí clyster tubes differ from this vessel in having a less evenly tapered shape.[55] Anal infusions of drugs such as Datura are still used among Amazonian groups during male coming-of-age rituals.

[54] Porras 1975: fig. 58c.
[55] Labbé 1986: 149.

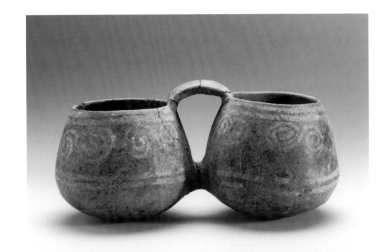

158. DOUBLE-CHAMBERED VESSEL
AD 800–1470
Ceramic with polychrome
decoration
30 x 15 x 15 cm
TR 7869

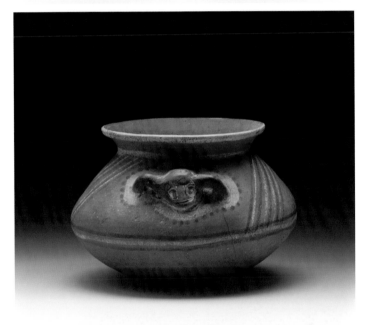

159. MONKEY-HANDLE VESSEL
AD 800–1470
Ceramic with polychrome
decoration
10.5 x 16 x 12.5 cm
2006.070.182 (C-223)

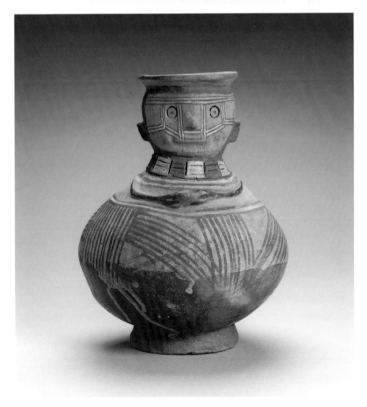

160. FACE-NECK JAR
Pichincha/Imbabura,
AD 800–1470
Ceramic with polychrome
decoration
27.5 x 22 x 10.2 cm
2006.070.179 (C-220)

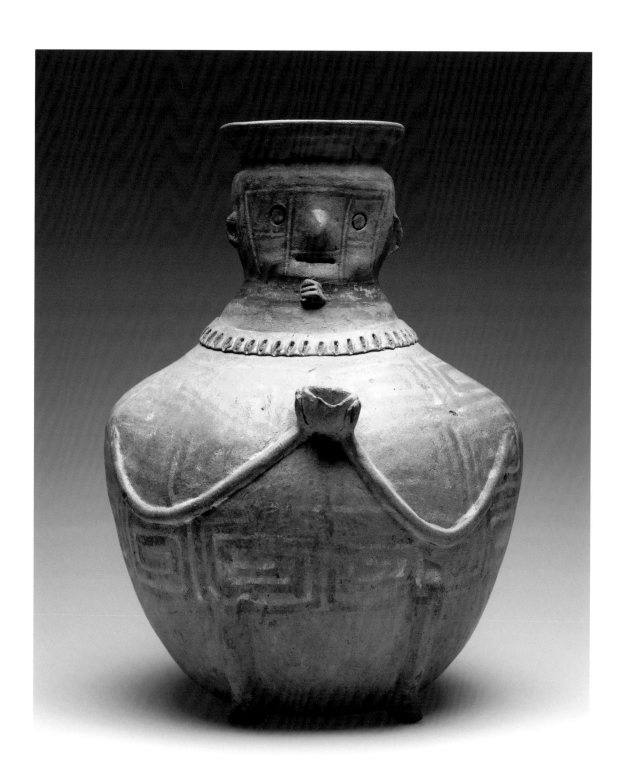

161. FACE-NECK JAR
Pichincha/Imbabura,
AD 800–1470
Ceramic with
polychrome decoration
35 x 26 x 11.5 cm
2006.070.180 (C-221)

⁵⁶ Porras 1975: Pl. 56–57.

This jar is in the form of a stylized human holding a bowl or coca offering. The bowl is functional and in the round, while the arms are thin fillets of clay stuck to the torso. There is no evidence of gender either on this piece or its close parallel, cat. 160. Its eyes are made by punches of hollow cane, forming perfectly blank circles. The vessel is painted with linear and geometric patterning of black, white, red, and yellow-orange in parallel lines and Greek keys. The two calves and feet are applied in higher relief to the bottom front of the vessel, suggesting that the figure is sitting. *Padre* Porras has published several similar vessels from the Píllaro site (see cat. 157) which have similar features.⁵⁶ Although less complete, figures from the Cosanga site east of Quito have the same features and decorative techniques, indicating they are all of one culture.

Piartal

162. *COMPOTERA* (FOOTED BOWL)
AD 600–1000
Slip-painted ceramic with
resist decoration
12 x 20 cm
2006.070.144 (C-179)

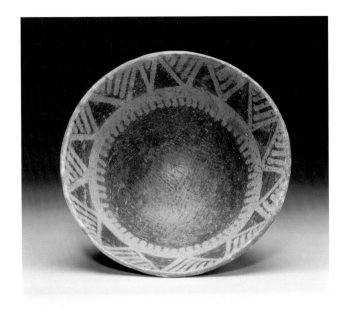

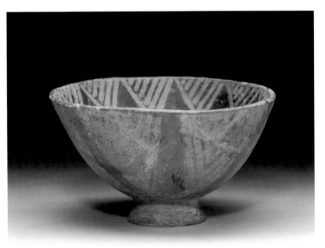

163. *COMPOTERA* (FOOTED BOWL)
WITH MONKEYS
AD 600–1000
Ceramic with resist and
polychrome decoration
8 x 21 cm
2006.070.145 (C-180)

Motifs on the interior of this *com-
potera* include two monkeys and
two frontal anthropomorphs,
with trapezoidal torsos facing the
viewer and triangular heads. Curly
tailed and round faced animals
on pedestals alternate with these
spectral anthromorphs.

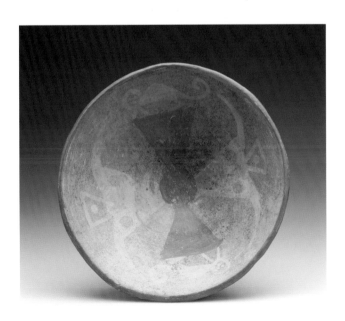

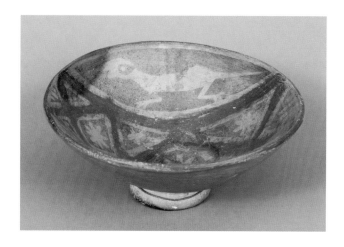

164. *COMPOTERA* (FOOTED BOWL)
WITH ANIMALS
AD 600–1000
Ceramic with resist and
polychrome decoration
8.5 x 20.3 cm
2006.070.148 (C-183)

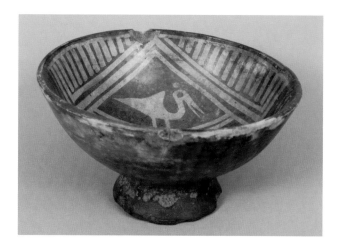

165. *COMPOTERA* (FOOTED BOWL)
WITH BIRDS
AD 600–1000
Burnished ceramic with
polychrome decoration
10 x 19.5 cm
2006.070.149 (C-184)

This open ceramic Piartal bowl with
an annular ring base or *compotera*
has two birds (pelicans?) painted
on the interior along with an ab-
stract geometric design of lines
and circles. The vessel is burnished;
the colors are red and buff with
some red overpaint.

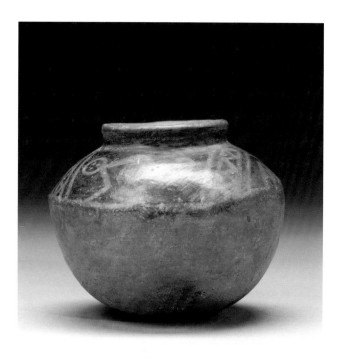

167. MONKEY JAR
AD 600–1000
Redware ceramic with
resist decoration
6.5 x 8.5 x 5 cm
2006.070.225 (C-275)

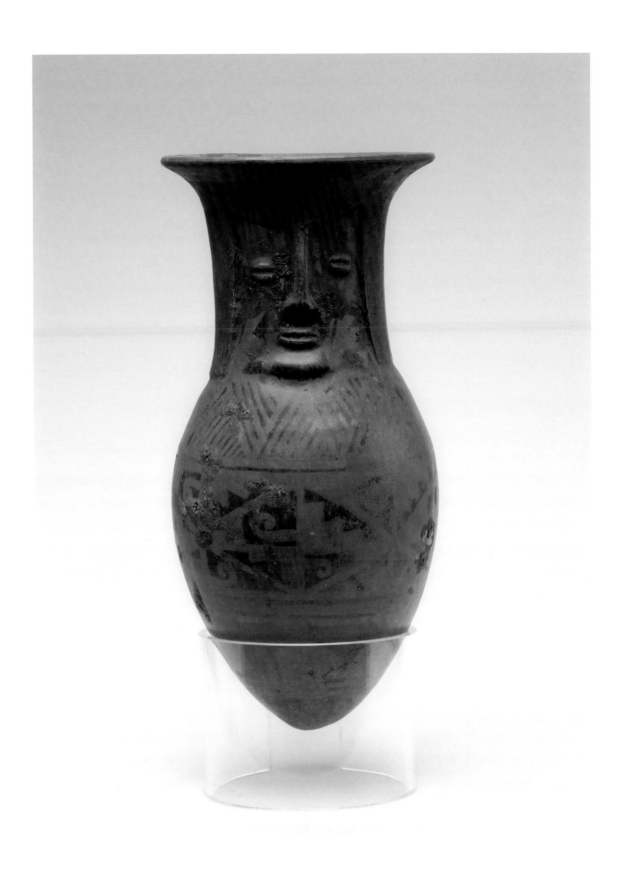

166. FACE-NECK FUNERARY URN
AD 600–1000
Ceramic with resist decoration
34.5 x 16 x 16.5 cm
2006.070.213 (C-262)

This urn has an anthropomorphic face on the vessel neck below the outflaring rim, with prominent nose and coffee-bean eyes and mouth. Piartal vessels of this type are known by the Greek name *amphora,* which refers to tall vessels with pointed bottoms used by the Greeks to transport wine. Urns like this were used for burial, some say of traders from the coast (Esmeraldas), since the local people were buried in large jars, such as the Atacama people used on the coast. The human face on the neck of the jar is formed very similarly to those from Puruhá, with simple, geometric features made from strips of clay placed horizontally (eyes, mouth) or vertically (nose). The geometry is similar to the negative painting of Puruhá: triangular forms with diagonal parallel lines and step designs. This jar is similar to another jar in the Johnson Museum's Zorach collection (74.053.107).

musical instruments

Sounds and music were important in the lives of pre-Columbian people. We know this because there are many representations of musicians playing the panpipes (such as cats. 59 and 168), and because of the large number of surviving ceramic whistles, whistling pots, and (more rarely) flutes. Many human figurines are actually whistles, as are numerous small animal effigy amulets. Some full-sized pottery vessels had special mechanisms molded into a secondary spout which allows them to produce whistling sounds when air is blown into them or when water moves within the vessel chambers. Although many of these instruments might more properly be dubbed noisemakers rather than musical instruments in the Western sense, such sounds were used to open connections to the spirit world. Even today, Catholic religious ceremonies in Latin America have a distinctly non-European flavor, and are usually accompanied by a cacophony of whistling, drumming, and chanting which may be reminiscent of pre-Columbian religious celebrations.

Tuza

168. PANPIPE PLAYER *CARACOL*
AD 800–1500
Burnished, incised ceramic
17 x 8 x 7 cm
C-169

169. Large *Caracol*
AD 800–1500
Slip-painted, burnished ceramic
20 x 14 x 11 cm
C-397

170. *Caracol* with Predation Scene
AD 800–1500
Slip-painted, burnished ceramic
8 x 6.5 x 5.5 cm
C-164

This effigy whistle or *caracol* is painted with two stylized feline (or canine) predators placed to each side of an antlered deer. The predatory figures are depicted with open mouths and are obviously menacing their prey. The ocarina is pierced by a post-firing hole at one end so that it could be hung as a pendant.[57]

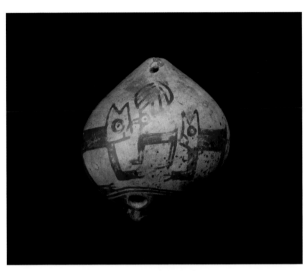

171. *Caracol* with Monkey
AD 1250–1500
Slip-painted, burnished ceramic
11.5 x 5.5 cm
2006.070.134 (C-168)

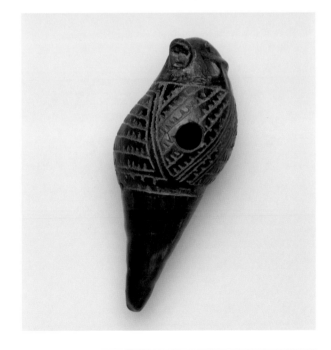

172. Monkey-Face *Caracol*
AD 800–1500
Slip-painted, burnished ceramic
8.5 x 5 cm
C-161

This shell effigy whistle is decorated with two so-called "Ohio" stars, and also has a raised-relief monkey face and arms on one end. In Tuza/Cuasmal cosmology, this particular variant of the eight-pointed star is the symbol for the planet Venus.[58] The amulet is pierced by a hole as though for hanging.

[57] See a shell effigy with similar animals on page 180 of Valdez and Veintimilla (1992), and on page 236 of Crespo and Holm (1977).

[58] Labbé 1986: 167.

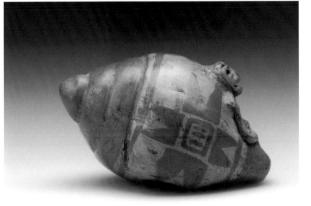

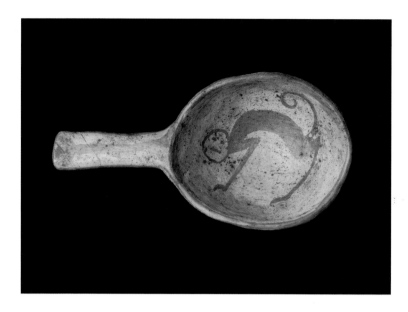

173. MONKEY SPOON
AD 800–1500
Slip-painted,
burnished ceramic
18 x 7.8 x 3.4 cm
C-466

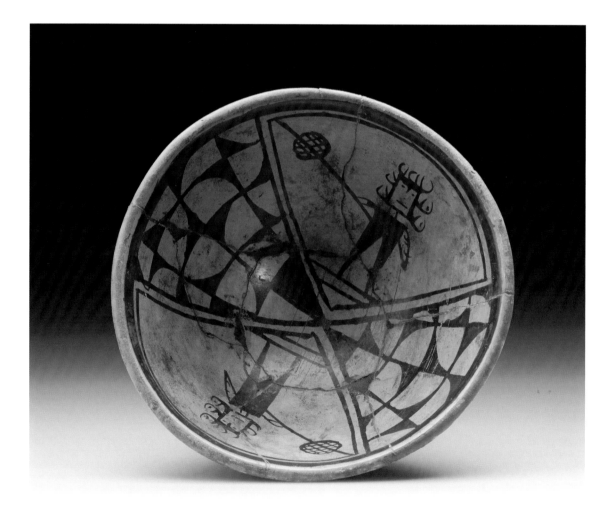

174. COMPOTERA (FOOTED BOWL) WITH NET CARRIERS
AD 800–1500
Slip-painted, burnished ceramic
7.5 x 17 cm
C-194

This *compotera* is decorated on its interior with standing human figures, perhaps fishermen or hunters, carrying net-like objects on long poles. Another Carroll piece not exhibited (2006.070.163) has the same figure also repeated twice inside its bowl. The net design makes one think of a sieve at the end of a pole that would permit screening desired items from water. The fact that these men hold their sticks in the air may possibly indicate that they are capturing flying creatures such as bats, birds, or insects. Their bodies are composed of rectangular torsos with pendant triangles for legs, and clear squares for heads with simple horizontal facial features.

175. *COMPOTERA* (FOOTED BOWL)
WITH **DEER**
AD 800–1500
Slip-painted, burnished ceramic
7 x 15 cm
C-189

The use of two colors is unusual for
Tuza bowls.

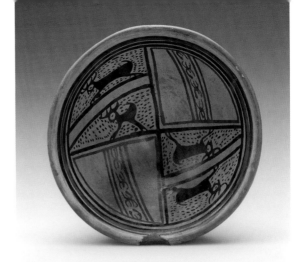

176. *COMPOTERA* (FOOTED BOWL)
WITH **WARRIOR**[59]
AD 800–1500
Slip-painted, burnished ceramic
17.5 x 8 cm
C-468

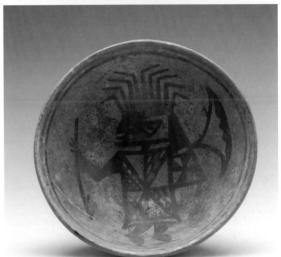

177. *COMPOTERA* (FOOTED BOWL)
WITH **VILLAGE SCENE**
AD 800–1500
Slip-painted, burnished ceramic
8 x 17 cm
C-474

The decoration of this *compotera's*
interior includes stylized houses
and fences with human figures and
flying birds.

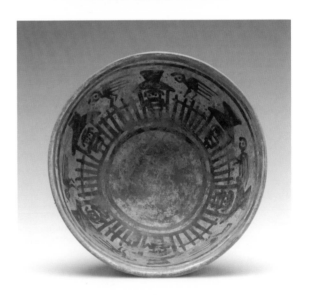

178. *COMPOTERA* (FOOTED BOWL)
WITH **DANCERS**
AD 800–1500
Slip-painted, burnished ceramic
with polychrome
8 x 17 cm
C-475

The interior of this footed ceramic
bowl has a ring of human figures
wearing colorblocked tunics and
crescent-shaped headdresses hold-
ing hands or dancing. Cats. 176,
177, and 178 appear as a series from
the same hand.[60]

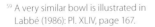

[59] A very similar bowl is illustrated in
Labbé (1986): Pl. XLIV, page 167.

[60] A *compotera* with very similar figures
is pictured on page 234 of Crespo
and Holm (1977) and on page 273 of
Bruhns (1994).

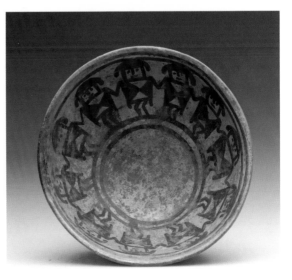

179. Funerary Urn
AD 1250–1500
Slip-painted,
burnished ceramic
47 x 19 cm
2006.070.447 (C-445)

This amphora's flat base and lack of narrowing at the neck are characteristic of Tuza vessels and are in sharp contrast to Piartal urns, which typically have conical, rounded bases and considerable incurving at the vessel neck (see cat. 166). Tuza artifacts are the archaeological remains left by the immediate ancestors of the Pasto people who lived in this area at European contact. The Pasto were likely latecomers to the region, since their artistic traditions share little with the earlier Capulí and neighboring Piartal peoples, who typically used black-on-red resist-painting, while the Tuza preferred red and brown on buff slip-painted decoration as found on this vessel.[61]

[61] Compare to #139 on pages 148–149 in Labbé (1986).

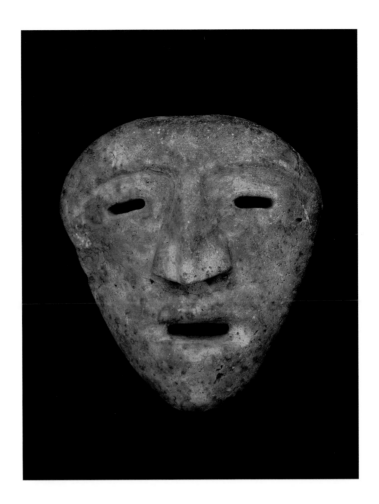

180. TRIANGULAR MASK
AD 1250–1500
Ceramic
17.5 x 16 x 16.5 cm
2006.070.341 (C-399)

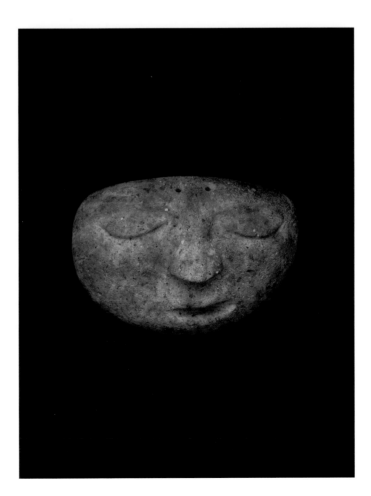

181. OVAL MASK
AD 1250–1500
Ceramic
13.5 x 9.7 x 5 cm
2006.070.343 (C-401)

The eyes of this mask are closed
and the mouth is open, suggest-
ing that the mask portrays sleep
or death.

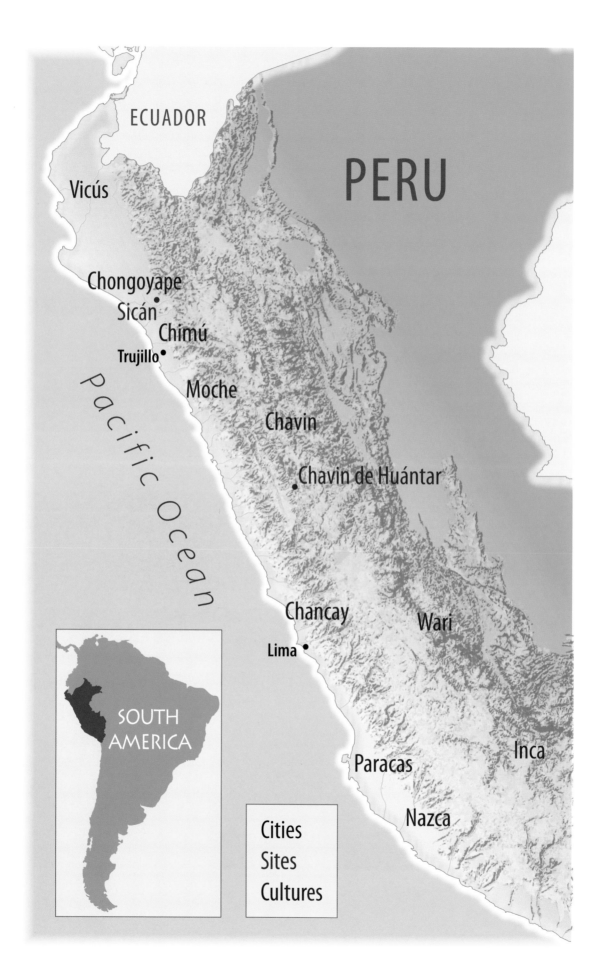

ECUADOR

PERU

Vicús

Chongoyape
Sicán
Chimú
Trujillo
Moche

Chavin

Chavin de Huántar

Pacific Ocean

Chancay
Wari
Lima

SOUTH
AMERICA

Inca

Paracas

Nazca

Cities
Sites
Cultures

PERU

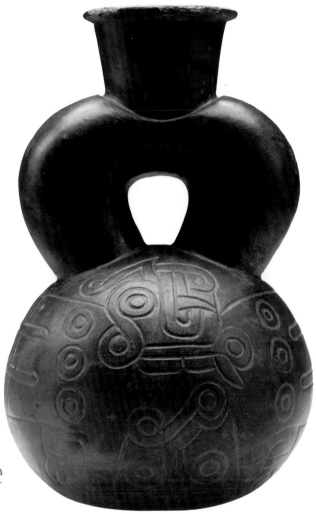

Chavin/Cupisnique

**182. STIRRUP-SPOUT VESSEL
WITH INCISED FELINE RAPTOR**
400–200 BC
Burnished, incised
blackware ceramic
21.5 x 12 x 6.5 cm
C-500

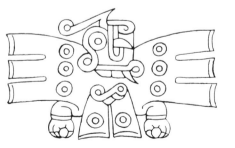

[1] Burger 1995: 147, fig. 138.

[2] Ibid., 165, 215

This impressive vessel has incised designs of a bird with a fanged feline face on each side of the globular vessel body (see drawing). A nearly identical design may be found at the type site of Chavín de Huántar in the north-central highlands of Peru; a cleanly cut rectangular block from the eastern wall of the Old Temple represents a "supernatural crested eagle with its wings extended to the sides and tail feathers spread at the bottom."[1] The crested, or Harpy, eagle is the largest hunting bird in South America; as such it embodied the greatest power in the air. Chavín iconography focused on three animals that embodied the greatest hunters in the three realms of the world: the Harpy eagle for the air; the jaguar for the land surface of the earth; and the caiman or crocodile for the water, often associated with the underground. As Donald Lathrap has pointed out, all three are tropical forest creatures, not highland or desert coastal inhabitants. Chavín de Huántar lies on the eastern side of the Andes, close to the cloud forest where Amazonian animals begin their range. This bottle preserves the iconography of the oldest part of the type site, even though it was made in a north coastal valley, probably Chicama, during the last phase of Chavín dominance during the Early Horizon. That phase is known as Janabarriu and dates about 400–200 BC, and the bottles with this thick, rounded stirrup spout are related to its style of pottery.[2]

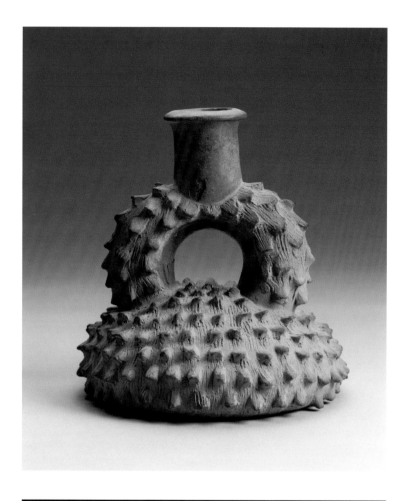

183. STIRRUP SPOUT SPONDYLUS VESSEL
900–200 BC
Ceramic
16.8 x 15 x 5.4 cm
2006.070.381 (C-501)

The protrusions on this vessel are in the form of a marine mollusk (Spondylus). Brightly colored spondylus shells were traded from the warm waters off the coast of Ecuador far south into Peru, where they were highly prized for their ritual use. Spondylus were said to be one of the favorite foods of the gods.

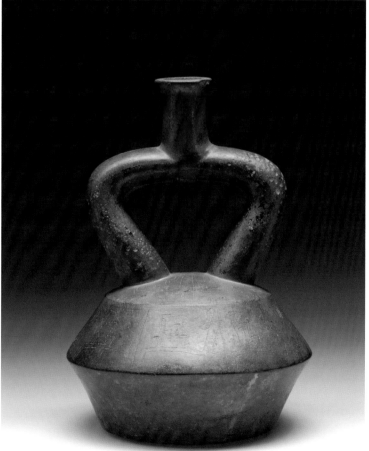

184. STIRRUP SPOUT BOTTLE[3]
900–200 BC
Burnished, incised ceramic
23 x 14.5 x 3.9 cm
2006.070.383 (C-503)

Incised on the angled shoulder are alternating poles and steps, often a reference to mountains.

[3] A nearly identically shaped vessel from Cerro Blanco, near the headwaters of the Jequetepeque River, is pictured in Burger (1995), page 113, fig. 103, and noted for its Cupisnique style.

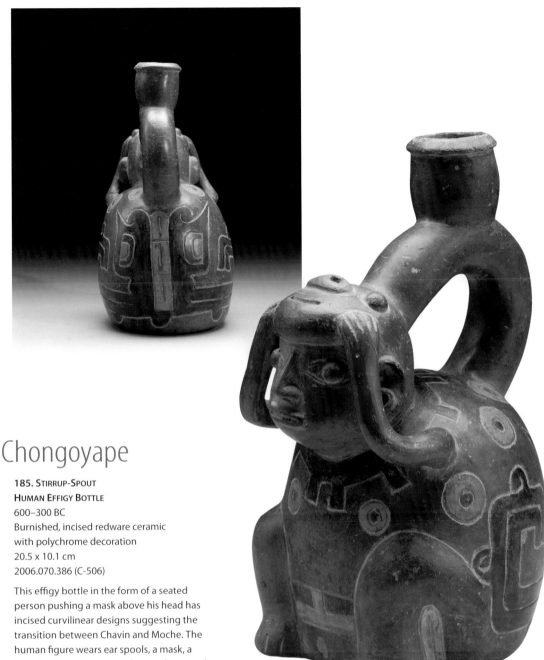

Chongoyape

**185. STIRRUP-SPOUT
HUMAN EFFIGY BOTTLE**
600–300 BC
Burnished, incised redware ceramic
with polychrome decoration
20.5 x 10.1 cm
2006.070.386 (C-506)

This effigy bottle in the form of a seated person pushing a mask above his head has incised curvilinear designs suggesting the transition between Chavin and Moche. The human figure wears ear spools, a mask, a broad collar with rectangular pendants, and a geometric belt.

This vessel is characteristic of ceramics from the Lambayeque Valley of Peru's North Coast. Chongoyape vessels differ from the better-known Chavin-influenced north coastal Cupisnique wares in their red ground color and polychrome decoration. The figure's eyes are made from clay balls and its arms from strips of rolled clay, which are typical of the Chongoyape style. Incised-line decorations and feline motifs are common in Chavin and Cupisnique wares; Chongoyape and the contemporary Tembladera wares, like the post-firing resin-painted Paracas pottery from the South Coast, are polychrome, with different paint colors carefully applied within the incised lines of the vessel. Later Moche vessels often have similar stirrup-spout human effigy forms but are not incised; their bichrome slip-painted decoration is painted directly onto the vessel.

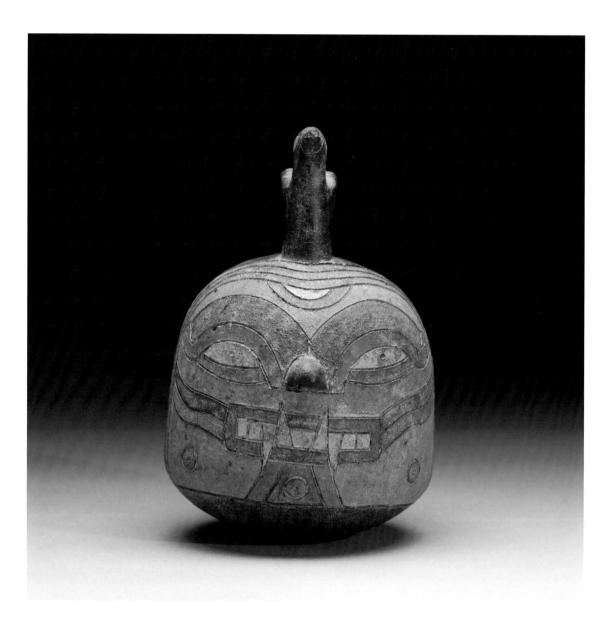

Paracas

186. FANGED MONSTER FELINE BOTTLE
800–200 BC
Burnished, incised ceramic
with post-firing resin paint
14 x 9.5 cm
2006.070.384 (C-504)

This delicate, thin-walled vessel has post-firing resin paint applied within incised panels depicting a fanged feline face on the body of the bottle. This decoration shows Chavin influence, while birds such as the one on the spout are a common motif in coastal Peruvian art.

The vessel shape, a somewhat conical spout connected by a bridge to a second spout or modeled head, is typical of the Paracas style. Although centered on and best known from the Paracas Peninsula, the Paracas cultural tradition extended through six coastal Peruvian valleys (Cañete, Topara, Chincha, Pisco, Ica, the Rio Grande de Nasca). It is interesting to note that post-firing multi-colored painting with plant resins means that vessels such as this could not have been used for cooking (or near heat). In addition, similar colors, designs, and motifs are found in Paracas textiles.

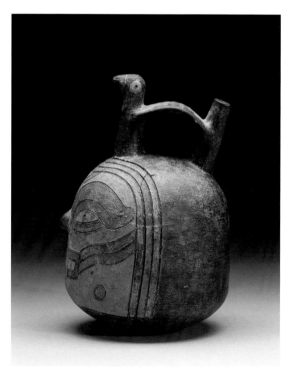

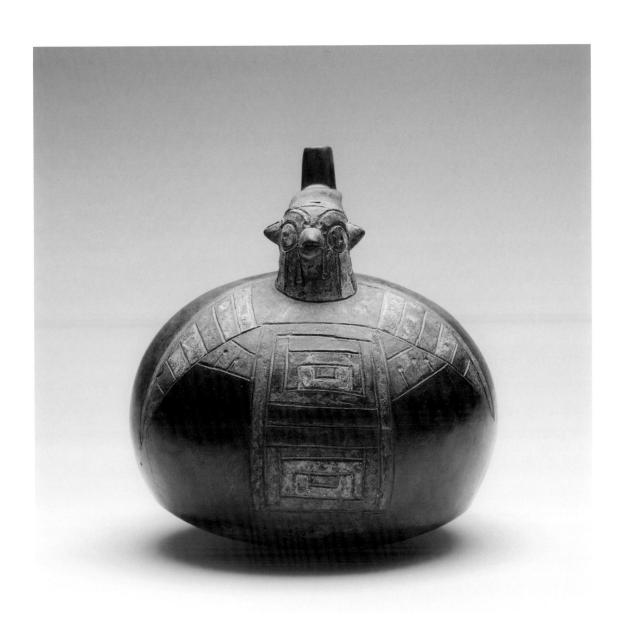

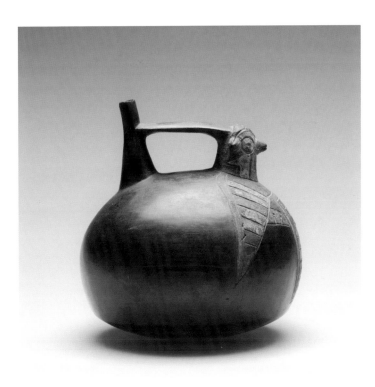

187. Double-spouted Falcon Bottle
800–200 BC
Burnished, incised ceramic with
post-firing resin paint
14 x 3 cm
2006.070.385 (C-505)

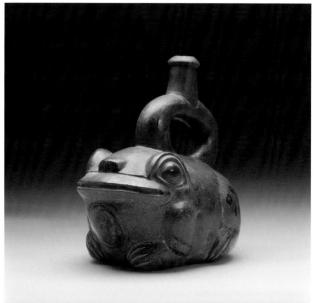

Moche

188. Frog Effigy Vessel
Early Moche (Vicús/Piura),
400 BC–AD 100
Slip-painted, burnished ceramic
14 x 9.5 x 2.5 cm
2006.070.387 (C-507)

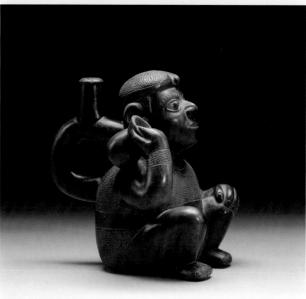

**189. Stirrup-Spout
Water Carrier Effigy Vessel**
Moche I, 400 BC–AD 100
Burnished brown ceramic
17 x 14.5 x 6 cm
2006.070.388 (C-509)

The coloration and surface
treatment of this vessel suggest
the transition between Chavin
and Moche.[4]

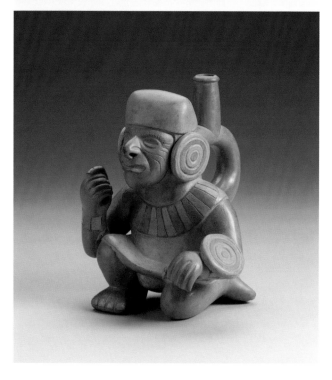

190. Kneeling Warrior Effigy Vessel
400 BC–AD 100
Burnished and incised
redware ceramic
17.5 x 14 x 14.5 cm
2006.070.389 (C-509)

[4] Other similar Early Moche bottles are pictured on
pages 92 and 332 in Makowski et al. (1994).

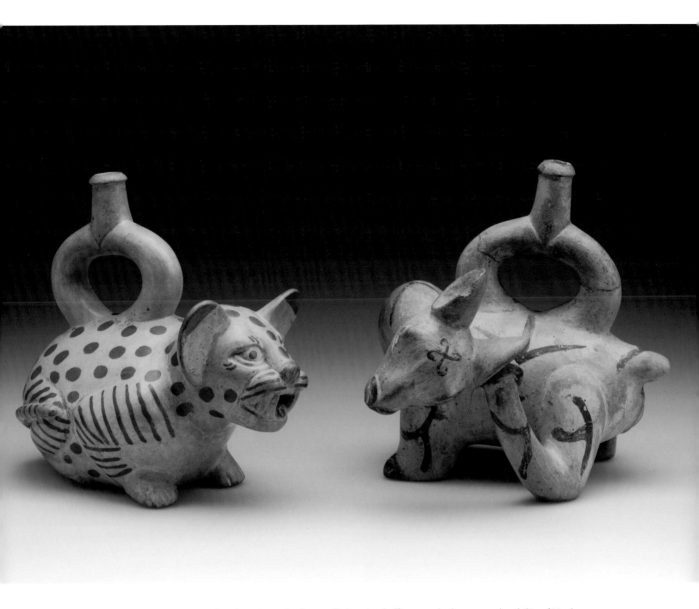

**191. Spotted Feline
Effigy Vessel**
Moche I, 400 BC–AD 100
Slip-painted, burnished
ceramic
16.2 x 18 x 9 cm
2006.070.390 (C-510)

192. Deer Effigy Vessel
Moche I, 400 BC–AD 100
Slip-painted, burnished
ceramic
17 x 14.5 x 15 cm
2006.070.391 (C-511)

This charming pair of naturalistic animal effigy vessels showcases the ability of Moche potters to capture live action. The spotted patterning on the feline vessel indicates that it is more likely a jaguar, pampas cat, or ocelot *(Leopardus pardalis)* rather than a puma. It is most consistent with being an ocelot, since the tops of the ocelot's ears have similar dark pigmentation, and ocelot spots can run into chain-like patterns of stripes, as depicted here. The modern range of the ocelot does not include the coastal Moche area; however, ocelots still live in the adjacent highlands. Deer hunting scenes are common on Moche ceramics; many bones of the North Andean deer *(Hippocamelus bisulcus)* are found in Moche sites, indicating that deer were plentiful along the north coast of Peru during the Early Intermediate Period.[5] The beveled ring at the top of the stirrup spouts of these two vessels identifies them as Moche I, the earliest of the five phases of Moche. However, in the northern valley of Piura, associated with the site of Vicús, this spout form lasted longer. It is believed that this northern valley was home to people of more Ecuadorian culture, but was colonized from the south by Moche overlords. The modeling and painting of these vessels may be more consistent with Moche III in the heartland.

[5] See page 132 in Lavalle (1985) for a Moche II llama in a similar pose with nearly identical painted cruciform markings. Camelids and deer were often depicted in similar postures; see the deer and llama effigy vessels on pages 130–132.

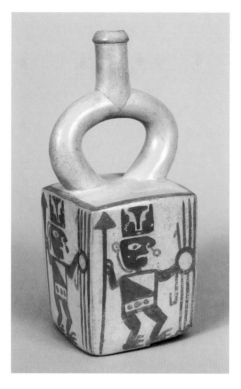

193. Square Stirrup-Spout Bottle
Moche I, 400 BC–AD 100
Slip-painted, burnished ceramic
18 x 7.2 cm
2006.070.392 (C-512)

The warrior figures depicted on this bottle hold pointed spears in their right hands and round objects with stripes (possibly shields or quipus) in their left hands. If the objects held in the figures' left hands are indeed quipus, the mnemonic device of knotted strings used in accounting and record-keeping in the non-literate Andean cultures, then they may represent the "quipu-camayoq," or master of record-keeping, known from the ethnohistoric record at the time of the Spanish Conquest. "Quipu-camayoqs" were accorded great respect because their knowledge was both specialized and vital to government operations.

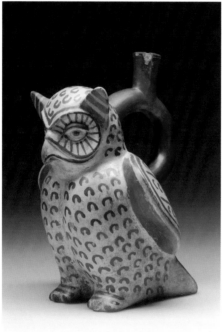

194. Owl Effigy Bottle
Moche II, AD 0–200
Slip-painted, burnished ceramic
23 x 15 x 13 cm
2006.070.393 (C-513)

This vessel may represent either the Great Horned Owl *(Bubo virginianus)* or the similar-looking Magellanic Owl *(Bubo magellanicus)*. Both owls are native to the north coast of Peru or adjacent highland areas and thus may have been encountered by the Moche.

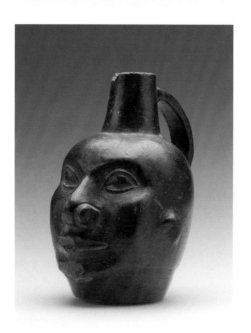

196. Portrait Bottle
Moche V, AD 600–750
Burnished ceramic
14 x 9.5 x 10
C-529

This bottle, with a single-spout and loop handle, was originally attributed to Cajamarca. No examples of portrait bottles are published from that north highland department. The facial features are characteristic of Moche V examples,[7] all of which come from the northern coastal valleys, but the spout and handle are more typical of Vicús-style bottles.

[7] Donnan 1992.

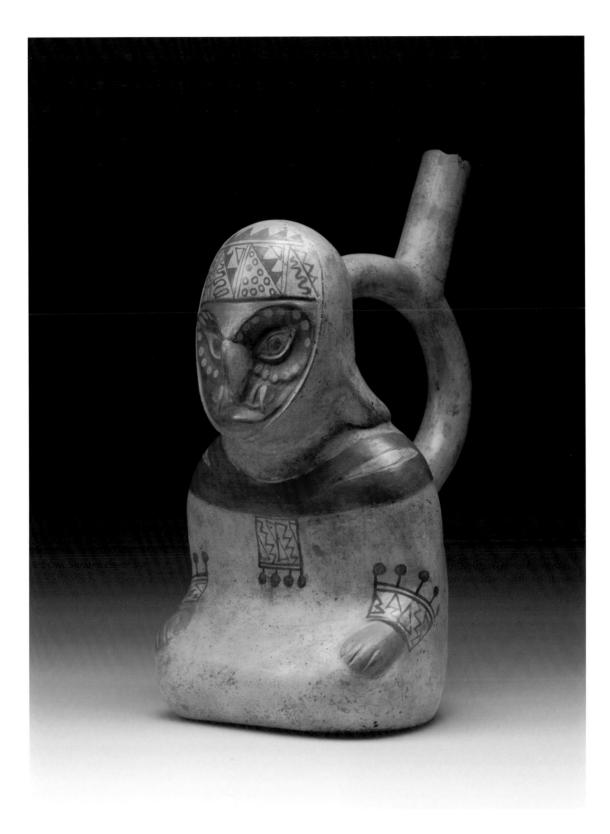

195. Owl Shaman Effigy Jar
Moche IV, Moche-Chicama Valleys,
AD 200–500
Slip-painted, burnished ceramic
25 x 13.5 x 17 cm
2006.070.394 (C-514)

This effigy vessel is in the form of the Moche shaman Owl Priest, with an owl-shaped face and fanged feline mouth. The figure wears a headdress decorated with a patterned geometric headband under a plain cover. The heavy white long clothing that covers the upper arms and crossed legs is characteristic of priests. Two solid red bands are painted around the shoulders, extending down the back, possibly representing a cloak or binding.[6] The shape of the stirrup spout is classic Moche IV, and thus places it chronologically at the end of the Early Intermediate Period.

[6] A very similar vessel with owl priest iconography is illustrated in Campana (1994: 59), with no documentation save the name of the photographer, Wilfredo Loayza.

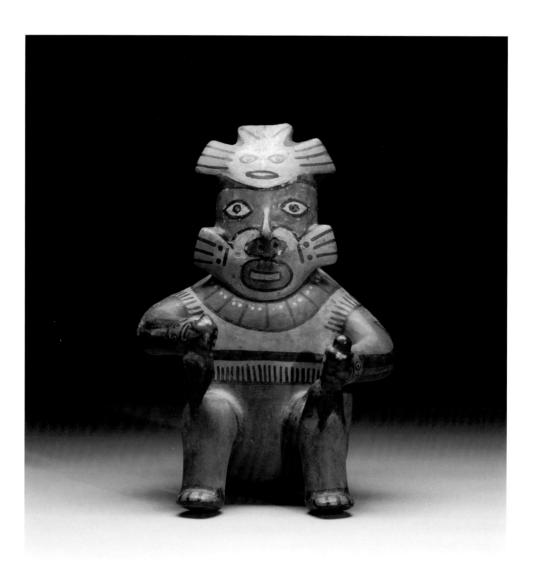

Nasca/Nazca

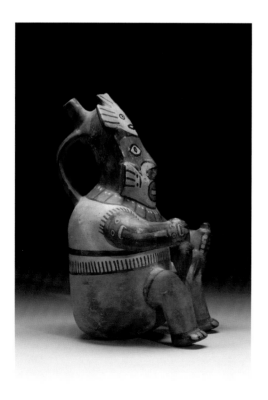

197. MYTHICAL BEING EFFIGY VESSEL
AD 0–300
Slip-painted, burnished ceramic
with polychrome decoration
20.5 x 14 x 11.5 cm
2006.070.398 (C-519)

This type of being is often referred to as an agricultural deity because of the crop plants in its hands, but is also known as a cat god or demon because of its whiskered feline face. More upswept whiskers may depict otter-cat deities, while side-extending whiskers such as the one on this vessel may be more typical of the trophy head cult monkey deity. Similar two-dimensional beings are frequent subjects in contemporary textiles and vessels of other shapes such as bowls and cups. The multiple-point object on the figure's left knee is probably manioc or *yuca (Manihot eculenta),* the starchy root crop from which we get tapioca; eaten boiled in soups, *yuca* is still a common food in Peru. The figure wears a headdress or hat with a second whiskered face, a short tunic, and collar-like necklace; pictures of (body painting, tattoos, textile motif, or actual) trophy heads are located on the arms. All nineteen known examples of similar anthropomorphic mythical being vessels date from Nasca Phases I through III.[8]

[8] See page 78 in Proulx (2006) for a comparable vessel.

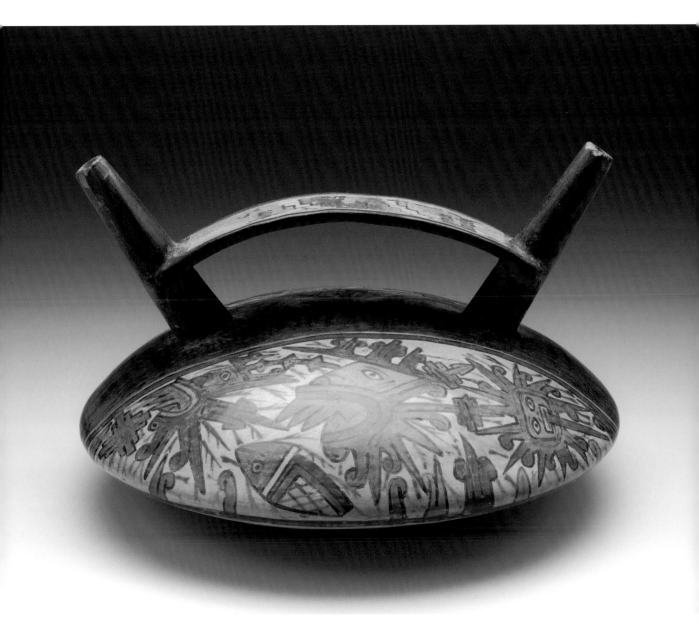

**198. Double Spout
and Bridge Vessel**
Nasca, AD 300–600
Slip-painted, burnished ceramic
with polychrome decoration
12 x 21 cm
C-522

This lenticular (lens-shaped) vessel shows a sharp carination at the shoulder. It is decorated with fish and floating marine monster heads in shades of red, orange, burgundy and gray on a cream ground. The tapered, flaring double spouts are connected by a strap handle painted with geometric motifs. Such spouts, combined with the "proliferous" painting style, may indicate a very late date, around AD 600.[9]

[9] A nearly identical vessel, pictured on page 209 of Cáceres Macedo (2005), is attributed to Nasca Phase III.

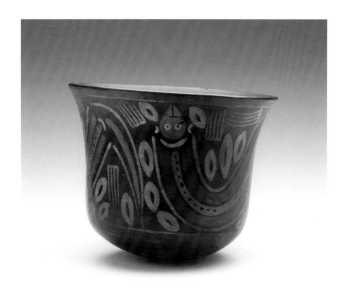

199. Cup with Lizard Design
Nasca Phase III, AD 100–400
Ceramic with polychrome
decoration
12.5 x 16 cm
C-523

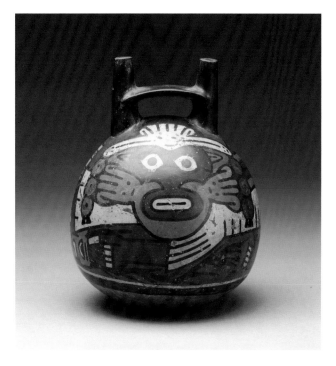

200. Double-Spouted Bottle
Middle Nasca, AD 100–500
Burnished ceramic with
polychrome decoration
15 x 12 cm
2006.070.399 (C-520)

The mythical being on this bottle
has a serpentine body with feline
attributes and trophy heads.

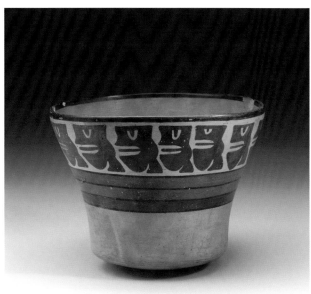

201. Cup with Trophy Heads
Nasca Phase III, AD 100–400
Burnished ceramic with
polychrome decoration
11 x 14.3 cm
2006.070.400 (C-521)

Trophy heads—the heads of foes
vanquished in battle—are com-
mon subjects in Nasca art, and
often appear on pottery vessels. At
some Nasca sites, archaeologists
have found mummified heads with
holes bored in the foreheads for
stringing on ropes.

202. BOWL WITH ANCHOVIES
Nasca Phase III, AD 100–400
Burnished ceramic with
polychrome decoration
11 x 14 x 11.4 cm
2006.070.401 (C-524)

This Nasca bowl is decorated on the exterior with vertical rows of realistic fish painted in gray on a band of dark brown, bordered by bands of red, on an orange ground. The Nasca were a coastal people, and fish were an important part of their diet. Proulx claims that these are anchovies, *Engraulis ringens*, an important part of both past and present diets in this area. Anchovies are abundant and easily caught from the coast with simple equipment, and were frequently dried, ground, and stored in the past just as today, when they form the basis of the fishmeal industry along the coast of Peru.

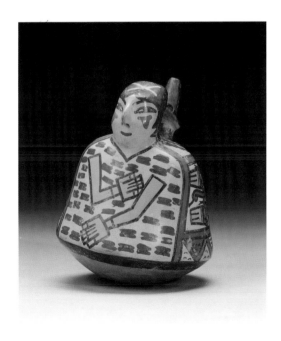

203. BRIDGE-SPOUTED VESSEL
Late Nasca, AD 200–600
Burnished ceramic with
polychrome decoration
10.5 x 9 cm
2006.070.402 (C-525)

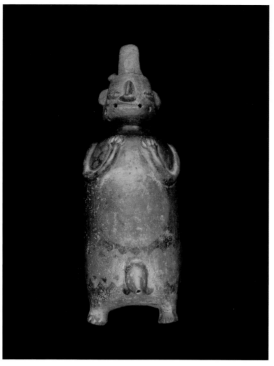

Vicús

204. HUMAN EFFIGY JAR
AD 100–400
Burnished redware ceramic
with resist decoration
24 x 8.3 x 7 cm
2006.070.395 (C-515)

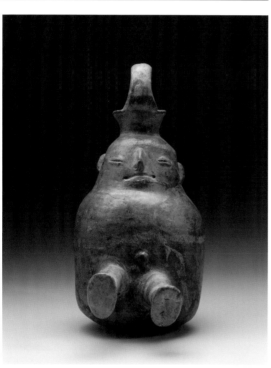

205. FACE-NECK JAR WITH LEGS[10]
AD 100–400
Burnished redware ceramic
with resist decoration
24.5 x 12.3 x 5 cm
2006.070.396 (516)

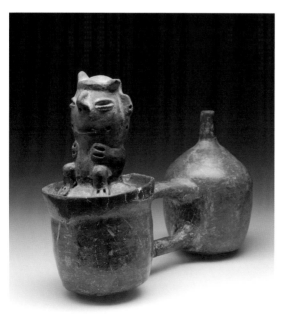

206. DOUBLE-CHAMBERED
WHISTLING BOTTLE[11]
AD 100–400
Burnished redware ceramic
with resist decoration
18 x 12.5 x 9 cm
2006.070.397 (C-517)

[10] For a comparable vessel, see page 105 in *Vicús: Colección Arqueológica*, Museo Banco Central de Reserva del Peru (1987).

[11] Comparable vessels are pictured on pages 64–66 in Makowski et al. (1994).

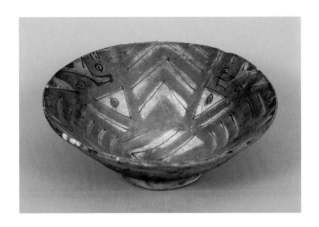

Cajamarca

207. SHALLOW FOOTED BOWL
AD 300–1400
Slip-painted, burnished ceramic
with polychrome decoration
5 x 17 cm
2006.070.409 (C-534)

Wari

208. QUERO (CUP)
AD 600–900
Slip-painted redware
ceramic with
polychrome decoration
11.5 x 12.3 x 13.2 cm
2006.070.418 (C-549)

This is a Wari (or Huari) cup in the classic beaker shape (*quero* or *kero*). The cup has three panels containing anthropomorphic figures circling the vessel exterior. The objects between the human figures may be plants, possibly corn or maize. Whatever is growing on the "plants" is also found around each of the human figures and on each figure's headdress; these figures thus may represent a maize or corn deity. Maize was highly prized as a foodstuff as well as the primary ingredient in the brewing of chicha (maize beer).

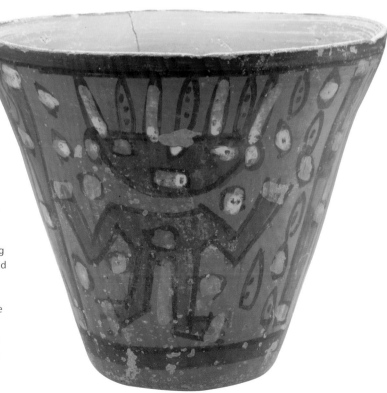

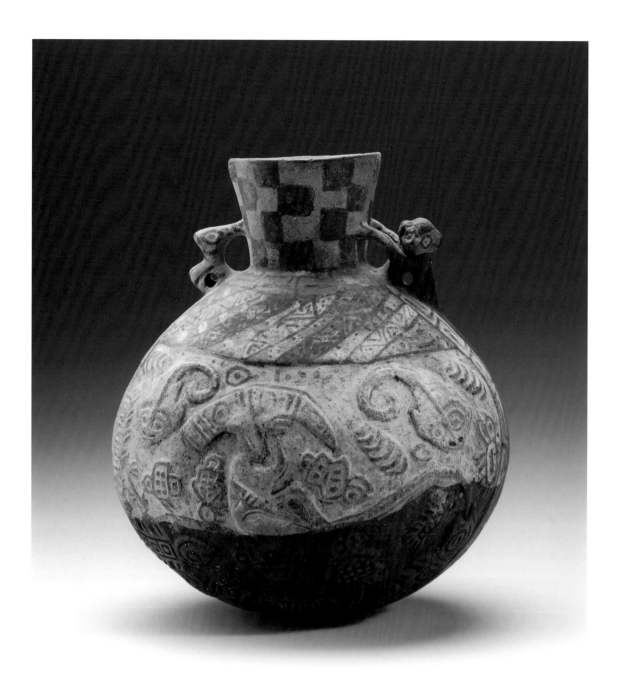

Huaylas/Santa

209. GLOBULAR JAR WITH FISHING SCENE
AD 600–1000
Ceramic with polychrome decoration
20.5 x 16.5 x 7.2 cm
2006.070.405 (C-528)

This jar has a round body with flaring spout and two small zoomorphic handles (one bird, one monkey) connecting the spout base to the vessel shoulder. It features a fishing scene depicted in raised relief; the upper half of the vessel has figures outlined in black on a white ground, while the bottom half of the vessel is painted black with sea creatures. The spout is painted in a reddish-brown and white checkerboard; a band of diagonal polychrome stripes lies below the vessel neck, just above the fishing scene.

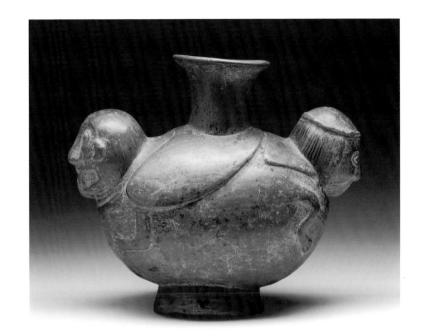

Sicán

210. Two-headed Effigy Vessel
AD 950–1375
Slip-painted, burnished ceramic
22 x 23.5 cm
2006.070.414 (C-539)

Chimú

**211. Stirrup Spout Vessel
with Deer Hunter**
AD 1200–1470
Burnished blackware ceramic
21.7 x 11 x 15 cm
2006.070.406 (C-531)

**212. Stirrup Spout Vessel
with Deer Hunter**
AD 1200–1470
Burnished blackware ceramic
20 x 11.5 x 14 cm
2006.070.407 (C-532)

These vessels may depict deer
hunters or men about to make
a sacrificial offering of a young
domesticated llama. It can be dif-
ficult to determine whether a given
animal represents a llama or a deer,
and it is possible that the two ani-
mals on these vessels, which differ
markedly in ear and nose shape,
are not the same species.[12] There
is a third vessel (80.064.001) of the
same type in the Johnson Museum
collection.

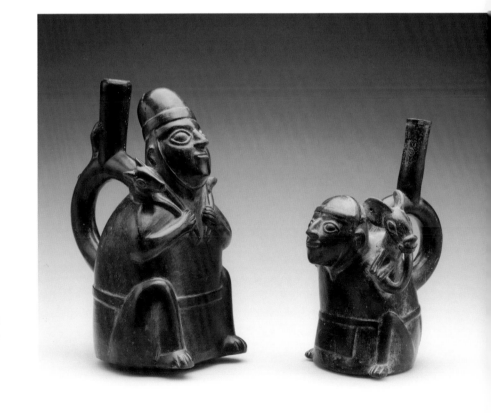

[12] Bruhns (1994) refers to a similar figure
(page 304) as "a man carrying a deer
on his back," while Martinez (1986)
describes vessels 757 and 758 (page
453) as carrying an animal, possibly a
camelid.

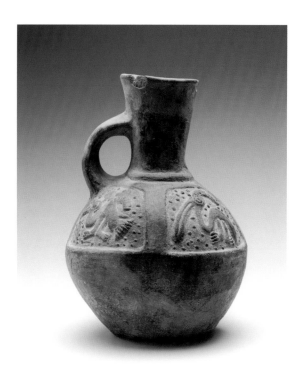

213. JAR WITH BIRD MOTIFS
AD 1200–1470
Burnished blackware ceramic
21 x 15.5 cm
2006.070.408 (C-533)

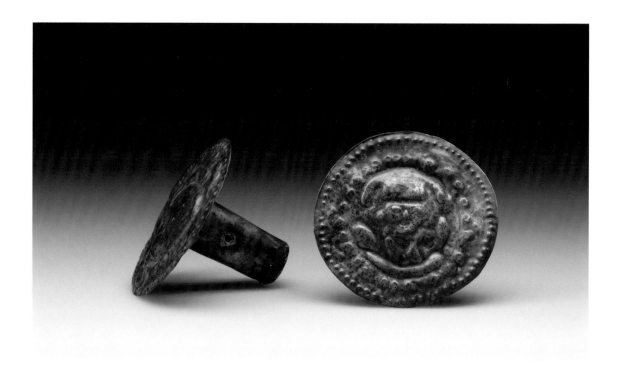

214–215. PAIR OF EAR SPOOLS
AD 950–1375
Silver
6.5 x 4 cm
2006.070.416 (C-541)
6.5 x 5 cm
2006.070.417 (C-542)

¹³ Background in Campana
 1994: opp. xvi.

This matched pair of silver ear spools once adorned the earlobes of a nobleman of the Chimor Empire. By wearing ever-larger ear plugs, ear lobes can be stretched out to accommodate large, thick posts such as the ones on these ear spools; at the time of the Spanish Conquest, high-status individuals were referred to as *orejones* (literally, "big eared ones"). The front disk of each earspool is embossed with a hammered repoussé image of a human figure in a small, crescent-shaped boat flanked by two fish, probably similar to modern boats made from bundled totora reeds. The figure sits with small flexed legs, with his head turned looking straight out at us, and he wears a large crescent headdress. Such crescents were worn by leaders beginning during the Moche culture, where the retainers of the Lord of Sipán wore them.[13] They then continue in the Sicán culture and emerge as signifiers of spiritual men (gods or deceased) in Chimú.

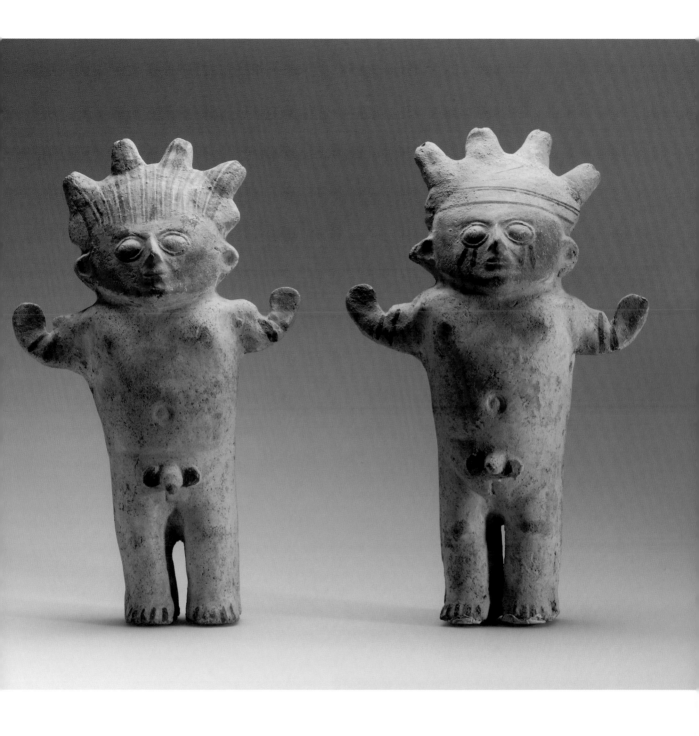

Chancay

216. STANDING "CUCHIMILCO" FIGURE
AD 1200–1470
Ceramic with polychrome
decoration
33 x 19.5 x 8 cm
2006.070.410 (C-535)

217. STANDING "CUCHIMILCO" FIGURE
AD 1200–1470
Ceramic with polychrome
decoration
33 x 20.5 x 8.5 cm
2006.070.411 (C-536)

This pair of figures were apparently made from the same mold. As in many Ecuadorian mold-made figures, no mold was used to form the backs of the figures. The highly colored sets of figures in Chancay are indicative of earlier works, whereas the plain, quickly painted black on white slipped figures are late. Each of these hollow ceramic Chancay figures stands with arms outstretched and palms held out in the "Cuchimilco" pose frequently found in female figures.[14] Each figure is naked except for a crested headdress and bracelets, and has small breasts and both male and female genitalia, suggesting that the figures may be hermaphrodites.

[14] Cáceres Macedo 2005.

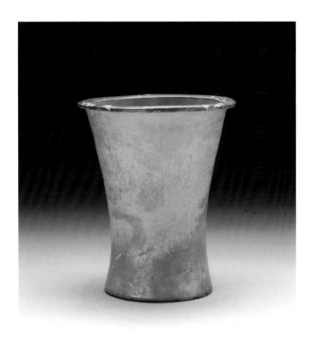

Inca/Provincial Inca

218. *QUERO* (**CUP**)
AD 1300–1532
Slip-painted, burnished ceramic
13.5 x 11.5 x 7.5 cm
2006.070.045 (C-058)

The color and shape of this *quero* are typical of Inca ceramics. The beaker shape became very common in the Andes during the Middle Horizon and extended into Inca times. This beaker is Provincial Inca, found in Ecuador.

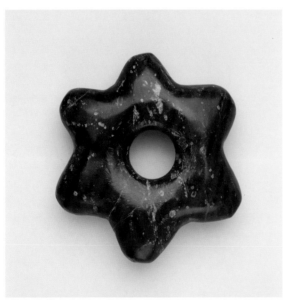

219. SIX-POINTED MACE HEAD
AD 1400–1550
Jadeite stone
10.5 x 2.5 cm
2006.070.376 (C-440)

This mace head is from Chimborazo Province, Ecuador. It has a central hole for hafting to a handle. Its weight would have made this stone an effective weapon when swung with force at an opponent, but its careful carving from highly valued jadeite may indicate that this item served a ceremonial purpose.

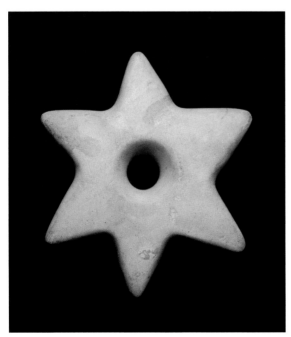

220. SIX-POINTED MACE HEAD
AD 1400–1532
Stone
14 x 3 cm
C-484

This mace head is probably Provincial Inca from Cañar Province, Ecuador. When hafted on a stout wooden shaft, this stone mace would have been a formidable weapon.

221. Semilunar "Tumi" Knife
AD 1400–1532
Stone
5 x 10.5 x 2.5 cm
2006.070.200 (C-249)

222. Ceremonial "Tumi" Knife
AD 1400–1532
Copper alloy
11.5 x 11.5 cm
2006.070.415 (C-540)

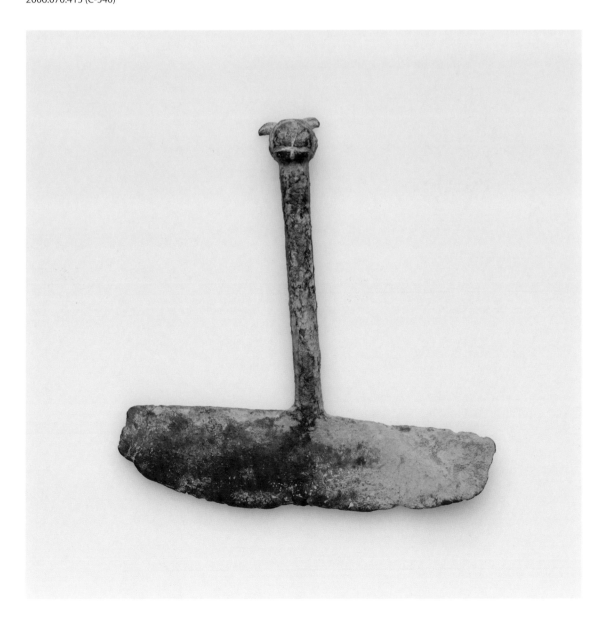

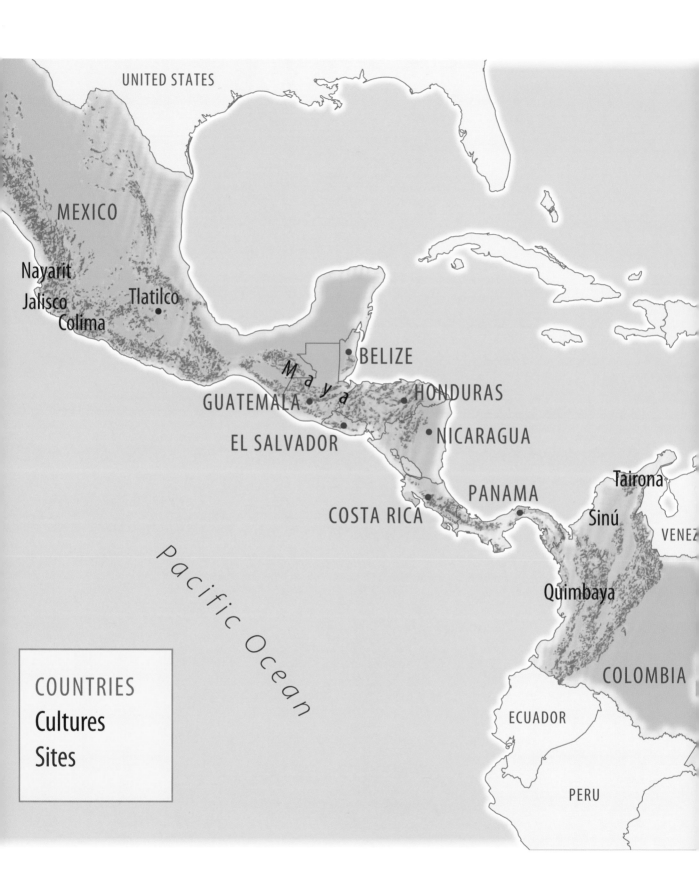

UNITED STATES

MEXICO

Nayarit

Jalisco

Colima

Tlatilco

Maya

GUATEMALA

BELIZE

HONDURAS

EL SALVADOR

NICARAGUA

Tairona

PANAMA

Sinú

VENEZ

COSTA RICA

Quimbaya

COLOMBIA

ECUADOR

PERU

Pacific Ocean

COUNTRIES
Cultures
Sites

COLOMBIA

Ilama

223. ALCARRAZA
Calima, Cauca Valley,
1500 BC–AD 100
Incised redware ceramic
15.5 x 14 cm
2006.070.178 (C-219)

This piece is attributed to La Chimba, a Late Formative site in the north highlands of Imbabura province, contemporary with Chorrera and Ilama. If so, it is probably a trade piece from Colombia.

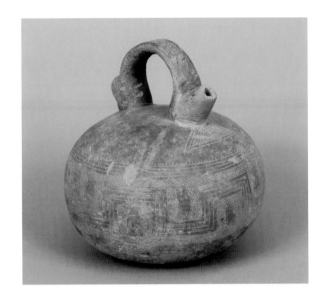

224. DOUBLE-FACED *TUMBAGA* MEDALLION
Late Ilama or Malagana,
Cauca River Valley,
300 BC–AD 500
Gold-copper alloy
9.5 x 8.5 x 4 cm
C-469

The simplicity of the face in this hinged double medallion makes this piece very different from the four pieces from La Tolita (cats. 102–105), to which it had been previously attributed. The newly discovered large, flat burial masks of Malagana share many features, such as perfectly round eyes and squared mouth. The Malagana cultural group includes large pincers or tongs as an artifact class, of which, because it is hinged, this piece may be a variant.[1] Trade in gold among the different cultural groups in southwestern Colombia and adjoining northern Ecuador produced many shared features, even while the ceramics are different.

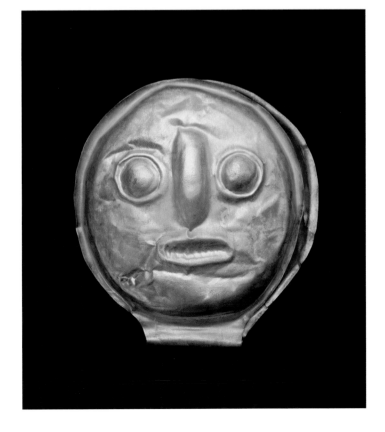

[1] See Labbé 1998: 160, 180.

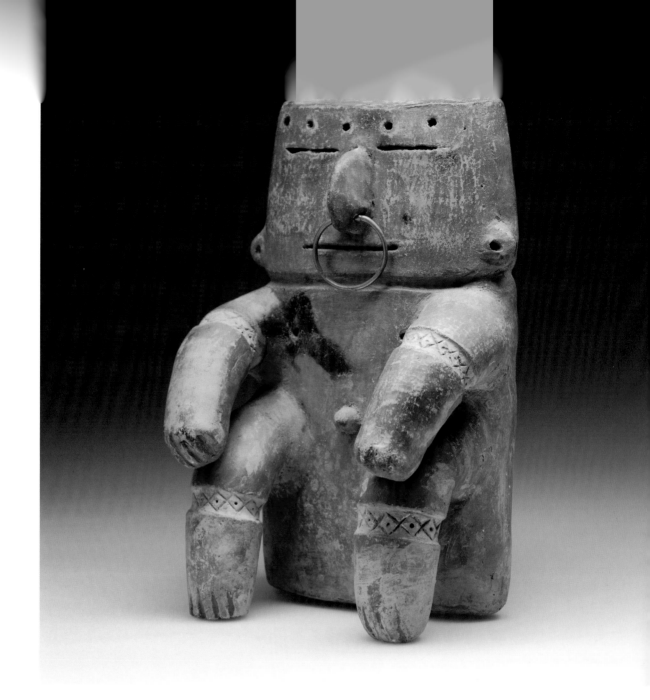

Quimbaya

225. Seated "Slab" Figure
Middle Cauca Valley,
AD 1050–1400
Slip-painted, incised ceramic
22 x 15 x 11 cm
2006.070.431 (C-610)

This seated male figure shows white incised bands on his arms and legs; such ligatures of threaded beads are worn by present-day forest men above their elbows and below their knees. The crosshatched diamond pattern in this figure's bands may be intended to indicate ligatures of this type. The figure's high modeled, hooked nose is pierced, through which is inserted a gold alloy *(tumbaga)* nose ring. Holes pierced along the upper border of his forehead are believed to be for the insertion of feathers, a typical tropical forest adornment.

These visual connections with tropical forest people are not coincidental. There is good evidence that Carib-speaking people from the eastern lowlands invaded the Cauca valley in the eleventh century,[2] pushing out previous people responsible for the Classic Quimbaya style (as exemplified by cat. 226). This strongly stylized "slab" figure is very different from the far more naturalistic modeling of Classic Quimbaya. Its use of incision and punctuation is characteristic of Amazonian archaeology of the later period.

Figures like this were placed in the tombs of tribal leaders along with food vessels for the deceased. As a mark of spiritual leadership, a bench was also placed in the tomb. Labbé interprets the bottom of the body slab in this kind of figure to be an abstraction of the bench,[3] since the legs arch out from the slab at a point above the bottom. The closed eyes of the figure would therefore be closed in a trance of a shaman, psychologically leaving his body to fly to the spirit world.[4]

[2] Labbé 1986: 83–4.

[3] Labbé 1998: 36–9.

[4] Similar figures are pictured in Bruhns (1994) on the cover and on page 275.

226. MINIATURE WARRIOR FIGURINE
AD 500–1000
Gold-copper alloy
3.5 x 1.5 x 1.5 cm
C-470

This intricately worked warrior who carries an elaborately hafted axe and a fan was made by the lost-wax casting method. This piece shares many features with the Classic Treasure of the Quimbayas, now in Madrid. Three gold "pins," from this treasure—really dipper sticks for the lime used in chewing coca—feature tiny figures like this one that hold similar conical items. Unlike the Quimbaya men, who wear abstract masks, the facial features of this figurine seem more like figurines of the Quimbayoid tradition[5] that spread north from southwestern Colombia during the first millennium AD up to the Sinú and Urubá regions near the Caribbean and even (by trade) on into Lower Central America.

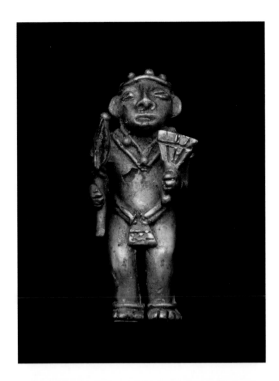

227. SPINDLE-WHORL
AD 600–1500
Burnished, incised ceramic
2.3 x 4.8 cm
2006.070.254 (C-304)

The delicate incisions on the top of this spindle whorl may represent stylized owls. Spindle whorls were the weights used on drop spindles to spin thread. After spinning, the thread was used in weaving textiles for clothing, blankets, bags and other items. Quimbaya whorls are much larger than Manteño ones (cat. 130), although they are also decorated with incised geometric designs.

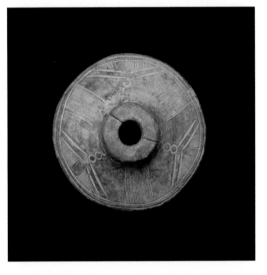

228. *QUERO* (CUP)
Caldas, middle Cauca Valley,
AD 1250–1500
Burnished ceramic with
polychrome decoration
15.5 x 14.7 cm
2006.070.432 (C-611)

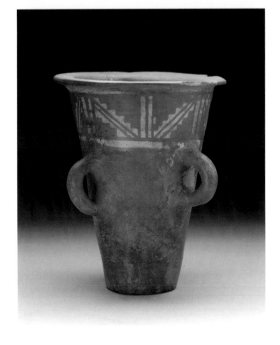

5 See Labbé 1998: 112, #90.

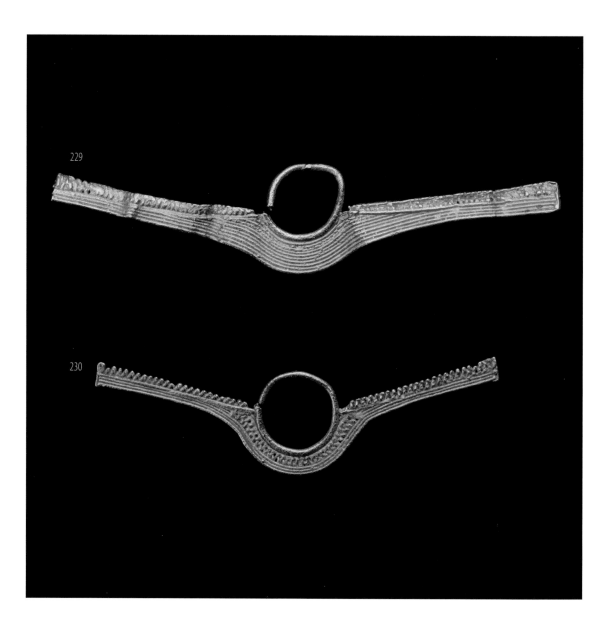

229

230

Sinú

229. "Bat Wing" *Tumbaga*
Earring or Nose Ring
AD 900–1500
Gold-copper alloy
6.7 x 1.4 cm
2006.070.439 (C-628)

230. "Bat Wing" *Tumbaga*
Earring or Nose Ring
AD 900–1500
Gold-copper alloy
5.3 x 1.3 cm
2006.070.440 (C-629)

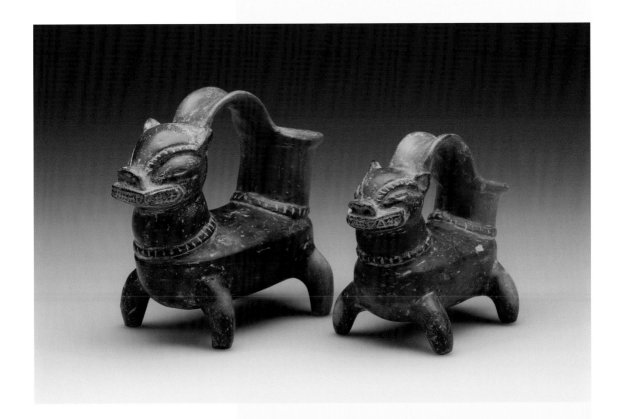

Tairona

231. ANIMAL EFFIGY VESSEL
AD 1250–1500
Slip-painted, burnished
redware ceramic
13 x 12 x 7 cm
C-237

232. ANIMAL EFFIGY VESSEL
AD 1250–1500
Slip-painted, burnished
redware ceramic
10.5 x 10 x 7 cm
C-238

These burnished redware Tairona animal effigy vessels form a pair, one larger, one smaller. The animal in both cases is a quadruped, with erect, pointed ears and a muzzle filled with sharp teeth. A strap handle connects the animal's head with the vessel spout, located above the hindquarters. The spout and handle are painted a lighter orange-red, while the balance of the animal body is painted brown. A similar brownware animal vessel with only the animal head as an effigy is interpreted as an opossum; of it, Labbé writes: "The Kurcha lineage of the Kogi Indians, who inhabit the Tairona region today, associate the opossum with twins and fertility."[6]

[6] Labbé 1986: #156 left.

animals

Zoomorphic (animal) motifs were commonly employed on a wide range of pre-Columbian artifacts, including pottery, textiles, and metalwork. Pre-Columbian works of art depict both wild and domesticated animals, creatures commonly encountered in everyday life, and creatures found rarely—or not at all—in the natural world. Aspects of many different animals can be found in pre-Columbian art, often mixed with human attributes in what may appear to us to be startling and fantastic combinations. Many works of art feature animals such as the great cats (jaguars or pumas), which held great spiritual power, and were key elements of many pre-Columbian religious traditions.

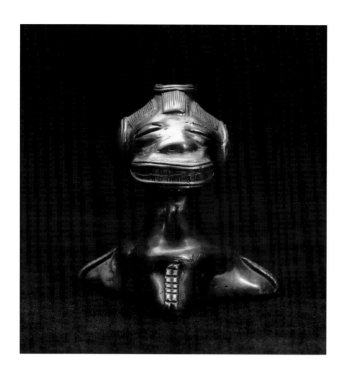

233. ANTHROPOMORPHIC
***TUMBAGA* AMULET**
AD 1000–1550
Gold-copper alloy
5 x 4.8 x 3.5 cm
2006.070.442 (C-631)

234. WINGED AMULET
(*PENDIENTE ALADO*)
Santa Marta,
AD 1250–1500
Stone
13 x 5 x 0.5 cm
2006.070.444 (C-633)

Pendants like this one are
thought to represent bats.

235. *TUMBAGA* EARRING
AD 1200–1500
Gold-copper alloy
6 x 7 x 2.5 cm
2006.070.438 (C-627)

This very large Tairona earring
was formed from a thin sheet of
hammered metal, which was rolled
and bent into the crescent shape
favored by this culture. One end
still has its original rounded end
cap, which would have prevented
the sharp metal from hurting the
wearer's ear. Originally it would
have been one of a pair of matched
earrings, very similar in shape
to nose rings used throughout
the region.

PANAMA

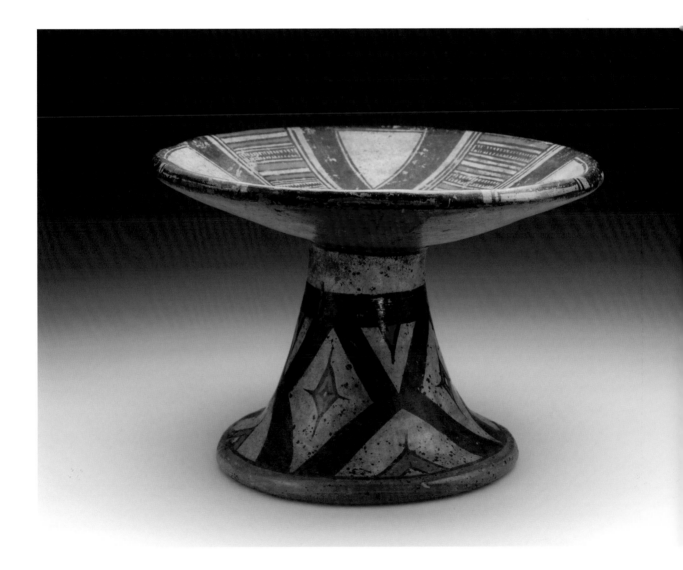

Coclé

**236. PEDESTAL PLATE OR
SHALLOW BOWL**
Coclé, Veraguas, AD 800–1100
Burnished ceramic with
polychrome decoration
16 x 24 cm
C-613

The angularity and *horror vacui* of this work place it chronologically in the Macaracas style of Late Coclé culture, dating AD 800–1100. The Coclé culture was situated near the Río Santa Marta, and was the source of river gold which was traded to Colombia in exchange for emeralds and copper. These Chibchan-speaking Indians in Central Panama were organized into a series of chiefdoms with hereditary rank; they performed elaborate burials of high-ranking individuals accompanied by many retainers and an abundance of gold grave goods or offerings of elaborate polychrome pottery.

COSTA RICA

El Bosque

237. SNUFF TUBE OR PIPE
AD 0–500
Slip-painted, burnished ceramic
17.5 x 3.3 x 2.5 cm
2006.070.437 (C-618)

This snuff tube in the shape of a
stylized bird would have been
used to inhale tobacco snuff or
hallucinogens.

Guanacaste-Nicoya

238. MINIATURE TURTLE VESSEL
AD 300–500
Slip-painted, burnished,
incised redware ceramic
9 x 6.5 x 3.5 cm
2006.070.223 (C-273)

This vessel and its decoration are
diagnostic of Incised Redware of
Early Polychrome A.[7]

[7] See Stone 1972: 49–50.

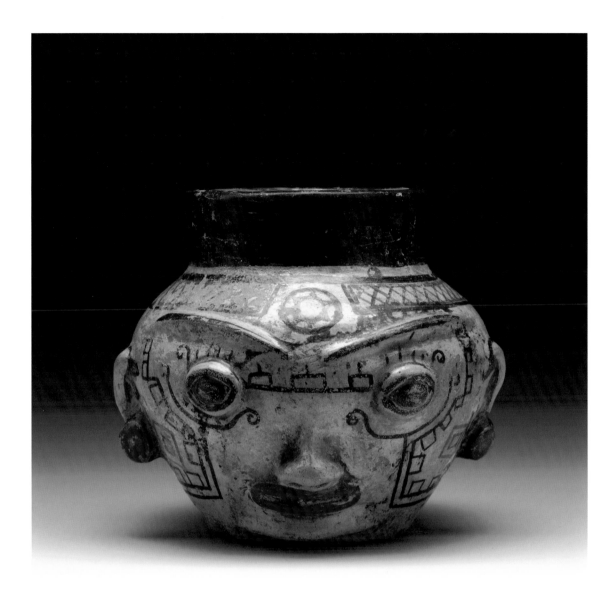

239. Face Jar
AD 500–800
Burnished ceramic with
polychrome decoration
11 x 12 x 8.2 cm
C-614

Galo Polychrome, the type of ceramic represented by this brilliantly decorated female face jar, is identified by Snarskis as "perhaps the finest ceramics from the period circa AD 500–800. Their mirror-bright burnished surfaces are technically unsurpassed by any pre-Columbian pottery, and the yellows, reds, oranges, creams, maroons, and blacks of their polychrome decoration are impressively vivid."[8] In particular, a seated female figure[9] has a face very similar in decoration and proportion to the present piece. On another, vertical lines passing through the eyes, as in the Carroll piece, are believed to be made with a cylinder seal. Cylinder seals are common in Costa Rica, as they are in Ecuador.

Face jars sometimes represent trophy heads, but in the case of Galo Polychrome vessels, almost all represent women. However, despite their liveliness and bright eyes of this example, such vessels tend to be idealized images, not portraits in the strict sense. Note that this individual has small red earplugs, certainly a mark of status and honor certainly not accorded to beheaded enemies.

[8] Snarskis 1981: 31.

[9] Ibid., 192, #85.

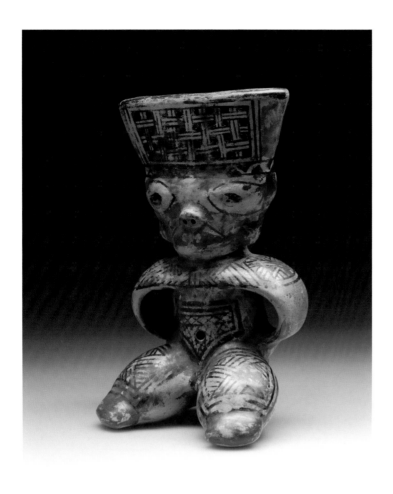

240. SEATED MALE FIGURE
AD 800–1400
Burnished ceramic with
polychrome decoration
19 x 11.5 x 3.5 cm
2006.070.434 (C-615)

The basketweave patterning
on the body and legs of this
figure may depict either clothing
or tattooing.

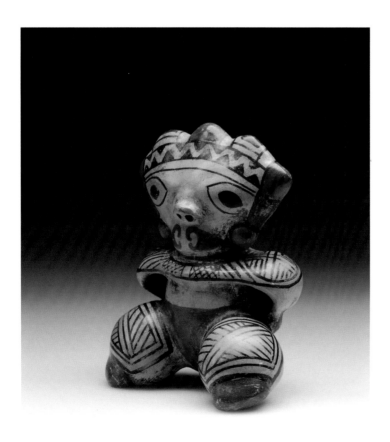

241. SEATED FIGURE
AD 700–1100
Burnished ceramic with
polychrome decoration
13 x 10 x 5 cm
2006.070.435 (C-616)

The basketweave patterning on the
figure's arms and legs may depict
either clothing or tattooing.

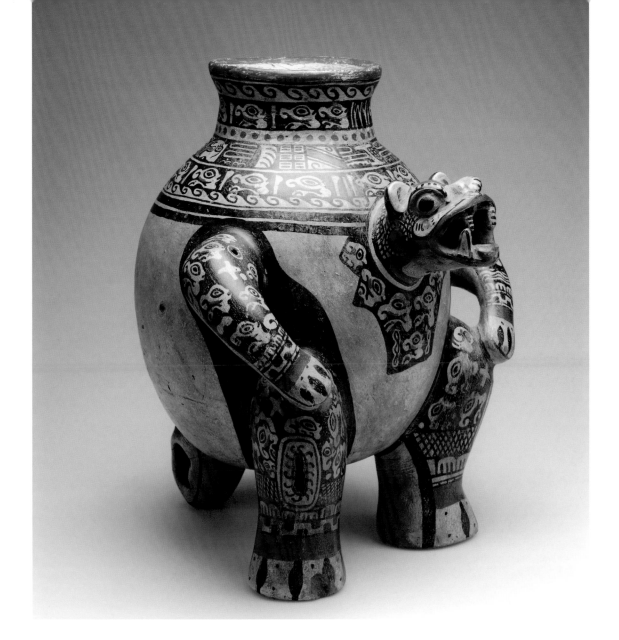

242. JAGUAR EFFIGY JAR
AD 1200–1400
Burnished ceramic with
polychrome decoration
34 x 27 x 29 cm
2006.070.436 (C-617)

This large, ornate Pataky Polychrome vessel was probably used to serve beverages such as beer or cacao (chocolate) on special occasions. The jaguar represents a sun-devouring Mesoamerican god; the smaller "silhouette-jaguars" on the arms, legs, tail/rear support, around the neck, and in the bands of upper decoration under the lip and circling the vessel shoulder may depict the stars revealed by approaching darkness. Rattles in the hollow legs are formed by clay balls.

Feline imagery is seen in a wide range of pre-Columbian artifacts, including pottery, textiles, metalwork, and even in site planning; for example, the archaeological ruins on the slopes of Mount Sangay, Ecuador, consist of tolas mounds arranged in the shape of a jaguar. Jaguars are the largest and strongest spotted cats in the Americas, and have had a profound influence on prehistoric art. Because jaguars are equally at home in trees and on land, they are seen as mediators between ground-dwelling humans and the divine; deities communicate to the world of mortal men through the jaguar. Both studies of modern people and writings from shortly after the Spanish Conquest emphasize the close association of shamans with jaguar spirits and the recurrent themes of jaguars as procreators, sexual unions with jaguars, jaguar-men, and jaguar clans.

Stylistically these Pataky Polychrome effigy vessels share iconographic and formal elements of the Mixteca-Puebla style of Mesoamerica.[10] This is not surprising, since the ethnic group living in the Nicoya Peninsula at the time of Spanish Conquest was the Chorotega, linguistically related to the Mixtec. It is believed they migrated there beginning around AD 500, when Maya influence also begins. Continuing migration from Mesoamerica, including the Nicarao immediately to their north in the Rivas Department of Nicaragua, continued the Mesoamerican connection. This piece is very close stylistically, proportionally, and in scale to a vessel in the Instituto Nacional de Seguros, San José, Costa Rica.[11] Notable in both examples is the trapezoidal polychrome bib hanging down from the jaguar's face onto a pale buff chest and underbelly. Also, the legs of both vessels are demarcated from the belly area by thick black bands, isolating the "silhouette-jaguar" motif on the front half of the legs; another thick black line separates that polychrome section from the rear of the legs, that are again pale buff.

[10] Scott 1999: 105.
[11] Snarskis 1981: 197, #107.

UPPER CENTRAL AMERICA

Maya

243. DANCING FIGURE BOWL
Early Classic, Petén
area of Guatemala,
AD 450–550
Slip-painted, burnished
ceramic with polychrome
decoration
18.2 x 35 cm
2006.070.422 (C-601)

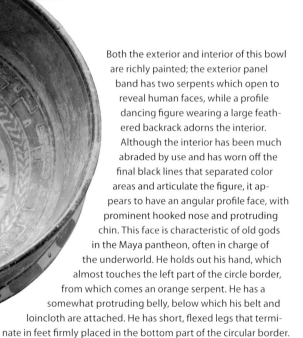

Both the exterior and interior of this bowl are richly painted; the exterior panel band has two serpents which open to reveal human faces, while a profile dancing figure wearing a large feathered backrack adorns the interior. Although the interior has been much abraded by use and has worn off the final black lines that separated color areas and articulate the figure, it appears to have an angular profile face, with prominent hooked nose and protruding chin. This face is characteristic of old gods in the Maya pantheon, often in charge of the underworld. He holds out his hand, which almost touches the left part of the circle border, from which comes an orange serpent. He has a somewhat protruding belly, below which his belt and loincloth are attached. He has short, flexed legs that terminate in feet firmly placed in the bottom part of the circular border.

Polychrome vessels like this one were used in major banquets, in which lords entertained each other, especially if one was a visiting dignitary. This would explain the wear on the inside bottom of the plate. These plates would have contained tamales covered with sauce, much as are found in Mexican cuisine today; the now missing lid, of a flattened conical shape with a large handle, would have kept the food warm. At the conclusion of the banquet, the honored guest would often be presented with the vessel as a keepsake. His heirs could then have it placed in his tomb upon his death, as a mark of his importance in life. These basal-flange bowls date to Tzakol 3, the final subperiod of the Early Classic, AD 450–550. Unfortunately, this plate, in common with most other plates, has no hieroglyphic writing to identify the personages involved.

244. HEAD FRAGMENT
Early Classic, Belize, AD 300–600
Ceramic with traces of
polychrome decoration
5.5 x 6 cm
2006.070.430 (C-609)

This fragment, whose stucco surface pre-
serves traces of blue paint, represents a
rain god, identified by the barbell coming
from the side of his mouth and the ring
around his eye. Its small scale suggests it
formed the front projected deity head of a
lidded cache bowl, one of a set often buried
in ceremonial centers.

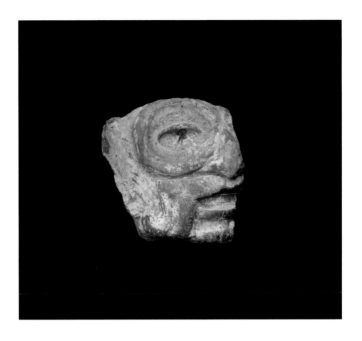

245. DUCK EFFIGY BOWL
Late Classic, Honduras/Nicaragua,
AD 500–800
Slip-painted, burnished ceramic
with polychrome decoration
6 x 13 cm
2006.070.423 (C-602)

The light buff ground color of this piece is
uncharacteristically light for a local poly-
chrome bowl from Honduras/Nicaragua, and
is more typical of colors found near the site
of Copán. The design on the bowl interior
above the tail is ladder-like and somewhat
like "bow tie" motifs found elsewhere. This
duck vessel is unusual in combining the
effigy form and polychrome painting. The
black framing around the red duck face,
combined with a circle and dot for the eye,
is very reminiscent of the way bird heads
are painted in local polychromes in the area
from the Sula Valley up the Chamelecón to
Copán (especially Chamelecón Polychrome).
Both the duck effigy form and the very light
ground color are consistent with an origin in
this area.

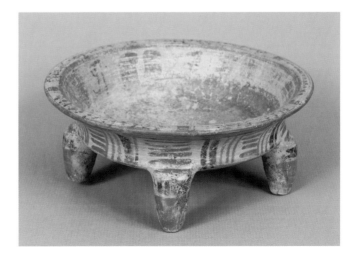

246. TETRAPOD BOWL
Late Classic, Honduras/Nicaragua,
AD 500–800
Slip-painted ceramic with
polychrome decoration
6.7 x 17 cm
2006.070.421 (C-600)

MEXICO

Tlatilco

247. FIGURINE BUST
1000–500 BC
Ceramic with traces of
polychrome decoration
7 x 2.4 x 2 cm
2006.070.221 (C-271)

Colima

248. STANDING MALE FIGURE
200–1 BC
Ceramic
20.5 x 9 x 2 cm
2006.070.427 (C-606)

The series of elaborate diamond-
pane incisions on the legs of this
figure may represent leggings
or leg-wraps fastened or held up
with cords.

Jalisco

249. STANDING FEMALE FIGURE
200–1 BC
Slip-painted, burnished ceramic
with resist decoration
49 x 24 x 9 cm
2006.070.424 (C-603)

This massively proportioned figure wears a skirt, hat with headband, nose ring, and earrings. The figure is decorated with burnished red slip paint over a buff ground. Fugitive lighter spots indicate that she once had negative black decoration, now largely rubbed off. The second firing required to produce the resist black was done at a low temperature over an already hard burnished surface, so it did not last. Like many indigenous women of the ancient Americas, she wears only a half-length wraparound skirt and is bare chested. Her facial features are pronounced, too, with a large chin and nose. Her pellet eyes are rubbed into her face; most figures of this type have just slit eyes. Only her arms are small in proportion; in this, the ceramist continued the Formative tradition of minimizing the arms.

The work was produced in the Jalisco border area with southwestern Nayarit. The heavy proportions and the red slip mark this as San Sebastián Red, the earliest of the major figure types of the area, according to the analysis by Stanley Long of a looted shaft-and-chamber tomb in Etzatlán, Jalisco, that had two different figurine styles, one San Sebastián Red, which was assigned the radiocarbon date of 130 BC.[12] Figures formed part of the elaborate grave goods of the shaft-and-chamber tombs of West Mexico, which are associated with leading families and were used like family vaults over a period of time. House compounds were placed above them. The fact that they were hidden at ground level and cut out of the stony ground to considerable depth has protected the contents, so that they seem very fresh and unbroken.

[12] Kan et al. 1970: 32.

250. Female "Sheep's Head" Figure
AD 50–200
Burnished ceramic with
polychrome decoration
28.5 x 14.3 x 8 cm
2006.070.425 (C-604)

This Tala-Tonalá style figure is seated in an animated pose with legs folded to one side. She is smiling, with her right arm on her abdomen and her left arm raised to her neck; the figure wears a skirt, ear spools, and hat or headband on the tall, elongated, axe-shaped head, with eyes widely spread. The placement of the eyes explains the nickname the style has been given, since the eyes are placed on opposite sides of the head like those of a sheep—even though domesticated sheep were only introduced to the New World following the Spanish Conquest.

A shallower tomb containing a solid figure of this type (Tomb 6) was excavated by Otto Schöndube and Javier Galván at the site of Tabachines, just north of Guadalajara.[13] The flattened, pigment-filled eyes correlate it to the later of the two styles found in Etzatlán, to the west (see cat. 249). Surprisingly, several other styles dating from the Protoclassic (Ameca, Colima) from west of that area also turned up in the Guadalajara excavations, so there was considerable trade. Dick Townsend prefers the term Tala-Tonalá to the rather unflattering "sheep's head," and he illustrates a seated female in very similar posture.[14] Her headdress includes not only the circular element of the Carroll piece but also a braided one of alternating color that is clearly intended to render twisted textile, which the ceramist has copied faithfully. Although the Carroll piece is not so brightly painted, it is far more graceful and even naturalistic in its depiction.

[13] Schöndube and Galván 1978: 151, fig. 20, #3.
[14] Anawalt 1998: 28, fig. 20.

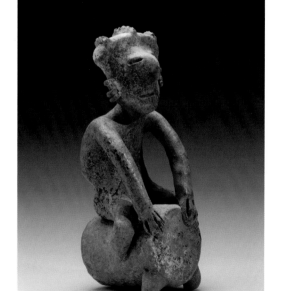

Nayarit

251. Seated Drummer Figure
200 BC–AD 300
Burnished redware ceramic
17 x 7.3 x 6.5 cm
2006.070.426 (C-605)

Bibliography

Anawalt, Patricia Rieff. "They Came to Trade Exquisite Things: Ancient West Mexican-Ecuadorian Contact." *Ancient West Mexico: Art and Archaeology of the Unknown Past*, edited by Richard Townsend. Chicago: Art Institute of Chicago, 1998.

Bákula B., Cecilia (1987) *Vicús: Colección Arqueológica*. Museo Banco Central de Reserva del Peru.

Bouchard, Jean-François and Pierre Usselmann. *Trois millénaires de civilization entre Colombie et Èquateur: La region de Tumaco La Tolita*. Paris: CNRS Èditions, 2003.

Bravomalo de Espinosa, Aurelia. *Ecuador ancestral*. Quito: Artes Gráficos Señal, 1992.

Bray, Warwick. *The Gold of El Dorado*. London: Times Newspapers Ltd., 1978.

Bruhns, Karen Olsen. *Ancient South America*. Cambridge University Press, 1994.

Burger, Richard L. *Chavin and the Origins of Andean Civilization*. London: Thames & Hudson, 1995.

Bushnell, Geoffrey H. S. *The Archaeology of the Santa Elena Peninsula in Southwest Ecuador*. Cambridge, U. K.: University of Cambridge Press, 1951.

Cáceres Macedo, Justo. *Cerámicas del Perú Prehispánico/Ceramics of the Prehispanic Peru* Volume I. Translated by Carolina Cáceres Enriquez and Ruth Monica Cáceres Enriquez. Lima: 2005.

Campana, Cristóbal. *La cultura mochica*. Lima: Consejo Nacional de Ciencia y Tecnología, 1994.

Coe, Michael D. "Archaeological Linkages with North and South America at La Victoria, Guatemala." *American Anthropologist* 52 (1960): 363–393.

Crespo Toral, Hernán and Olaf Holm. *Arte Precolombino de Ecuador*. Salvat Editores Ecuatoriana: Quito, 1977.

Cummins, Thomas, Julio Burgos Cabrera, and Carlos Mora Hoyos. *Arte prehispánico del Ecuador: Huellas del pasado: Los sellos de Jama-Coaque*. Miscelánea Antropológica Ecuatoriana, Serie Monográfica 11. Guayaquil: Banco Central del Ecuador, 1996.

Diskurs 70—Culturas en la Costa del Ecuador. Guayaquil: Colegio Alemán Humboldt, 1969–70.

Donnan, Christopher B. *Ceramics of Ancient Peru*. Los Angeles: Fowler Museum of Cultural History, University of California, 1992.

Doyon, Leon G. "La secuencia cultural Carchi-Nariño visto desde Quito." *Perspectivas regionales en la arqueología del suroccidente de Colombia y norte del Ecuador*, edited by Cristóbal Gnecco. Popayán: Editorial Universidad del Cauca, 1995.

Estrada, Víctor Emilio. *Últimas civilizaciones pre-históricas de la Cuenca del río Guayas*. Guayaquil: Publicaciones del Museo Víctor Emilio Estrada, no. 2, 1957.

Falchetti, Ana María. *El Oro del Gran Zenú: Metalurgia prehispánica en las llanuras del Caribe colombiano*. Bogotá: Banco de la República, Museo del Oro, 1995.

Guinea, Mercedes. "Los símbolos del poder o el poder de los símbolos." *Simbolismo y ritual en los Andes septentrionales*, edited by Mercedes Guinea. Quito: Ediciones Abya-Yala, 2004.

Gutiérrez Usillos, Andrés. *Dioses, símbolos y alimentación en los Andes: Interrelación hombre-fauna en el Ecuador perhispánico*. Quito: Ediciones Abya-Yala, 2002.

Holm, Olaf. *Cultura Milagro-Quevedo*. Guayaquil: Museo Antropológico y Pinacoteca del Banco Central del Ecuador, 1981.

Hosler, Dorothy. *The Sounds and Colors of Power: The Sacred Metallurgical Technology of Ancient West Mexico*. Cambridge, MA: MIT Press, 1994.

_____, Heather Lechtman, and Olaf Holm. *Axe-Monies and Their Relatives*. Studies in Pre-Columbian Art & Archaeology, no. 30 (1990). Washington: Dumbarton Oaks Research Library and Collection.

Jijón y Caamaño, Jacinto. *El Ecuador interandino y occidental antes de la Conquista Castellana*, 4 vols. Quito: Editorial Ecuatoriana, 1943.

Kan, Michael, Clement Meighan, and H. B. Nicholson. *Sculpture of Ancient West Mexico: Nayarit, Jalisco, Colima: The Proctor Stafford Collection*. Los Angeles: Los Angeles County Museum of Art, 1970.

Labbé, Armand J. *Colombia Before Columbus: The People, Culture, and Ceramic Art of Prehispanic Colombia*. Rizzoli: New York, 1986.

_____. *Shamans, Gods and Mythic Beasts: Colombian Gold and Ceramics in Antiquity*. New York: American Federation of Arts, 1998.

Lathrap, Donald W. "The Tropical Forest and the Cultural Context of Chavin." *Dumbarton Oaks Conference on Chavin*, edited by Elizabeth P. Benson. Washington: Dumbarton Oaks Research Library and Collections, 1970.

_____. *Ancient Ecuador: Culture, Clay and Creativity, 3000–300 BC*. Catalogue by Donald Collier and Helen Chandra. Chicago: Field Museum of Natural History, 1975.

Lavalle, José Antonio. *Culturas Precolombinas: Moche*. Colección Arte y Tesoros del Peru. Lima: Banco de Credito del Peru en la Cultura, 1985.

Makowski, Krysztof, Christopher B. Donnan, Ivan Amaro Bullon, Luis Jaime Castillo, Magdalena Diez Canseco, Otto Elespuru Revoredo, and Juan Antonio Murro Mena. *Vicús*. Lima: Banco de Credito del Peru, 1994.

Martínez, Cruz. *Cerámica prehispánica norperuana: Estudio de la cerámica chimú de la colección del Museo de América de Madrid*. Oxford: BAR International Series 323, 1986.

Meggers, Betty J. *Ecuador*. Ancient Peoples and Places (series). New York: Praeger, 1966.

———, Clifford Evans, and Emilio Estrada. *The Early Formative Period of Coastal Ecuador: The Valdivia and Machalilla Phases*. Smithsonian Contributions to Anthropology I. Washington: Smithsonian Institution, 1965.

Moseley, Michael E. *The Inca and Their Ancestors: The Archaeology of Peru*. New York: Thames & Hudson, 1992.

Ontaneda Luciano, Santiago. "Culturas precolombinas de la Sierra Norte del Ecuador." *Ibarra: Museo del Banco Central del Ecuador*. Quito: Ediciones del Museo del Banco Central del Ecuador, 1998.

Pang, Hildegard Delgado. *Pre-Columbian Art: Investigations and Insights*. Norman: University of Oklahoma Press, 1992.

Paulsen, Allison Clement. "A Chronology of Guangala and Libertad Ceramics of the Santa Elena Peninsula in South Coastal Ecuador." PhD diss., Columbia University, New York, 1970. Ann Arbor, MI: University Microfilms 71–6236.

Porras G., Pedro I. *Fase Cosanga*. Quito: Ediciones de la Universidad Católica, 1975.

———. *Nuestro Ayer: Manual de arqueología ecuatoriana*. Quito: Centro de Investigaciones Arqueológicas, 1987.

Proulx, Donald A. *A sourcebook of Nasca Ceramic Iconography: Reading a Culture Through Its Art*. Iowa City: University of Iowa Press, 2006.

Schöndube B., Otto, and L. Javier Galván V. "Salvage Archaeology at El Grillo-Tabachines, Zapopán, Jalisco, Mexico." *Across the Chichimec Sea: Papers in Honor of J. Charles Kelley*, edited by Carroll L. Riley and Basil C. Hedrick. Carbondale: Southern Illinois University Press, 1978.

Scott, John F. "Pre-Hispanic Arts of Ecuador." *Pre-Columbian Art of Ecuador from the Peggy and Tessim Zorach Collection*. Ithaca: Herbert F. Johnson Museum of Art, Cornell University, 1982.

———. "Relaciones del Tesoro de los Quimbayas con otros estilos andinos septentrionales." *Relaciones interculturales en el area ecuatorial del Pacífico durante la época precolombiana*, edited by J. Bouchard & M. Guinea. Cambridge, U.K.: BAR International Series 509, 1989.

———. "El dragon mítico en el arte prehispánico andino." *Cultura y medio ambiente en el area andina septentrional*, edited by Mercedes Guinea, J.-F. Bouchard, and J. Marcos. Quito: Abya-Yala, 1995.

———. "El estilo Chorrera y su influencia en los Andes septentrionales." *El área septentrional andina: Arqueología y etnohistoria*, edited by M. Guinea, J. Marcos, & J.-F. Bouchard. Quito: Editorial Abya-Yala. Colección Biblioteca 59, 1998.

———. *Latin American Art: Ancient to Modern*. Gainesville: University Press of Florida, 1999.

———. "El hombre-pájaro en los Andes Septentrionales." *Simbolismo y ritual en los Andes Septentrionales*, edited by M. Guinea. Quito: Editorial Abya-Yala, 2004.

Snarskis, Michael J. "The Archaeology of Costa Rica" and catalogue. *Between Continents/Between Seas: Precolumbian Art of Costa Rica*. New York: Harry N. Abrams, Inc., in association with The Detroit Institute of Arts, 1981.

Stone, Doris. *Pre-Columbian Man Finds Central America: The Archaeological Bridge*. Cambridge, MA: Peabody Museum Press, 1972.

Stothert, Karen E. "Expression of Ideology in the Formative Period of Ecuador." *Archaeology of Formative Ecuador*, edited by J. S. Raymond and R. L. Burger. Washington: Dumbarton Oaks Research Library and Collection, 2003.

Uribe, María Victoria. "Asentamientos prehispánicos en el altiplano de Ipailes, Colombia." *Revista colombiana de antropología* 21 (1977): 57–195.

———. "Los pastos y etnías relacionadas: arqueología y etnología." *Area septentrional andina norte: Arqueología y etnohistoria*, edited by José Echeverría A. and Ma. Victoria Uribe. Quito: Banco Central del Ecuador, Colección Pendoneros, 1995.

Valdez, Francisco. *Proyecto arqueológico "La Tolita" 1983–1986*. Quito: Museo del Banco Central, 1987.

——— and Diego Veintimilla. *Amerindian Signs: 5,000 Years of Precolumbian Art in Ecuador*. Quito: Dinediciones, 1992.

Wilbert, Johannes. *The Thread of Life: Symbolism of Miniature Art from Ecuador*. Studies in Pre-Columbian Art & Archaeology 12. Washington: Dumbarton Oaks Trustees for Harvard University, 1974.

Zeidler, James A. "Feline Imagery, Stone Mortars, and Formative Period Interaction Spheres in the Northern Andean Area." *Journal of Latin American Lore* 14-#2 (1988): 243-283.

———. "Formative Period Chronology for the Coast and Western Lowlands of Ecuador, Appendix A." *Archaeology of Formative Ecuador*, edited by J. S. Raymond and R. L. Burger. Washington: Dumbarton Oaks Research Library and Collection, 2003.

This book was designed by
Mo Viele
Ithaca, New York

The book was printed by Eastwood Litho, Inc.
on Centura Dull paper.

1,200 copies
on the occasion of the exhibition

April 2008